THE INTEGRATION OF WOMEN INTO THE ECONOMY

ORGANISATION FOR ECONOMIC CO-OPERATION AND DEVELOPMENT

Pursuant to article 1 of the Convention signed in Paris on 14th December, 1960, and which came into force on 30th September, 1961, the Organisation for Economic Co-operation and Development (OECD) shall promote policies designed:

- to achieve the highest sustainable economic growth and employment and a rising standard of living in Member countries, while maintaining financial stability, and thus to contribute to the development of the world economy;
- to contribute to sound economic expansion in Member as well as non-member countries in the process of economic development; and
- to contribute to the expansion of world trade on a multilateral, non-discriminatory basis in accordance with international obligations.

The Signatories of the Convention on the OECD are Austria, Belgium, Canada, Denmark, France, the Federal Republic of Germany, Greece, Iceland, Ireland, Italy, Luxembourg, the Netherlands, Norway, Portugal, Spain, Sweden, Switzerland, Turkey, the United Kingdom and the United States. The following countries acceded subsequently to this Convention (the dates are those on which the instruments of accession were deposited): Japan (28th April, 1964), Finland (28th January, 1969), Australia (7th June, 1971) and New Zealand (29th May, 1973).

The Socialist Federal Republic of Yugoslavia takes part in certain work of the OECD (agreement of 28th October, 1961).

Publié en français sous le titre:

L'INTÉGRATION DES FEMMES
DANS L'ÉCONOMIE

Over the past decade the OECD Working Party on the Role of Women in the Economy has been examining the social and economic issues arising from the growing participation of women in the labour force. At a High Level Conference held in 1980 a Declaration on Policies for the Employment of Women was adopted setting out a range of policy aims which should be given priority in OECD countries.

The present volume provides a comprehensive and up-to-date analysis of relevant socio-economic and institutional developments affecting the status of women in the economy and reports on policy issues arising from the implementation of the 1980 Declaration.

This report of the Working Party on the Role of Women in the Economy was discussed by the Manpower and Social Affairs Committee in May 1984 and is published on the responsibility of the Secretary General.

Also available

OECD EMPLOYMENT OUTLOOK (September 1984)
(81 84 08 1) ISBN 92-64-12621-X 118 pages
£6.50 US$13.00 F65.00

THE EMPLOYMENT AND UNEMPLOYMENT OF WOMEN IN OECD COUNTRIES by Liba Paukert (April 1984)
(81 84 06 1) ISBN 92-64-12570-1 88 pages
£5.60 US$11.00 F56.00

THE CHALLENGE OF UNEMPLOYMENT. A Report to Labour Ministers (June 1982)
(81 82 04 1) ISBN 92-64-12332-6 166 pages
£7.60 US$17.00 F76.00

THE WELFARE STATE IN CRISIS (September 1981)
(81 81 01 1) ISBN 92-64-12192-7 274 pages
£7.00 US$17.50 F70.00

WOMEN AND EMPLOYMENT. Policies for Equal Opportunities (December 1980)
(81 80 04 1) ISBN 92-64-12136-6 170 pages
£3.80 US$9.50 F38.00

LABOUR FORCE STATISTICS 1962-1982 (Annual) (January 1985) bilingual
(30 85 01 3) ISBN 92-64-02664-9 494 pages
£15.00 US$30.00 F150.00

QUARTERLY LABOUR FORCE STATISTICS. Quarterly supplement to the Yearbook, bilingual
ISSN 0255-3627 1985 Subscription
£8.50 US$17.00 F85.00

CONTENTS

Chapter VIII
CONCLUSIONS AND POLICY DIRECTIONS

INTRODUCTION

The economic status of women has altered considerably in recent years. Female labour force participation rates have increased rapidly and have continued to rise in most countries despite the recession. Concomitantly, other factors affecting the role of women have been changing, including patterns of fertility, marriage and family organisation. Nevertheless, marked differentials between men and women persist in labour market participation, structure of employment and level of earnings, as well as in the domestic division of labour.

It is now ten years since the Manpower and Social Affairs Committee established the Working Party on the Role of Women in the Economy in recognition of the need to examine social and economic issues arising from the growing participation of women in the labour force. The Working Party's first report, published in 1979 as *Equal Opportunities for Women*, identified a range of problems affecting women's progress towards equality with men in employment and outlined some policy measures that could be adopted. Following that report, OECD Member countries held a High Level Conference in 1980 to discuss:

a) the implications of high and rising female participation rates in the labour force, and

b) the persistence of labour market segregation despite the introduction of equal opportunity policies in many Member countries.

The Conference issued a fourteen-point Declaration on Policies for the Employment of Women setting out a range of policy aims which should be given priority by the Governments of OECD countries. The Conference proceedings were published in 1980 as *Women and Employment: Policies for Equal Opportunities*.

The aim of this report is to provide a more comprehensive, comparative analysis of economic, social and institutional factors affecting the economic status of women. Throughout, emphasis is placed on the policy conclusions arising from the analysis, and guidelines are proposed with respect to policies for supporting and furthering equal opportunity for women. Chapter I outlines recent trends in female labour force participation patterns and unemployment rates, with particular reference to issues arising in the context of slow economic growth and rapid technological change. Chapter II provides a theoretical and empirical analysis of occupational segregation by sex and draws detailed conclusions regarding policies necessary to break down such segregation. Chapter III documents male and female earnings differentials and explores a range of possible explanatory factors. Chapter IV addresses the more specific problem of disadvantages faced by women migrants in OECD countries. In Chapter V, the position of girls and women in education is analysed and attention is drawn to the links between the labour market inequalities and persisting sex inequalities in education. Chapter VI, on the treatment of women in social security and taxation, emphasizes that practices in this field have lagged behind the changing role of women and sets out the principles which might form the basis of a more equitable approach. Chapter VII examines

9

the extent to which the policies recommended in the 1980 Declaration on Policies for the Employment of Women have been adopted in OECD countries, while Chapter VIII draws together the main policy conclusions of the report.

A major concern now of the Working Party on the Role of Women in the Economy is with promoting the adoption of policies which have been identified in this report and this will be an important focus of its future work. In this context the 1980 Declaration on Policies for the Employment of Women, which represents the policy stance by OECD Member countries, provides a crucial point of reference and particular attention will be given to encouraging and monitoring its implementation.

Chapter I

EMPLOYMENT AND UNEMPLOYMENT

1. INTRODUCTION

Demographic, economic and social changes in the post-war period have resulted in the increased participation of women in the formal labour market in all OECD countries. Women's incomes are now an important factor in maintaining consumer demand and in determining income distribution. Nevertheless, labour market bias against women persists and this, in combination with the recession, has resulted in greater economic insecurity for them and those who depend wholly or partly on their earnings. Inequality in the education system, in training, in employment and in the tax and social security systems, along with the domestic division of labour have combined to perpetuate occupational segregation and women's greater vulnerability to poverty and dependence. Budgetary cutbacks and restrictions in many of the OECD countries have had a particularly negative impact on women. Reductions in income support schemes, such as family allowances, along with reductions in payments to the unemployed and in training programmes are just a few examples pointing to the increasing economic hardships facing many women, especially those with low incomes.

This chapter will examine current trends in women's labour force participation, including the significant changes in labour market structure due to the advent of part-time employment, which has absorbed much of the increase in female employment, and the introduction of new technology, particularly in the service sector. While there has been a levelling off of the female participation rate, it is still on the increase in almost all OECD countries. In contrast, the participation rates of prime-age males, youth and older workers have been on the decline. The results of these changes will be discussed. A high proportion of women workers remain concentrated in a limited number of categories of service and public sector jobs; due to budget constraints in most OECD countries, these sectors are experiencing less employment growth than in previous periods. The increasing demand for part-time labour has been translated into more jobs for women, yet there may be drawbacks to this type of employment if part-time workers' level of pay and social security benefits are not proportional to those of full-time workers, and if they do not enjoy the same levels of working conditions and standards of protection. The impact of technological changes on women's employment and unemployment is analysed in a general way in order to pinpoint the most significant possible outcomes. An examination of female unemployment trends follows, focusing in particular on the period since the second oil-price shock (post-1979). Overall unemployment has increased significantly in the OECD area since 1980 and the chapter disaggregates the current trends according to sex, age, education, and economic level. Underemployment, discouraged

11

workers, and long-term unemployment are also considered. The subterranean economy or "grey" employment is not dealt with in this chapter although the Working Party may launch a study in the future on this increasingly important subject.

2. CURRENT TRENDS IN WOMEN'S LABOUR FORCE PARTICIPATION RATES IN OECD COUNTRIES

After four years of modest recovery since the first oil-price shock, the OECD economies again experienced a recession from the beginning of 1980 due to the effects of the second oil shock in 1979. Recovery from the present recession has been slower and more difficult than after the first oil shock, when real GDP in the OECD area began to recover within a period of eighteen months. Nevertheless, the female participation rate has generally increased, while male participation has continued to decline in virtually all OECD countries. How has this economic back-drop influenced women's labour-market position since 1979 and what are the possible future developments?

Examining participation rates (defined here as the numbers in the total labour force divided by the numbers in the working age population), which are the channel through which cyclical variations influence the size of the labour force, it is evident that since 1979 the overall participation rate for the OECD area has remained stable, the decline in Europe being offset by continued growth in North America and Japan. Disaggregating the data by sex (Table I.1), the male participation rate in the OECD area declined from 87.0 to 85.7 per cent between 1975 and 1979, while the female participation rate rose steadily over the same period from 49.2 to 52.7 per cent. Since 1979, the decline in male rates has continued in all OECD countries (except for slight increases in Austria in 1982, Finland in 1980 and 1981, Japan in 1981, and Italy and Norway in 1980). The female participation rate has levelled off slightly since 1979, but it has nonetheless been on the increase in most of the OECD countries.

A number of age-specific participation-rate changes have also occurred in the last few years and have influenced both male and female workers. The participation rate of older workers (age 55 and over), both male and female, has declined steadily in all countries since 1975, with the rate of decline slowing down after 1979. Generally labour force participation rates for young people, teenagers in particular, have declined, with rates for females occasionally equal, but usually substantially less than the rate for males. In North America, the decline in labour force participation rates has come after they had been rising steadily for years. In most of Europe the declines have simply continued secular trends. The generally downward trend in labour force participation has been accompanied by increases in enrolment in education and training, perhaps reflecting a pattern of voluntary withdrawal from the labour force in the face of declining job opportunities.

The effect of the trends in labour force participation on male/female rate differentials has been mixed. For teenagers the gender gap has stayed roughly the same overall, the differential growing in as many countries as it narrowed. The picture was a little more positive for young adults; the gap between female and male labour force participation rates narrowed in seven out of thirteen countries, although only in Japan and Finland did female labour force participation rates actually exceed male rates[1].

Participation behaviour is not independent of the state of the labour market but must be linked to the rate of unemployment, the level of vacancies (cyclical or demand variables), and to the discouraged and added worker effects[2]. However, these "effects" are not sufficient to explain the long-term growth trend of female labour force participation. Longer-term factors

12

Table I.1. Male and female participation rates
Percentages

	Males						Females					
	1975	1979	1980	1981	1982	1983a	1975	1979	1980	1981	1982	1983a
Australia	90.7	87.7	88.0	87.7	87.1	87.0	50.8	50.5	52.0	51.9	52.0	52.4
Austria	82.5	82.3	81.8	81.6	84.2	82.7	47.9	49.6	49.2	49.6	50.9	50.3
Belgium	83.7	80.9	80.4	80.0	79.6	79.4	43.9	47.3	48.0	48.7	49.5	49.4
Canada	86.2	86.2	86.3	86.4	84.9	85.0	50.0	55.5	57.2	58.8	58.9	60.3
Denmark	89.8	89.6	89.0	88.3	88.7	89.2	63.5	69.9	71.4	71.8	72.0	72.5
Finland	79.7	82.2	82.8	83.0	82.9	82.7	65.6	68.9	70.1	71.4	72.8	73.5
France	84.4	83.2	82.5	81.2	80.4	79.4	49.9	52.5	52.5	52.5	52.9	52.1
Germany	87.0	84.5	83.4	82.3	81.2	80.0	49.6	49.6	50.0	50.1	49.8	49.6
Greece	81.4	79.0	79.6	81.2	80.0	78.8	33.0	32.8	33.0	36.9	36.5	36.1
Ireland	88.5	87.3	87.9	87.5	86.8	86.5	34.8	35.2	35.0	35.7	36.2	36.2
Italy	84.2	82.7	82.9	82.8	81.8	81.0	34.6	38.8	39.8	40.5	40.3	40.8
Japan	89.7	89.2	89.1	89.3	89.1	89.1	51.7	54.7	54.9	55.2	55.9	57.2
Netherlands	83.2	79.0	79.6	79.9	80.5	80.3	31.0	33.4	35.4	37.5	38.8	38.7
New Zealand	88.6	87.0	86.5	86.6	85.7	85.8	41.1	45.0	44.8	45.6	45.2	45.4
Norway	85.9	87.0	87.6	87.5	87.2	86.1	53.3	61.7	63.2	64.2	65.3	67.0
Portugal	95.3	93.4	93.0	91.9	90.5	89.5	51.8	55.4	55.7	57.4	56.3	55.8
Spain	91.3	82.6	81.3	80.6	79.6	79.3	31.6	32.4	31.9	31.7	33.0	33.1
Sweden	89.2	87.9	87.8	86.5	86.2	85.9	67.6	72.8	74.1	75.3	76.0	76.6
Switzerland	97.4	93.8	94.1	93.6	91.9	90.0	49.6	49.4	49.9	50.3	49.6	48.6
United Kingdom	92.2	90.6	90.5	89.8	89.1	87.9	55.3	58.2	58.5	56.9	56.2	57.5
United States	84.7	85.1	84.7	84.5	84.3	84.7	53.2	58.9	59.7	60.7	61.4	61.9
North America	84.9	85.2	84.9	84.7	84.3	84.7	52.9	58.5	59.4	60.4	61.2	61.8
OECD Europe	87.3	84.8	84.5	83.8	83.1	82.2	45.7	47.9	48.3	48.5	48.7	48.7
Total OECD	87.0	85.7	85.4	85.1	84.6	84.3	49.2	52.7	53.3	53.8	54.3	54.7

a) Secretariat estimates.
Source: OECD Employment Outlook, September 1984, Statistical Annex.

are also at work, including demographic changes, alterations in marriage and divorce patterns, increasing education, changing social attitudes, new consumption patterns, inflationary pressures which increase the need for two-wage-earner families, government equal-opportunity policies and changes in the economy, such as the increase in part-time jobs which may have enabled workers with specific characteristics, such as the aged, youth and women responsible for dependents, to enter the labour market[3].

In the context of a discussion of fairly recent increases in the labour-market participation of women, it should be remembered that in a longer historical perspective the employment of both married and unmarried women is the norm, not only in agriculture, domestic work and commerce, but also in industry from its earliest days, when high levels of participation by married and unmarried women were attained[4].

Structural change leading to a varied pattern of employment growth by sector has had a significant impact on participation rates. Over the period 1975-79, the service sector was by far the major source of net job creation, and by 1980, 60-85 per cent of working women were concentrated in services in all OECD countries except those of Southern Europe where the agricultural sector still occupies a large share of the labour force[5].

While there have been expanding job opportunities for women in the private sector, it is the public sector that has played the most notable role, especially in the creation of part-time employment. Data on women's share of public-sector employment in eight countries reveal wide differences, however: in Scandinavian countries, the public sector is highly female intensive (seven out of ten workers being women), whereas Japan and Australia represent the other end of the scale (two men to every woman). Nevertheless, there is a clear tendency for the public sector to become more female intensive over time[6].

Data on the occupational distribution of women in the public sector are required for a more in-depth assessment of the impact of that sector on women's employment opportunities. Furthermore, the growth in public-sector employment is slowing down considerably because of budgetary restraints. The impact this will have on women's welfare needs assessment

Table I.2. **Female share of the labour force**
Percentages[a]

	1950	1977	1982		1950	1977	1982
Australia	22.4	35.8	37.0	Japan	38.4	38.2	39.0
Austria	38.5	38.5	38.7	Luxembourg	29.2	26.2	29.7
Belgium	27.9	35.6	37.7[e]	Netherlands	23.4	28.0	30.5
Canada	21.3	37.8	40.9	New Zealand	23.5	31.5	34.6[e]
Denmark	33.6	42.2	44.4[d]	Norway	27.1	39.6	42.2
Finland	40.6	45.8	47.1	Portugal	22.4	39.1	40.4[d]
France	35.9	37.6	38.6	Spain	15.8	28.6	29.5
Germany	35.1	37.6	38.2	Sweden	26.3	43.7	46.2
Greece	32.1	27.7[b]	32.0[d]	Switzerland	29.7	34.1	35.3
Iceland	28.5	31.6	31.1[e]	Turkey	44.4	38.4	—
Ireland	25.5	27.5[c]	27.7[e]	United Kingdom	30.7	38.2	39.1
Italy	25.4	31.9	33.8	United States	28.9	40.3	42.8

a) Population aged 15-64.
b) 1971.
c) 1975.
d) 1980.
e) 1981.
Sources: *Demographic Trends 1950-1990*, OECD, Paris, 1979; OECD, *Labour Force Statistics*, August 1983.

14

because, while the cyclical responsiveness of service-sector employment is less than in other sectors, the last recession has created a fairly widespread slowdown in service-sector employment especially in the United States and several European countries. In the United Kingdom, service-sector employment has actually declined since 1980[7], which may be partly due to a decline in the growth of public-sector employment.

3. PART-TIME EMPLOYMENT

One of the most significant structural shifts that has occurred in virtually all OECD Member countries over the past two decades has been the fall in average hours worked per person per year. Major factors have been reductions in the normal work week, increases in annual paid holidays, the growth of part-time work, and the growth in service-sector jobs where average hours worked are typically less than in other sectors[8]. Structural changes in the composition of employment and labour supply have supported a complementary development in the area of part-time employment.

This growth in part-time employment has been particularly pronounced since 1973. The proportion of part-time employment in total employment increased in all countries between 1973 and 1981 except in Ireland, Italy, the United Kingdom and the United States[9].

The implications for women's employment are important since the number of jobs held by women on a part-time basis is growing in every country. In some (Denmark, Norway, Sweden, the Netherlands) they account for over 40 per cent of jobs held by women. Conversely, the female share of part-time work is large everywhere, especially in Belgium, Denmark, Germany and the United Kingdom, where it now exceeds 90 per cent.

Aside from sex-specific differences, there are several other noteworthy characteristics of part-time employment. First, the age distribution of part-time workers reveals a divergence in the patterns for men and women. Male part-time workers tend to be concentrated in the older age groups in European countries and among the young in North America and Australia. Female part-time workers, on the other hand, tend to be concentrated in the prime age group[10] suggesting that women are entering into part-time employment at prime age (25-35) as a temporary measure[11] though this is not certain as the data are cross-sectional rather than longitudinal.

A further characteristic of part-time employment is its concentration in the service sector, which typically takes in more than 60 per cent of all part-time workers. In Australia, Belgium, Canada, Denmark, Finland, the Netherlands, New Zealand and the United States, the service sector accounts for more than 80 per cent of part-time employment[12]. A recent Canadian government study on part-time employment has concluded that "what the distribution of part-time workers across industries and occupations does show quite categorically is that part-time workers are markedly concentrated within a few industries, and that they have a limited range of occupations in comparison to the range of occupations of full-time workers"[13].

The rapid growth in part-time employment can be attributed to both demand and supply factors. On the demand side, the growth of service sector employment has created many part-time jobs, for many service sector activities benefit from the use of part-time workers. There is some evidence of a deliberate shift in enterprise employment policy toward greater use of temporary labour, much of which is of a part-time nature[14].

This increasing demand for part-time labour has dovetailed with changes in the structure of labour supply. Women with family responsibilities frequently have a severely restricted

15

Table I.3. **Overall size and structure of part-time employment**[a]

| | Ratio of part-time working | | | | | | Women's share in part-time employment | |
| | Both sexes | | Men | | Women | | | |
	1973	1981	1973	1981	1973	1981	1973	1981
Australia	11.4	15.9	3.4	5.2	27.3	34.6	79.6	79.0
Belgium	2.8	6.4	0.4	1.3	8.2	16.4	89.8	86.2
Canada[b]	10.6	13.5	5.1	6.8	20.3	31.8	69.5	72.0
Denmark	17.0	20.8	1.9	3.0	40.3	43.6	93.4	92.0
Finland[c]	3.9	4.5	1.4	1.7	6.7	7.6	81.0	80.2
France	5.1	7.4	1.4	1.9	11.2	15.9	82.1	84.6
Germany	7.7	10.2	1.0	1.0	20.0	25.7	92.4	93.8
Greece	—	2.1	—	1.1	—	4.3	—	63.0
Ireland[d]	4.0	3.1	1.8	1.3	10.1	8.0	67.5	68.6
Italy	3.9	2.7	2.3	1.4	8.5	5.8	55.4	64.1
Japan	7.9	10.0	4.8	4.9	17.3	19.6	60.9	67.3
Luxembourg[d]	4.5	5.8	1.0	1.0	13.9	17.1	83.3	87.5
Netherlands[e]	4.4	19.4	1.1	8.4	15.5	45.2	80.4	67.6
New Zealand	10.8	13.9	4.7	5.0	22.0	27.4	71.3	78.7
Norway[b]	23.5	28.3	8.7	10.6	47.6	53.6	77.0	77.9
Sweden	18.0	25.2	3.7	7.2	38.8	46.4	88.0	84.5
United Kingdom	15.3	15.4	1.8	1.4	38.3	37.1	92.1	94.3
United States	13.9	14.4	7.2	7.5	23.8	23.7	68.4	70.3

a) See Note D of the Technical Annex for definitions of part-time employment in *Employment Outlook 1983*.
b) 1975 and 1981.
c) 1976 and 1981.
d) 1973 and 1979.
e) 1981 data are not comparable with 1973 data because of a change in the definition of part-time workers. For details see the Technical Annex of *Employment Outlook*.
Source: *OECD Employment Outlook*, 1983, p. 44.

choice of employment, of hours worked and of location of work, especially where child-care facilities of reasonable cost are lacking. The existence of such constraints may point to the involuntary nature of much part-time employment.

A more restricted definition of involuntary part-time employment, for statistical purposes, is that it occurs if a worker is forced to take a part-time job instead of a full-time job because of the difficulty of finding the latter[15]. The *OECD Employment Outlook* has found that the proportion of part-time workers considered to be involuntary under this definition has risen since the mid-1970s for Canada and the United States, while in Australia the proportion, stable in the mid-1970s, has since risen dramatically. In the United States, it has been estimated that 536 000 women were working part-time because they could not find full-time work[16]. An Australian Office of the Status of Women report cites a 1982 survey which revealed that 21 per cent of women who worked between ten and thirty hours a week would have preferred to work more hours[17]. In addition, most involuntary part-timers are women because women form such a high proportion of total part-time workers[18].

Part-time work is for some also a form of underemployment. A recent U.S. Commission on Civil Rights report (1982) defines underemployment as including marginal jobs and inequitable pay. Marginal jobs refer to those in the secondary labour market, with low wages and benefits and high labour turnover. Inequitable pay refers to earnings that are not commensurable with a person's qualifications[19]. There are many indications that women suffer disproportionately from these forms of underemployment.

The flexibility of part-time work is its most frequently cited advantage for women, yet many part-time workers are "on-call", working irregular hours. This makes it even more difficult to manage household responsibilities and especially to arrange for the working parent's alternative child care. In continuous service industries such as health care, part-time employees are often required to work evenings and weekends.

It is argued that part-time jobs help women maintain their professional skills while simultaneously reducing their hours of work. This may be a valid argument in some cases, such as paramedical or medical professions, teaching, or highly educated professions, but only a small number of part-time jobs have a significant skill component. Also, part-time workers may experience depreciation of any skills they do have, since on-the-job training is rarely offered to them. Advancement opportunities are often minimal; furthermore, the exclusion of part-time workers from pension schemes in some countries means that there will be no retirement income on the basis of employment-related pension schemes. Part-time workers frequently have less job security since they are often the first to be laid off.

But part-time work will continue to grow, especially in the industrial sectors which already employ part-time workers, and it will be introduced into many workplaces traditionally dominated by full-time workers because of its scheduling and productivity advantages to employers. Many workers are beginning to demand more flexible working hours over their life cycle to meet other responsibilities, educational fulfillments and financial requirements. It remains to be seen what impact women can have on the economic and social decision-making process via women's associations, unions and professional associations[20], government bodies, and as individual workers.

4. TECHNOLOGICAL CHANGE AND WOMEN'S EMPLOYMENT

The concentration of women's employment in the tertiary sector and the advent of new technology for the office are trends whose consequences cannot yet be determined and which are the object of much debate. Because micro-electronically-based equipment is generally labour saving, there has been growing concern about its labour displacement effects. As a recent study by Diane Werneke[21] points out, it is difficult to reach a definite conclusion since the relationship between technological change and employment is not a direct one. The speed and pattern of diffusion of the technology (how quickly it is introduced and into which sectors) is important as well as the capacity of the economy to accommodate the structural changes that occur as new technologies are increasingly introduced[22]. However, in the medium term, in a climate of low production growth and weak aggregate demand, there may be worker displacements and a mismatching of skill requirements and supply, to name just a few possible consequences for women.

With some jobs being lost through implementation of the new technology and a curtailment in the growth of new office jobs, women will be negatively affected since they have more limited access to alternative job possibilities owing to a host of factors including limited geographical mobility, inadequate information about jobs in the primary sector, and low technical skills due to early streaming in education and a lack of training[23].

Werneke surveys the studies in this area and finds that most analysts look at increases in productivity due to machines and then translate this into fewer workers, or jobs, available. The problem with such an approach is that it fails to recognise that rising costs and low-reliability of non-automated systems might be followed by a falling demand for such services; jobs, therefore, may be lost without the introduction of the new technology.

The second problem of such an analysis is that it fails to take into account that increasing productivity resulting from the implementation of the new technology may make it possible for the enterprise to offer new services which might not have been undertaken otherwise[24]. For example, bank analysts in the United States and Canada believe that as computers become more refined, banks will move towards new uses of information such as tax counselling, budget counselling and retail services that will allow customers to ponder investments and purchases given a certain future income picture. Many banks are also shifting their data-processing requirements to in-house operations[25]. Canadian research findings indicate that the productivity of clerical workers is in fact increasing[26]. In New Zealand, the introduction of computerised grocery ordering and electronic cash registers in several outlets of a major supermarket chain in 1978-1980 did not cause a loss of jobs despite an increase of labour productivity of between 20-50 per cent. Further research supporting or disclaiming these preliminary findings would provide more precision with respect to the effects of these developments on the employment, skills and learnings of women.

Women workers constitute the group that will be most immediately and directly affected by the new information technology in the offices. They could be threatened by displacement and the need to retrain in view of their relative concentration in clerical and related occupations. The majority of women have found employment in the tertiary sector (see Table I.4) in a concentrated range of occupations many of which will be affected by skill changes due to office automation (see Table I.6 for United States data). They will be largely responsible for making the adjustments that are required. Because of changing skill requirements, women seeking to re-enter the labour market and new entrants who have been trained only in traditional skills may be faced with increasing difficulties. Older persons may also experience problems since they tend to lack the relevant basic knowledge and general office skills that may provide some flexibility in the context of change[27].

Within the information sector there are skilled occupations involved in the creation, analysis, coordination and interpretation of information as well as less skilled jobs involving the manipulation of information. It is within these less skilled occupations that women are largely concentrated as secretaries, typists, book-keepers, stenographers and cashiers (see Table I.5). Men tend to be concentrated in the upper strata of information occupations, where micro-electronics is conceived of as a tool to assist in the analysis and decision-making process. Furthermore, the change in information technology is frequently implemented without changing traditional organisational and administrative structures[28].

While it is difficult to predict the range of jobs that will be created, it is clear that computer applications – programming, systems analysis, data management – and electronics engineering are growth areas. Werneke cites evidence that points to a bleak future for women in these jobs. In the United States, for example, women hold only 25 per cent of computer-specialist occupations and represent 20 per cent of engineering and science technicians where they tend to be concentrated at the lower end of the skill spectrum. In Europe, the proportion of women in higher-skill-level computer courses has grown over the last two decades, but women still account for only 10-25 per cent of all course participants[29]. The extent to which women will be able to obtain these new skills also depends a great deal on the rate of diffusion of the new technology.

It is not only the labour-displacement effects of the new office technology that are of concern to female workers but also their impact on job content and work organisation. On the one hand, it is argued that the new technology will enhance jobs, upgrade skills and vary the tasks of the information handler. Another view suggests that the introduction of the new technology will de-skill information-handling jobs and will make them more monotonous by fragmenting tasks according to the principles of scientific management. The outcome will

Table I.4. **Concentration of women workers by sector of activity (1977)**

	Sector			Total number employed (thousands)
	Agriculture (%)	Industry (%)	Services (%)	
Germany	7.5	29.5	61.6	9 012
France	8.6	24.4	67.0	8 077
Italy	13.2	31.2	55.6	5 366
Netherlands	1.5	14.0	83.3	1 154
Belgium	2.1	23.0	72.4	1 120
Luxembourg	0.5	12.5	80.0	40
United Kingdom	1.3	25.6	72.3	9 373
EEC 9	6.3	26.5	66.3	35 189
United States (1980)	1.6	17.9[a]	80.5[b]	41 283
Canada (1979)	3.2	15.8	81.0	4 022
Australia (1979)	3.8	17.1	79.0	2 137

a) Includes manufacturing, mining and construction.
b) Includes transportation, public utilities, trade, finance, public administration, private household services and miscellaneous services.
Source: Werneke, *op. cit.*, Chapter III.

Table I.5. **Concentration of women workers by occupation**
Percentage of female labour force

	Occupation				
	Clerical	Sales	Professional and technical	Administrative and managerial	Service workers
Germany	31.0	13.2	13.8	1.5	16.9
France	26.9	10.4	19.7	1.5	15.3
Italy	14.4	12.4	13.1	0.2	13.5
United Kingdom	30.8	12.2	12.2	0.9	23.3
United States	34.3	6.8	15.2	5.9	21.0
Canada	34.0	10.5	19.3	4.8	18.0
Australia	33.7	13.0	14.4	2.7	15.5

Source: Werneke, *op. cit.*, Chapter III.

depend a great deal upon the collective organisation of women office workers and their ability to participate in the reorganisation of their workplaces and tasks.

The increasing ability to perform computer-applications work in the home via rapid communication between geographically separate sites is being monitored closely by researchers as it is being promoted as a solution for workers with young children or dependants because of its flexible working hours, its potential to provide an extra source of pay and uninterrupted career development. Others view this development toward "home work" as being a mere modernisation of the traditional piece-work system in the home. It reinforces women's isolation since they are involved in virtually no social contacts and it effectively "hides" the work they do. Furthermore, there exists the clear possibility for the exploitation of female home-workers in terms of pay and benefits, similar to that of the home piece-work system[30]. In addition, home work allows for no control of working hours, rarely is it guided by protective measures in terms of health, it does not fall under trade-union jurisdiction, nor does

Table I.6. **Female white-collar occupations likely to be affected by micro-electronics in the United States (1980)**

Occupation	Percentage of women	Number of women employed (000s)
Book-keepers	90.5	1 723
Cashiers	86.6	1 346
Secretaries	99.1	3 841
Typists	96.6	991
Bank tellers	92.7	515
Billing clerks	90.2	147
Clerical supervisors	70.5	169
Collectors	56.4	44
Counter clerks	73.4	257
Estimators	56.2	300
File clerks	86.4	280
Insurance adjusters	57.5	100
Office machine operators	72.6	682
Payroll and time keeping	81.0	188
Receptionists	96.3	606
Statistical clerks	78.0	302
Stenographers	89.1	57
Telephone operators	91.8	290
All other clerical	77.1	1 435
Total employed		41 283

Source: Werneke, op. cit., Chapter III.

it allow for a distinct work/leisure separation. The disadvantages of home-work seem to outweigh initially-perceived advantages. However, some studies find little evidence that micro-electronics will lead to home-based office work on any substantial scale[31]. Technological developments, however, which provide for new possibilities for the decentralisation of employment outside urban centres can have positive effects on the employment of women where there is a lack of balance between male and female employment opportunities.

The service sector is not the only one affected by the new technology. The Science Policy Research Unit study for Britain also examines the manufacturing industries and the impact that micro-electronics will have on women employed as operatives. The findings vary depending on the industry in question but it is concluded, in general, that it is very difficult to disentangle the effects due to economic or technological change[32].

Finally, the issue of health and safety in the context of the new technology has generated a great deal of concern. This includes a discussion of stress-related diseases as well as other health problems particularly associated with the use of visual display units (VDUs), such as eye, neck, and back fatigue, migraine headaches, nausea, and repetition injury[33].

Overall, then, the slowing of demand for certain categories of workers (especially clerical), the ensuing skill gaps, job content changes, gender-specific changes in job categories due to the introduction of new technology and home work are all vital areas of investigation in considering the present and future labour market position of female workers in OECD countries, and, in particular, the situation of potential female re-entrants into the labour market. Given present and potential changes in the structure of the economy, the threat of women being burdened with an unequal proportion of unemployment must be considered.

5. UNEMPLOYMENT TRENDS OF FEMALE WORKERS

The overall unemployment situation in the OECD Member countries has deteriorated dramatically since 1980. The area unemployment rate, which stood at 3.6 per cent in 1973, rose sharply in the wake of the first oil shock to 5.2 per cent in 1975 which represented 17.4 million unemployed. The rate remained unchanged until 1979 but following the second oil shock, the unemployment rate began to rise in the first half of 1980 and has continued to increase since then. In 1981, the OECD area had an unemployment rate of 6.7 per cent. The overall unemployment rate has continued to increase to reach 8.7 per cent in 1983, a level of 32.3 million persons unemployed[34].

During periods of high unemployment, the number of "discouraged" workers increases and so measured unemployment underestimates the actual level of labour market slack during a period of slow economic growth[35]. For example, the Australian Bureau of Statistics found there to be 113 200 discouraged job seekers, 84.8 per cent of whom were women (at March 1983). The ABS also indicated that there were 397 400 women who for various reasons, including lack of child care, were deterred from actively seeking paid work, although they were available to start work[36].

Male and female unemployment rates have behaved differently in recent years. In most OECD countries female unemployment tended to increase faster than male unemployment in the 1960s and 1970s but this trend has not persisted since the second oil shock.

Table I.7 traces the development of unemployment by sex in the majority of OECD countries for certain key years since 1973. While the male unemployment rate in these countries declined by almost 0.75 percentage point between 1975 and 1979, the female unemployment rate declined only by 0.25 percentage point. However, since 1980, male unemployment has risen faster than female unemployment. The excess of female over male unemployment rates, which was 1.8 percentage points in 1979 declined to 1.3 percentage points in 1981 and the gap was further reduced to about 0.75 percentage point in 1982. For 1983, in all OECD countries for which data are available, female unemployment rates were higher than male rates, except in Canada, Finland, the United Kingdom and the United States. This lower cyclical elasticity of female unemployment was also apparent in many countries during the 1974-75 recession[37] but it is more pronounced during the current recession.

The causes are twofold. First, the goods-producing sector (mining, manufacturing, construction), which employs relatively more men than does the service sector, has been hit especially hard during the present recession. This is not to infer that there have been no cuts in jobs in the service or public sectors of the economy, both of which are characterised by a relatively large concentration of female workers. Second, the rate of growth of the female labour force has slowed down substantially since 1979, thereby contributing to easing the pressure on female unemployment.

However, the narrowing of the differential in the unemployment rates of males and females may also reflect the fact that women have been withdrawing from the labour market or delaying re-entry given the lack of available work. The Australian figures for March 1983 indicate that if estimates of the unemployment rate included recorded discouraged workers together with those persons not in the labour force, but who wanted a job and were available to start work immediately, then the unemployment rate for men would have increased from 9.9 to 12.8 per cent, but for women the rise would have been from 11.25 to 26.7 per cent[38]. This case at least seems to indicate that it is largely unemployed women rather than men who are not being counted in unemployment statistics.

Table I.7. **Unemployment rates by sex**

	1973 M	1973 F	1975 M	1975 F	1979 M	1979 F	1981 M	1981 F	1982 M	1982 F	1983 M	1983 F
Australia	1.6	3.6	3.7	7.0	5.0	8.0	4.7	7.4	6.2	8.4	9.6	10.3
Austria	0.6	1.8	1.4	2.3	1.5	3.1	1.9	3.6	2.8	4.6	3.5	5.6[a]
Belgium	1.8	3.1	3.1	6.3	4.1	12.2	6.6	14.6	8.2	15.9	9.2[a]	17.1[a]
Canada	4.9	6.7	6.1	8.1	6.6	8.7	7.0	8.3	11.0	10.8	12.0	11.6
Denmark	0.7	1.1	4.7	5.1	4.2	8.3	10.0	10.7	10.5	11.1	11.1[a]	11.9[a]
Finland	2.4	2.2	2.3	2.1	6.2	5.5	5.1	5.1	5.8	5.8	6.1	6.0
France	1.5	4.6	2.8	6.3	4.0	8.9	5.0	10.9	5.6	11.5	5.9	11.3
Germany	0.9	1.2	3.7	4.5	2.5	4.5	3.8	5.9	6.0	7.7	7.5	9.3
Greece	1.7	2.7	1.8	3.5	1.3	3.2	3.3	5.7	4.8	8.5	5.1[a]	9.1[a]
Ireland	6.6	3.9	7.2	4.1	6.6	4.7	9.9	6.4	11.7	8.1	14.6[a]	12.0[a]
Italy	4.1	11.4	3.7	10.5	4.8	13.1	5.3	14.2	6.0	14.7	6.4	16.1
Japan	1.3	1.2	2.0	1.7	2.2	2.0	2.3	2.1	2.4	2.3	2.7	2.6
Netherlands	2.4	1.8	5.4	4.7	4.8	6.7	8.3	9.1	11.4	11.4	14.0[a]	13.5[a]
New Zealand	0.1	0.3	0.2	0.3	1.7	2.3	3.3	4.2	3.5	4.6	5.4[a]	6.0[a]
Norway	1.0	2.4	1.9	2.9	1.6	2.4	1.5	2.8	2.3	3.0	2.9	3.8
Portugal			5.1	6.1	4.8	12.9	4.0	13.6	3.6	12.3	4.6[a]	15.1[a]
Spain	2.5	2.3	4.4	3.9	8.7	10.8	13.8	18.0	15.1	20.3	16.5	21.4
Sweden	2.3	2.8	1.3	2.0	1.9	2.3	2.3	2.7	3.0	3.4	3.4	3.6
Switzerland	0.0	0.0	0.4	0.2	0.3	0.4	0.2	0.2	0.4	0.5	0.8	1.0
United Kingdom	2.9	0.9	4.3	1.4	5.5	3.3	10.9	6.0	12.6	7.1	13.3[a]	7.9[a]
United States	4.0	6.0	7.7	9.3	5.0	6.8	7.2	7.9	9.7	9.4	9.7	9.2
Seven major countries	2.8	4.2	4.9	6.2	4.2	6.0	5.8	7.1	7.4	8.2	7.8	8.5

a) Secretariat estimates.
Source: OECD Employment Outlook, 1984, Statistical Annex.

Disaggregating by age, unemployment for female teenagers and 20-24 year-olds was higher than for the respective male age groups in most countries, with the greatest differences occurring in France and Germany where 20-24 year-old women fared substantially worse than male teenagers. Only Canada, Finland and Great Britain recorded lower jobless rates for women; gender differences were small in Japan, Sweden, the United States and Norway.

For female unemployment of all ages, data can be disaggregated further to take into account the number of dependants and their ages, education and economic levels. The highest incidence of unemployment is to be found among women without dependants and this is partly related to the high rates of unemployment of young people[39] and due to the fact that unemployed young people have a high probability of being counted in official statistics. Also, women without dependants may experience more frictional unemployment due to greater mobility in job search and their desire for new employment. A number of women are sole-support mothers who are concentrated at the lower income levels and who have not had sufficient education and skill training to facilitate their steady employment. Another reason may be that a certain number of married women do not register as unemployed because of the restricted coverage of unemployment and related benefits in a few countries (for example, the United Kingdom and Australia). It has been recognised that in the latter country women are less likely than men to register with the Commonwealth Employment Service. For instance, in July 1982, 37.2 per cent of women who were looking for work were not registered with the CES compared to 19.7 per cent of unemployed men[40].

A concentration of unemployment in certain families or household units exists in all countries for which data are available. Data for the United States indicate that wives of unemployed husbands have above-average unemployment rates, just as husbands of unemployed wives have particularly high unemployment records. In Australia, in 1980, wives of unemployed men were more than six times as likely to be unemployed and one third as likely to be employed compared with the wives of employed husbands. This phenomenon can be partly explained by sectoral and geographical factors. In families residing in economically depressed areas, all members are more likely to become unemployed than in areas having a higher level of economic activity with more diversified job opportunities. Moreover, the higher incidence of unemployment in manufacturing, characteristic of the two recessions in the 1970s, is likely to affect industrial manual workers who are frequently found together in the same families or households.

The level of education, a worker's investment in human capital or in a job-entry certificate, is a factor which is associated (positively) with rising participation rates and (negatively) with the probability of becoming unemployed. For example, in Canada, women with less than nine years of school have a participation rate of 25.9 per cent, while university graduates have a participation rate of 71.8 per cent. In the United States, a woman who has four or more years of college is twice as likely to be economically active than a woman who is not a high school graduate. In Belgium, 30 per cent of women with only primary or incomplete secondary education are working, compared to 82 per cent of university graduates. Also, highly educated women are more likely to have uninterrupted and longer working careers than women whose level of education is low[41].

The incidence of unemployment tends to vary also by income groups and by type of family. Unemployment rates are higher among single-parent, female-headed households, and divorced, separated or widowed women have higher unemployment rates than married or single adult women. In addition, in countries for which data are available, relatives living in single-parent families have higher unemployment rates than those living in two-parent families[42].

Thus, the burden of unemployment does not fall equally upon men and women. Furthermore, there is evidence for some countries that the level of female unemployment varies among different groups of women. In the United States, for example, the unemployment rate of minority women has averaged about 80 per cent above that of white women over the last quarter of a century[43]. Another important consequence that may be a result of the general increase in unemployment in the OECD economies is the increasingly precarious nature of much of female employment. This feminisation of the "secondary", and peripheral labour markets, often characterised by intermittent employment and low wages, is in sharp contrast to much of male, full-time "primary-segment" employment[44].

6. LONG-TERM UNEMPLOYMENT

Having looked at the proportion of the labour force entering unemployment, one needs to consider the length of time workers remain there[45].

A recent OECD study notes that given the outlook for rising unemployment, it is almost inevitable that the numbers in long-term unemployment will grow further as many of those who lost jobs over the past year will find it very difficult to re-enter the labour market[46].

While the composition of long-term unemployment varies considerably, certain trends can be ascertained from Tables B and C of the Statistical Annex. As unemployment has increased, the proportion of long-term unemployed accounted for by both youth and prime-age workers has tended to rise and the proportion of older workers has tended to fall. In the majority of countries there has been since 1973 a marked tendency for the proportion of women in long-term unemployment to rise, which is only partly accounted for by the rise in female participation rates. Generally, the groups most affected by long-term unemployment are the old, the sick and those with below average or out-dated skills. This last feature can be attributed to many women working in the service sector, especially on a part-time basis. Without further skill development, many women concentrated in the lower-paying marginal jobs of the tertiary sector will not equally share the opportunities offered by an economic recovery.

7. CONCLUSIONS AND POLICY DIRECTIONS

Many women support dependants. Women's work, be it in paid employment, the home, agriculture, or various forms of small-scale production, has always been a vital component of family income, particularly in low-income families. Today, women's earnings are essential to maintaining consumer demand, and in many countries women's paid employment is the primary factor keeping families from falling to poverty levels[47]. In addition, about one-fifth of working women in Western Europe and North America are sole providers for themselves and their dependants[48]. Despite this, women's contribution is hindered by the recessionary state of the economy, continuing labour market bias which is exemplified by their lower wages in comparison to men's, occupational segregation, greater unemployment than men in some countries, hidden unemployment and involuntary part-time work. This results in greater economic insecurity for women and their families and leads to increasing poverty that is translated into a greater burden on the Welfare State.

Women's liberation from dependency and poverty is linked with the need to pursue economic recovery in general. Economic recovery must go hand in hand with equity, however, if the specific problems facing women are to be addressed. For example, government unemployment policies may not always take into account the specifics of women's unemployment. Consequently, it is necessary to design programmes that are specifically tailored to expanding women's vocational options and targeting particular job creation programmes to workers with particular labour market problems, as discussed in the OECD's *The Challenge of Unemployment* (1982). Legislation preventing discrimination against women combined with affirmative action programmes will also be required[49].

Specific policy implications can be drawn from this chapter's discussion of part-time employment and technological changes. Both are inevitable and increasingly important developments in the long term, for increasing competitiveness, productivity and new employment opportunities. However, in the medium term, given low production growth and weak demand, technological changes may lead to loss of jobs (especially in those occupations primarily employing women) and part-time employment may become a last resort if no full-time work is available. As women are the vast majority of part-time workers, they also, at present, bear the disadvantages of part-time work disproportionately.

For part-time work to be in harmony with equity, fundamental changes are required – for as long as part-time jobs are considered to be the prerogative of women, this will only represent another form of labour market segregation and inequality. Countries must develop definitions

of part-time employment that will provide the basis for legislative protection for the majority of part-time workers[50]. The lack of pension and other fringe-benefit coverage for part-time workers must be addressed by policy makers. Specifically, the argument that part-time workers do not need such benefits because they are covered by their spouse or by their parents needs to be removed from the policy arena as it assumes that compensation should be based on marital or family status. This is not a criterion applied to full-time workers nor should it apply to part-time workers, be they married women or students. Lack of job security and opportunities of advancement for part-time workers also need to be considered. The possibility for older workers to pursue part-time employment with a partial pension needs to be analysed[51].

The possibility of technological unemployment is a very real one in certain occupations and sectors. Consideration must be given to how the costs and benefits of technological change can be socially distributed in an equitable way. It is in this area that education and training policies will play a key role. Access of women to a greater number of occupations and to new, specialised technical skills will require specific projects to be put in place by the authorities. This is an especially important area for girls and young women who still suffer from vocational and academic counselling that steers them into traditional roles, into jobs with limited upward or lateral mobility, or indeed into unemployment. Even if they are trained in non-traditional areas, employer recruitment, training and promotion policies often incorporate intentional or unintentional sex biases.

Countries have responded in diverse ways to the various economic, political and social changes since the first oil-price shock. Some are concretely committed to "equal opportunities for paid employment independently of the rate of economic growth and conditions in the labour market"[52]. In others, the harsh reality of negative employment growth has resurrected a "back-to-the-home" ideology. The Working Party might consider, as part of its future work, evaluating markets and other economic pressures. Has this led to a subtle or overt effort to push women back into the home in order to allow the "male breadwinner" to pursue the limited number of possible job opportunities? Have budgetary pressures meant declining institutional support for working parents? Has the level of sex segregation in the labour market ameliorated or intensified?

For women to participate equally in the labour market and in economic recovery, programmes must be developed that will reduce their dependency and their increasing burden of poverty. This will require efforts not only in the employment, education and training spheres, but also in the tax and social security systems.

STATISTICAL ANNEX

Table A. Male and female unemployment rates, by age

		1973		1979		1982	
		M	F	M	F	M	F
Australia	20	4.6	4.9	14.7	20.4	16.4	17.1
	20-24	2.1	2.5	8.3	8.0	11.2	8.8
	25-54	0.8	2.4	2.9	5.1	4.4	5.4
	55+	0.8	1.4	2.7	1.8	3.3	2.7
Canada	20	13.5	11.2	16.4	15.8	24.6	18.9
	20-24	9.8	6.5	11.1	10.4	19.0	14.3
	25-54	4.2	3.6	4.6	7.3	8.5	9.2
	55+	4.6	2.5	4.1	4.4	6.3	5.7
Finland	20	7.3	7.1	22.5	19.2	20.0	17.7
	20-24	3.3	3.6	10.2	8.5	9.5	8.4
	25-54	1.8	1.5	5.0	4.2	4.3	3.8
	55+	2.2	1.6	5.4	6.0	12.0	13.2
France	20	4.1	8.0	13.6	32.9	21.5	44.4
	20-24	2.5	4.5	7.6	14.2	13.5	20.6
	25-54	1.0	2.4	3.1	5.7	4.2	7.6
	55+	2.1	2.2	3.5	4.1	4.9	5.9
Germany	20	0.7	1.4	2.4	5.5	6.4[a]	9.2[a]
	20-24	0.6	1.3	2.5	5.2	5.7[a]	8.0[a]
	25-54	0.5	1.1	1.6	3.7	3.0[a]	5.5[a]
	55+	1.3	1.0	3.5	4.6	4.6[a]	5.7[a]
Italy	20	15.8	15.7	26.5	39.7	28.3[a]	41.9[a]
	20-24	10.3	10.7	17.9	24.3	19.4[a]	26.9[a]
	25-54	1.5	2.0	1.9	7.1	1.9[a]	7.7[a]
	55+	0.5	0.0	4.2	15.3	4.6[a]	16.9[a]
Japan	20	3.8	1.8	5.4	2.7	6.5	4.3
	20-24	2.2	2.3	3.2	3.3	3.6	4.4
	25-54	1.0	1.0	1.6	2.0	1.8	2.0
	55+	1.6	0.3	3.7	0.9	3.8	1.3
Netherlands	20	—	—	6.3	7.5	13.1[a]	11.3[a]
	20-24	—	—	—	—	—	—
	25-54	—	—	2.6	2.7	4.9[a]	3.7[a]
	55+	—	—	2.9	2.4	3.6[a]	2.2[a]

Country	Age						
(country cut off at top)	20-24	3.2	3.8	4.9	4.3	3.8	4.3
	25-54	0.4	1.4	0.8	1.6	0.7[a]	2.2[a]
	55+	0.7	1.4	0.7	0.0	0.7[a]	0.0[a]
Portugal	20	—	—	13.0[b] / 13.3[c]	28.6 / 31.4	11.3[a,b] / 9.7[a,c]	28.1[a,b] / 27.6[a,c]
	20-24	—	—	9.1[b] / 7.8[c]	24.1 / 24.1	7.8[a,b] / 6.4[a,c]	25.8[a,b] / 22.0[a,c]
	25-54	—	—	2.9[b] / 2.4[c]	7.3	1.8[a,b] / 1.7[a,c]	10.8[a,b] / 7.6[a,c]
	55+	—	—	0.7[b] / 0.2[c]	0.5 / 0.5	0.8[a,b] / 0.8[a,c]	1.0[a,b] / 1.6[a,c]
Spain	20	7.4	6.3	28.0	31.5	44.4	52.6
	20-24	3.5	3.1	14.9	19.8	26.8	36.5
	25-54	1.5	1.2	6.4	5.3	10.8	10.6
	55+	1.2	0.4	4.6	1.1	8.2	0.9
Sweden	20	5.8	8.0	7.0	7.9	9.6	11.6
	20-24	4.2	4.7	3.6	3.8	6.3	5.8
	25-54	1.6	2.1	1.3	1.6	2.0	2.4
	55+	2.3	2.3	1.6	2.1	2.7	2.8
Great Britain	20	6.9[a] / 4.3[e]	4.7[a] / 2.8[e]	10.1[a] / 16.4[e]	10.3[a] / 16.6[e]	22.7[a] / 28.9[e]	19.7[a] / 25.9[e]
	20-24	5.5[a] / 3.6[e]	2.6[a] / 1.8[a]	8.8[a] / 7.3[a]	7.7[a] / 7.3[a]	19.5[e] / 19.0[e]	14.3[a] / 14.0[e]
	25-54	3.2[a] / 2.2[a]	0.8[a] / 0.6[e]	5.0[a] / 4.1[a]	2.5[a] / 2.4[a]	10.6[a] / 10.3[a]	5.5[a] / 5.6[e]
	55+	5.5[a] / 4.5[e]	0.8[a] / 0.6[e]	7.5[a] / 7.0[e]	1.8[a] / 1.8[a]	15.4[a] / 15.4[e]	3.9[a] / 4.0[e]
United States	20	12.9	15.2	15.0	16.3	23.1	17.0
	20-24	6.5	8.4	8.0	9.5	15.0	7.7
	25-54	2.5	4.4	3.3	5.2	7.8	4.8
	55+	2.5	2.8	2.9	3.2	5.1	

a) 1981.
b) First semester.
c) Second semester.
d) January.
e) July.

Source: OECD, Labour Force Statistics, August 1983.

29

Table B. **Composition of long-term unemployment (12 months and over)**
Percentage share of long-term unemployed by age and sex[a]

	Year	Youth	Prime-age adults	Older workers	Males	Females	Overall unemployment rates[b]
Austria	1973	14.9	34.8	50.3	43.6	56.4	1.1
	1975	14.2	39.6	46.2	45.4	54.6	1.7
	1979	12.8	40.9	46.3	52.3	47.7	2.1
	1981	13.5	39.5	47.0	52.2	47.8	2.5
	1982	13.4	43.8	42.8	58.8	41.2	3.4
Belgium	1973	5.2	22.3	72.5	58.7	41.3	2.8
	1975	11.1	28.7	60.2	46.2	53.8	5.1
	1979	21.0	46.9	32.1	29.3	70.7	8.4
	1981	21.1	49.5	29.4	30.3	69.7	19.1
	1982	23.0	49.6	27.3	37.9	62.1	13.0
Canada	1979	32.1	46.4	21.4	64.3	35.7	7.4
	1981	33.3	47.2	19.4	72.2	27.8	7.5
	1982	32.4	44.1	23.5	66.2	33.8	10.9
Finland[c]	1979	11.5	45.2	43.3	58.1	41.9	6.0
	1981	10.4	48.5	41.1	50.7	49.3	5.2
	1982	10.8	49.9	39.3	52.7	47.3	6.1
France	1973	17.9	37.9	44.3	54.2	45.8	2.6
	1975	25.8	44.5	29.7	36.5	63.5	4.1
	1979	28.1	46.2	25.7	37.5	62.5	5.9
	1981	27.8	45.1	27.1	33.7	66.3	7.3
	1982	30.8	45.3	23.9	38.3	61.7	8.0
Germany	1973	3.4	23.8	72.8	73.8	26.2	0.8
	1975	12.8	43.3	43.9	62.3	37.7	3.6
	1979	9.0	35.1	55.9	48.1	51.9	3.2
	1981	11.5	39.2	49.4	48.6	51.4	4.4
	1982	14.8	44.6	40.6	53.1	46.9	6.1
Netherlands	1973	8.4	49.2	42.4	84.8	15.2	2.3
	1975	11.6	54.3	34.1	82.4	17.6	4.0
	1979	23.7	52.2	24.1	69.0	31.0	4.2
	1981						4.2

1981	13.6	23.4	60.5	57.6	42.2	2.5
1982	13.9	27.0	59.1	55.7	44.3	3.1
Great Britain[d]						
1973	6.3	23.7	70.0	91.0	9.0	3.2
1975	8.4	25.1	66.5	90.3	9.7	4.7
1979	16.8	32.1	51.1	78.9	21.1	5.5
1981	24.4	34.7	40.9	78.2	21.8	11.0
1982	25.8	37.1	37.1	79.2	20.8	12.7
United States						
1973	26.1	35.9	38.0	64.1	35.9	4.8
1975	26.1	36.3	37.5	64.6	35.4	8.3
1979	27.8	39.4	32.8	60.2	39.8	5.7
1981	31.9	45.9	22.2	67.4	32.6	7.5
1982	28.5	49.8	21.7	68.7	31.3	9.5

a) Youth are those aged less 25 years (30 years in Norway). Prime-age adults are those aged between 25-44 or 25-49.
b) On international definitions.
c) May data.
d) July data.
Source: OECD Employment Outlook, September 1983, p. 59.

31

Table C. The incidence of long-term unemployment by age and sex (12 months and over)

Percentage share of long-term unemployment in total unemployment within age and sex groups[a]

	Year	Youth	Prime-age adults	Older workers	Males	Females	Total
Austria	1973	2.2	7.4	24.0	24.8	4.8	7.4
	1975	2.5	5.9	14.7	7.9	5.6	6.5
	1979	3.1	7.8	20.1	12.0	6.5	8.6
	1981	2.4	5.5	17.9	7.7	5.5	6.5
	1982	1.9	5.6	16.2	6.1	5.2	5.7
Belgium	1973	15.0	40.4	68.4	56.5	44.9	51.0
	1975	12.6	31.0	61.1	34.4	37.2	35.9
	1979	39.4	62.0	73.8	46.6	64.5	58.0
	1981	34.3	57.0	68.9	37.2	63.6	52.4
	1982	42.6	64.2	74.4	49.9	67.3	59.5
Canada	1979	2.3	4.4	4.6	4.1	2.7	3.5
	1981	3.0	5.1	5.3	5.4	2.6	4.2
	1982	4.0	5.7	7.8	5.9	4.4	5.3
Finland[c]	1979	8.1	18.9	31.2	18.5	20.4	19.3
	1981	4.2	13.7	20.6	11.7	13.4	12.5
	1982	3.6	13.7	18.1	11.1	11.8	11.4
France	1973	9.5	21.0	46.4	22.9	20.2	21.6
	1975	11.0	16.7	33.3	14.0	19.3	17.0
	1979	21.1	31.7	49.8	26.4	33.2	30.3
	1981	22.6	32.7	57.8	26.7	36.5	32.5
	1982	31.1	40.1	61.0	35.7	42.9	39.8
Germany	1973	1.2	5.1	16.6	12.9	4.3	8.5
	1975	4.3	9.0	16.8	11.0	7.9	9.6
	1979	6.8	16.6	34.9	22.2	18.1	19.9
	1981	6.2	14.5	30.3	16.0	16.3	16.2
	1982	10.3	21.2	34.5	20.9	21.6	21.2
Netherlands	1973	3.8	12.3	26.9	13.3	10.6	12.8
	1975	3.6	12.2	27.2	11.6	9.9	11.2
	1979	15.2	30.9	54.1	29.4	23.1	27.1

1981	2.3	3.8	16.4	6.7	5.2	6.0
1982	3.1	5.9	20.7	9.2	7.5	8.4
Great Britain[d]						
1973	6.2	21.4	44.0	29.2	14.8	26.9
1975	2.8	11.4	32.7	15.9	6.1	13.7
1979	9.3	27.0	46.8	28.8	15.7	24.5
1981	12.9	22.5	34.4	24.0	16.0	21.6
1982	21.2	36.9	47.6	37.5	23.4	33.3
United States						
1973	1.6	3.9	6.7	4.0	2.4	3.3
1975	3.0	5.6	10.1	6.1	4.3	5.3
1979	2.4	4.7	8.6	5.0	3.4	4.2
1981	4.8	7.8	9.9	8.2	4.9	6.7
1982	5.4	8.9	10.4	9.2	5.7	7.7

Notes: See notes to Table B.
Source: *OECD Employment Outlook, op. cit.,* p. 60.

33

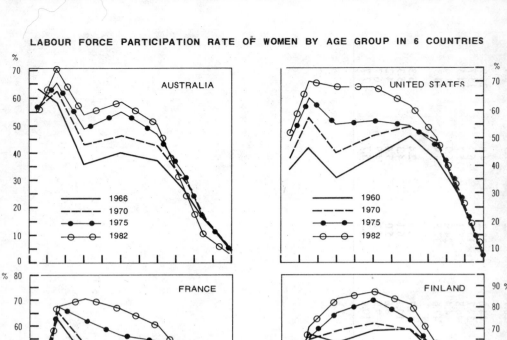

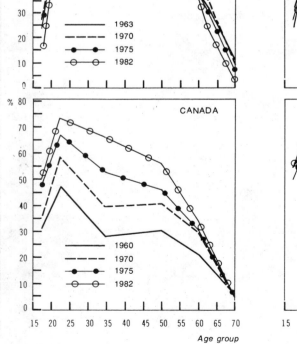

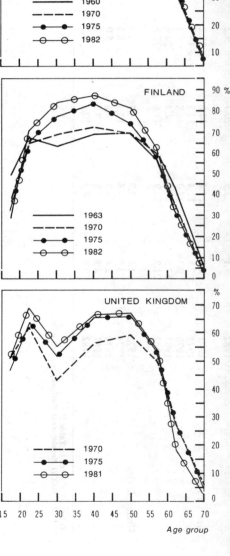

AGE GROUPS:

Australia	(15-19, 20-24, 25-34, 35-44, 45-54, 55-59, 60-64, 65)
United States	(16-19, 20-24, 25-34, 35-44, 45-54, 55-59, 60-64, 65)
France	(15-19, 20-24, 25-34, 35-44, 45-54, 55-59, 60-64, 65)
Finland	(15-19, 20-24, 25-35, 35-44, 45-54, 55-59, 60-64, 65)
Canada	(15-19, 20-24, 25-44, 45-54, 55-64, 65)
United Kingdom	(16-19, 20-24, 25-34, 35-44, 45-54, 55-59, 60-64, 65)

NOTES AND REFERENCES



1. See OECD, *New Policies for the Young,* OECD, Paris, (forthcoming) for further details.

2. See *OECD Employment Outlook, 1983,* p. 19.

3. OECD, *The Role of Women in the Economy,* Paris, 1975;
OECD, *Equal Opportunities for Women,* Paris, 1979;
OECD, *Women and Employment : Policies for Equal Opportunities,* Paris, 1980.
Liba Paukert, *The Employment and Unemployment of Women in OECD Countries,* OECD, Paris, 1984.

4. See Lourdes Beneria, *Women and Development: The Sexual Division of Labour in Rural Economies,* a study prepared for the International Labour Office within the framework of the World Employment Programme, New York, Praeger Publishers, 1982, for a discussion on accounting for women's work. Also Andrée Michel (ed.) *Les femmes dans la société marchande,* Paris, Presses Universitaires de France, 1978. There is a large and well-established literature on the history of women's work in its various aspects. See, for example, Ivy Pinchbeck, *Women Workers and the Industrial Revolution,* London, 1930; Evelyne Sullerot, *Histoire et sociologie du travail féminin,* Paris, 1968; Elyce J. Rotella, *From Home to Office: U.S. Women and Work 1870-1930,* Ann Arbor, Michigan, 1981; Martine Segalen, *Mari et femme dans la société paysanne,* Paris, 1980.

5. Paukert, *op.cit.*

6. OECD, *Employment in the Public Sector,* Paris, 1982.

7. *OECD Employment Outlook, 1983,* p. 21.

8. *Ibid.*

9. *Ibid.*

10. In the United States, Canada and Australia the share of under-25s (youth, students) in the part-time labour market is high in comparison to other countries: in these countries, young females account for 20-30 per cent of total female part-time employment.

11. See Labour Canada, *Part-Time Work in Canada: Report of the Commission of Inquiry into Part-Time Work,* Ottawa, 1983; Office of the Status of Women, *Women's Contribution to Economic Recovery,* Second Addendum to *Information Paper on the Economy,* National Economic Summit Conference, April 1983, Canberra.

12. *OECD Employment Outlook, 1983,* p. 51.

13. Labour Canada, *op. cit.,* p. 58.

14. See *OECD Employment Outlook, 1983,* Chapter IV, for a further elaboration; and also Labour Canada, *op. cit.,* Chapter IV, Part E.

15. *OECD Employment Outlook, 1983,* p. 45.



35

16. Anne J. Stone & Sara E. Rix, *Employment and Unemployment Issues for Women*, (Washington, D.C., Women's Research and Education Institute, January 1983).

17. Office of the Status of Women (Canberra), *op. cit.*, p. 25.

18. See *OECD Employment Outlook, 1983*, p. 46.

19. U.S. Commission on Civil Rights, *Unemployment and Underemployment Among Blacks, Hispanics and Women*, (Washington, D.C.; U.S. Commission on Civil Rights, Clearing House Publication 74, November 1982).

20. For a recent discussion, see Alice H. Cook (ed.), *Women and Trade Unions in Eleven Industrialized Countries*, Philadelphia, Temple University Press, 1984.

21. Diane Werneke, *Microelectronics and Office Jobs: The Impact of the Chip on Women's Employment*, ILO, Geneva, 1983.

22. Heather Menzies, *Women and the Chip*, The Institute for Research on Public Policy, Montreal, 1982. Menzies incorporates such an analysis in attempting to forecast "scenarios for the future" in the Canadian case.

23. Werneke, *op. cit.*, Chapter II.

24. Science Policy Research unit (SPRU), *Microelectronics and Women's Work in Britain*, University of Sussex, 1982.

25. Werneke, *op. cit.*, Chapter IV.

26. Menzies, *op. cit.*, Chapter 7.

27. Werneke, *op. cit.*, Chapter III.

28. G.W. Ford, "Technology, Women and Employment: The Need for New Concepts and Criteria for Policy Formulation", University of New South Wales, Australia, unpublished paper, 1982.

29. Werneke, *op. cit.*, Chapter III.

30. *Ibid.*, Chapter V.

31. Working Women, *Warning: Health Hazards for Office Workers*, Cleveland: Working Women Education Fund, April 1981; for U.K. studies on this subject, see C. Hakim and J. Field, "Employers' Use of Outwork: A Study Based on the 1980 Workplace Industrial Relations Survey", Research Paper No. 47, London: Department of Employment (1984), or J. Rubery and F. Wilkinson, "Outwork and Segmented Labour Markets", in *The Dynamics of Labour Market Segmentation*, F. Wilkinson (ed.), London: Academic Press, 1981.

32. SPRU, *op. cit.* in note 24.

33. See, for instance, M. Kundi and P. Kolm, *Richtlinien zur Gestaltung von Bildschirmarbeit*, Vienna: Gewerkschaft der Privatangestellten, 1980.

34. *OECD Employment Outlook, 1984*, Chapter I.

35. *OECD Employment Outlook, 1983*, for a summary view.

36. Office of the Status of Women (Canberra), *op. cit.*, p. 22.

37. See OECD, *The 1974-1975 Recession and the Employment of Women*, Paris, 1976, for an in-depth look at this phenomenon.

38. Office of Status of Women, *op. cit.*, p. 22. Hidden unemployment is defined as those who were not in the labour force but would have liked a job.

39. Paukert, *op. cit.* in note 3.

40. Office of the Status of Women (Canberra), *op. cit.*, p. 30.

41. Paukert, *op. cit.* in note 3.

42. *Ibid.*

43. Alice Amsden (ed.), *The Economics of Women and Work*, (England: Penguin Books, 1980) p. 23.

44. For a consideration of this issue in the European context see, Martine Levy, *Le chômage des femmes*, Etude, April 1983, p. 53, 1/798/83 document 37 – Commission des Communautés européennes.

45. The expression "long-term unemployment" will generally refer to unemployment of twelve months and over.

46. *OECD Employment Outlook, 1983*, p. 29. The Secretariat has developed a simple set of forecasting models relating movements in long-term unemployment to a set of labour market and trend factors. (See Note B of the Technical Annex of the *Employment Outlook*.)

47. In Australia, data from the Henderson Poverty Inquiry (1975) reveal that the number of poor families would have doubled if married women had not been in paid employment.

48. Liba Paukert, "Personal preference, social change or economic necessity? Why women work", *Labour and Society*, Vol. 7, No. 4, October-December 1982, Geneva.

49. See OECD, *Women and Employment, op. cit.*, Declaration adopted by the High Level Conference on the Employment of Women, pp. 153-155. Also, André Calame and Maria Fiedler, *Massnahmen zugunsten einer besseren Vereinbarkeit von Familie und Beruf: Erfahrungen aus der DDR, Frankreich, Grossbritannien und Schweden sowie Empfehlungen für die Bundesrepublik Deutschland*, Arbeitsmarktpolitik, Wissenschaftszentrum, Berlin, 1982.

50. For a discussion of various definitions, see *Labour Canada, op. cit.* in note 11, Chapter 2, Part C.

51. The Swedish Partial Pension System could serve as an example.

52. OECD, *Women and Employment, op. cit.* in note 3, "Declaration on Policies for the Employment of Women".

Chapter II

OCCUPATIONAL SEGREGATION BY SEX

1. INTRODUCTION

This chapter is concerned with occupational segregation of women in OECD Member countries. It builds on the analysis produced for the April 1980 OECD High Level Conference on the Employment of Women, and published in *Women and Employment*[1]. The main purpose of this chapter is to review recent empirical studies of occupational segregation. These studies are at two levels: aggregate studies, updating and extending those in *Women and Employment,* and detailed national studies commissioned for the Working Party on the Role of Women in the Economy or supplied by its members.

In order to evaluate the empirical statistical material in the complex area of occupational segregation, it is necessary to have both a theoretical framework for the analysis and an appreciation of the strengths and weaknesses of the statistical methodology. For details of the statistical methodology the reader is referred to the Annex, designed to allow the main text to concentrate on setting out the message conveyed by the statistics while still indicating the broad principles of the approach. The chapter begins by explaining the crucial importance of occupational segregation in the employment of women and briefly outlining some of the theories which seek to explain the general conclusion, confirmed by the evidence here, that "high degrees of segregation have persisted in spite of widespread policies to promote equal opportunities and treatment of women"[2].

A. The Significance of Occupational Segregation by Sex

The term "occupational segregation by sex" will be used to refer to the fact that men and women are concentrated in different occupations (the "horizontal" component of occupational segregation) and that even when women occupy the same occupation they are often employed at different levels of responsibility and allocated different tasks than men (the "vertical" component). The labour market is largely divided into segments which are broadly self-contained, to which access is limited and between which there is usually little mobility, except at a lower level of skill. Historically, most labour market segments have been dominated either by men or by women and this segregation has largely persisted despite the fact that the participation rates of women have increased relative to those of men, as described in Chapter I, and the earnings gap between workers of the two sexes has declined, as described in Chapter III.

This segregation is of special policy importance because the labour market segments in which women are concentrated tend to be disadvantaged in terms of skill, status, security and earnings. Indeed a large proportion of the labour market segments dominated by women are found in what many labour economists and industrial sociologists have referred to as the

"secondary labour market", characterised by low skills, low wages, high turnover and low status[3]. An analysis of segregation is fundamental to any study of the different needs of men and women with regard to education and training, the question of earnings differentials by sex, and the special problems of minority groups such as migrant women. It is a theme which unifies many topics relating to the employment of women.

B. Direct and Indirect Discrimination

Segregation is deep-rooted and its causes are many, as discussed in the Policy Conclusions to this chapter. Within the labour market itself, women may be subject to various forms of adverse discrimination, often classified (somewhat loosely) into direct and indirect discrimination.

Direct discrimination occurs, for example, when a woman doing the same work as a similarly qualified man receives lower pay or status. Another example is where a woman is considered to be a less suitable candidate for a perhaps relatively responsible post than a similarly qualified man: despite the fact that more and more women do not interrupt their careers, some employers may discriminate against all women on the grounds that some women leave the labour market temporarily or even permanently following the birth of children. (This type of direct discrimination is referred to as "statistical discrimination".) A third example is legislation, perhaps originally designed to protect women, which acts as a barrier to certain occupations, for example those involving night work.

Indirect discrimination, on the other hand, occurs in situations where the pay of men and women is apparently established by the same criteria and where they may appear to have equal access to employment opportunities but where in practice established procedures favour men. One example of this occurs in systems where promotion prospects are linked to the continuous service rather more typical of male career paths. Another is where access to higher paying jobs depends upon the ability to lift heavy objects. (Often such a requirement is not actually necessary to perform the job in question.)

C. Economic Theories of Occupational Segregation by Sex

Many economic theories have been put forward to attempt to account for part, if not all, of occupational segregation by sex. Several of these theories are reviewed very briefly below. It must be emphasized that none of these approaches seems able to account for the extent or persistence of this type of segregation. While the empirical literature is vast, it is also rather inconclusive and does not decisively support or reject any one approach. Thus the theories mentioned here are best regarded as complementary. One reason for their lack of robustness is of course that the factors at work go beyond the purely economic. Indeed, Arrow draws an analogy between the attitudes involved in sex discrimination and the attitudes involved in feelings of national identity, noting that "It is true that economic theories can say something about the effects, given that you have sexual discrimination or national identity. They are not in a position to explain why the phenomenon occurred in the first place."[4]

Theoretical frameworks purporting to explain the persistence of occupational sex segregation largely fall into two broad categories: those which consider the individual worker as the unit of analysis based on human capital theory and sex-role stereotyping; and those which are based upon a structural analysis of labour market processes, such as the dual labour market theory.

Human capital theory argues that women and men are not perfectly substitutable for one another in the labour market because women tend to accumulate less human capital through work experience since they spend fewer years in the labour force than men, and that this leads

in turn to productivity differentials between men and women, higher turnover rates and pay differentials. There have been many criticisms of this theory, the most fundamental being that there is little evidence that productivity differentials can account for the persistence of sex segregation in the labour market. Another factor believed to be important by human capital theorists is that many women carry extra responsibilities for their families, as opposed to the labour market. However, this could only help to explain the greater tendency of women to be in "low-skill" jobs – it cannot explain the concentration of women in a small number of female occupations within each skill category[5].

The theory of sex-role stereotypes postulates that women are forced into a relatively small number of occupations because of the perceptions and tastes of employers (linked to general attitudes towards the employment of women in society as a whole). However, this cannot account for the observable variability in the sex-labelling of occupations between different industries in the same or, for example, fairly similar countries in Europe.

Dual labour market theory rejects the notion of a single, competitive labour market in favour of a stratified market and goes some way in tying segregation to the structural features of the labour market. It can also include Bergman's theory that the exclusion of women from the primary market "crowds" them into secondary-sector occupations, thereby inflating the supply of labour and reducing the level of earnings below normal level[6]. Two key assumptions accompany this model: that workers are perfectly substitutable for one another although they have differing ascriptive characteristics and that it is demand-side conditions that are responsible for overcrowding, i.e., tastes of employers. What it fails to explain is the considerable degree of occupational segregation between men and women *within* each sector and it also fails to provide a precise analysis of the causes and mechanisms of labour market segregation. Hakim argues that the operative degree of occupational segregation is at the level of the establishment, rather than at the national level[7]. The more radical labour market segmentation analysis of Gordon would suggest that not much can be done to improve the employment conditions for women in the small numbers of job categories in which they are concentrated without thoroughly transforming the economic system[8].

D. Measuring Occupational Segregation

Fuller details of the statistical methodology and data sources are given in the Annex. The basic principles involved are, however, described below, before the results are presented. The task of devising an appropriate statistical methodology is, as always, to produce clear definitions of quantities which are capable of measurement, while attempting to capture the phenomenon as faithfully as possible, recognising always that it is possible to produce only a restricted view of the phenomenon concerned.

The term "segregation" is often used in ordinary usage to mean situations where there is total division according to some characteristic. However, this is not the way the term is used in studies of occupational segregation, where what is at issue is any marked imbalance in the distribution of persons between occupations according to the given characteristic, in this case sex. Segregation is thus determined in relation to a standard.

It is possible to define segregation relative to an absolute level, for example by ruling that over 70 per cent of a given occupation must be of one or other sex before measured segregation is deemed to exist. However, while this may be useful for certain policy purposes, for overall statistical measurement the usual approach is to define the standard in terms of the proportion of men and women in the labour force, or simply in paid employment. In any given occupation, the degree of segregation is measured by the relationship between the proportion of women in the occupation and the proportion of women in the labour force.

Defining the coefficient of female representation (CFR) as the ratio between these two proportions, women are said to be over-represented in a given occupation if the CFR for that occupation is greater than unity and under-represented if it is less than unity. Similarly, we may define a coefficient of male representation (CMR).

A statistical description of labour market segregation may thus consist essentially of a set of CFRs, coupled with information about the importance of the employment categories to which they refer. As discussed in more detail in the Annex, the employment categories may be defined by a range of criteria, including geographical location, industrial sector and occupational grouping on the one hand; level of responsibility and type of working arrangements on the other. A very detailed approach using narrowly-defined occupational classifications is necessary to bring out the full dimensions of occupational segregation, but an aggregate approach, using broad classifications, while it cannot show every dimension of the problem, has the advantage of providing a more manageable set of information and may still provoke valid questions and allow useful conclusions to be drawn. At an international level, data corresponding to the International Standard Classification of Occupations (ISCO) definitions are available only at a very aggregate level. The international tables below based on ISCO are therefore supplemented by tables showing segregation across industrial sectors, based on the International Standard Industrial Classification (ISIC). The industrial data are a useful adjunct to the occupational data since the types of jobs, their content, remuneration and working conditions, vary from sector to sector.

Nevertheless, it must be recognised that even very detailed occupational data coupled with industrial data will not be able to bring out the full dimensions of segregation, since even within the finest categories, the status and working conditions of men and women may not be the same. For example, women may receive lower rates of pay, as discussed in Chapter III. Again, they may occupy lower positions within a hierarchy or may be employed only part-time. In principle, special very highly detailed occupational classifications could be developed to incorporate many of these status distinctions. But, in practice, even the most detailed of the available data only include distinctions of the type "supervisory/non-supervisory workers".

Whatever level of detail is used, the resulting information may be compressed into a summary index equal to the average deviation of the coefficients of representation from unity, or from each other. The averages may be weighted by the employment size of each sector and standardized to lie between 0 and 1. Two such summary indices are used below, the so-called WE index, named after the report *Women and Employment* in which it appears, and the DI or "dissimilarity" index, frequently used in the literature. The indices are discussed fully in the Annex and the formulae for them are given in Notes 40 and 43.

Whichever of these indices is used, a value of zero would correspond to a situation where there was no segregation. The maximum theoretical value of the DI index is 1 or 100 per cent, when there is complete segregation. The maximum value of the WE index depends on the female share of employment. If this were 50 per cent its maximum possible value would also be one, but as the share of female employment increases, its maximum, theoretical value decreases. The WE index may be interpreted as twice the (minimum) proportion of women who would need to exchange their jobs with men for segregation to be removed. Of course, this is not the way in which segregation will be removed, but this interpretation may add colour to the statistics and highlight how very segregated the labour market is.

Changes in a summary index of segregation may be decomposed into a part attributable to changes in representation rates (CFRs and CMRs) and a part attributable to changes in the employment structure, plus a residual, the "interaction" term, which must be attributed to the effect of the two factors working together. This may be compared to a farmer with a

41

rectangular field who increases the area by extending two adjacent boundary fences: the increase in area can be ascribed partly to the extension of one fence alone, partly to the other, but there is a small extra piece which is there only because the two fences were extended together.

2. AGGREGATE TRENDS IN SEGREGATION BY SEX

Tables II.1 to 6 contain the results of the calculations carried out by the Secretariat on aggregate data for several countries. Tables II.1 and 2 show the values of the WE and DI indices, respectively, for one-digit occupational data according to ISCO as published in the ILO *Yearbook of Labour Statistics*. Tables II.3 and 4 show the results of the same calculations performed on one-digit industrial data according to ISIC, derived from the OECD publication *Labour Force Statistics*. The final two tables are both based on the DI index: Table II.5 refers to occupations and Table II.6 to industries. The tables show respectively the results of

Table II.1. **Occupational data, WE index**[a]
Percentages

	1970 (or nearby year)	1976	1977	1978	1979	1980	1981	1982	1983
Australia	64.1		62.8	62.7	61.7	62.4	60.2	60.7	
Canada	53.4 (1971)			49.9	49.5	46.9	46.7	44.6	40.9
Germany	41.8			44.0		44.1		44.2	
Japan	30.6		28.9	28.4	28.6	28.6	27.5	27.5	
New Zealand	59.7 (1971)	56.1					70.1		
Norway	71.1		69.3	56.8	54.4	54.9	55.8	55.8	
Sweden			50.2	47.4	46.7	46.6	45.7	44.2	
United States	47.5		51.1	50.1	49.4	48.4	47.4	46.5	

a) Calculated at the ISCO one-digit level.
Source: *ILO Yearbook of Labour Statistics*, various issues.

Table II.2. **Occupational data, DI index**[a]
Percentages

	1970 (or nearby year)	1976	1977	1978	1979	1980	1981	1982	1983
Australia	47.4		48.7	48.9	47.7	49.0	47.3	47.9	
Canada	40.8 (1971)			40.6	40.4	39.2	39.3	37.9	35.1
Germany	32.6			35.3		35.5		35.9	
Japan	25.1		23.3	23.0	23.3	23.3	22.4	22.5	
New Zealand	42.5 (1971)	41.3					48.6		
Norway	49.1		55.3	47.4	46.0	46.8	47.8	48.3	
Sweden			44.1	42.5	42.2	42.4	42.2	41.1	
United States	37.9		42.7	42.4	42.2	41.6	41.1	40.6	

a) Calculated at the one-digit ISCO level.
Source: *ILO Yearbook of Labour Statistics*, various issues.

42

decomposing the changes in the DI index to account for the change in female representation within employment categories, the changes in the sizes of the employment categories and the interaction between these two effects. The way in which this decomposition is done is described in the Annex.

Several conclusions may be drawn from these data. The first is that even at this aggregate level, the data clearly show a high degree of occupational and industrial segregation by sex in all countries. For 1980, Table II.1 indicates that the WE index for occupations varied from 62.4 in the case of Australia to 28.6 in the case of Japan. Thus, in order to equalise the distribution of men and women across main occupational groups, 31.2 per cent of women in Australia and 14.3 per cent in Japan would have to exchange jobs with a man in another main occupational group.

A second conclusion is that the degree of segregation appears to vary widely from country to country. As the maximum value of the WE index is inversely related to the rate of female participation, it might be expected that the countries with the highest female participation

Table II.3. **Industrial sector data, WE index**[a]
Percentages

	1970 (or nearby year)	1976	1977	1978	1979	1980	1981
Australia	45.1	42.9	42.3	41.0	42.1	41.9	39.5
Belgium	44.9	44.9	45.6	45.5	45.2	45.7	47.9
Canada	40.3 (1975)	39.0	39.0	38.9	37.9	37.0	36.4
Finland	33.8	32.4	34.2	34.2	34.6	35.1	36.2
Germany	35.2	35.6	35.3	35.0	35.2	35.0	36.3
Japan	22.3	23.5	23.4	23.1	23.2	22.7	22.0
Norway	55.1	46.7	46.9	47.2	45.2	45.1	54.0
Sweden	50.4	45.0	44.7	43.3	42.6	42.5	42.6
United Kingdom	39.0	40.8	40.3	40.4	40.6	40.9	41.2

a) Calculated at the one-digit ISIC level.
Source: OECD, *Labour Force Statistics,* various issues.

Table II.4. **Industrial sector data, DI index**[a]
Percentages

	1970 (or nearby year)	1976	1977	1978	1979	1980	1981
Australia	33.3	33.0	32.8	32.0	32.6	32.9	31.0
Belgium	34.4	34.3	34.9	35.1	35.0	35.6	35.2
Canada	31.7 (1975)	31.0	31.2	31.5	31.0	33.3	30.5
Finland	30.6	30.5	32.5	32.5	32.9	33.3	34.6
Germany	27.8	28.6	28.5	28.2	28.5	28.3	28.7
Japan	18.4	18.8	18.9	18.8	18.9	18.5	18.0
Norway	39.9	38.2	38.7	39.3	38.1	38.3	38.3
Sweden	41.6	39.4	39.6	38.8	38.5	38.6	39.4
United Kingdom	30.6	33.5	33.3	33.5	33.8	34.1	34.5

a) Calculated at the one-digit ISIC level.
Source: OECD, *Labour Force Statistics,* various issues.

rates have the lowest values of the WE index. However, this is not the case. Again the DI index, which statistically speaking is independent of the female participation rate, also varies widely from country to country. Chart 1 below shows the relationship between the female participation rate and the DI index of occupational segregation. By and large, the countries with the highest levels of participation also have higher measured occupational segregation, but there is no clear relationship.

A third conclusion is that the degree of segregation of women by industrial sector is less than the segregation by broad occupational group. This is clearly because women tend to be concentrated in a small range of occupations within different industries.

Fourth, there is the question of the changes over time. The differences between the pictures shown by the WE and DI indices warn against too simple an interpretation. The movements from country to country are also very varied. There does seem to be an overall tendency towards a decline in segregation, but it is neither uniform across countries nor across time. The recent recession appears to have made no major difference to the trends in individual countries.

Finally, Tables II.5 and 6 contain an analysis of the decomposition of the changes in the indices over time. *A priori* it might be expected that the major structural changes in employment have been working towards greater segregation, these changes being the major structural change towards a greater and greater tertiary sector and a smaller manufacturing

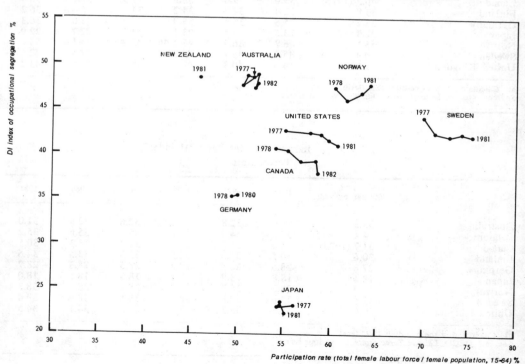

Chart 1 RELATIONSHIP BETWEEN SEGREGATION AND PARTICIPATION IN RECENT YEARS

Table II.5. **Occupational data: Decomposition of changes in DI index**[a]
Percentages

	1970 (or nearby year) to 1978	1978-79	1979-80	1980-81	1981-82	1982-83
Australia						
Earlier year	47.4	48.9	47.7	49.0	47.3	
Later year	48.9	47.7	49.0	47.3	47.9	
Change	1.47	−1.16	1.35	−1.78	0.65	
of which due to:						
Change in representation rates	2.07	−1.06	1.56	−1.82	0.76	
Change in structure	−0.26	−0.10	−0.24	0.03	−0.08	
Interaction	−0.34	0.00	0.03	0.02	−0.03	
Canada						
Earlier year	40.8 (1971)	40.6	40.5	39.2	39.4	37.9
Later year	40.6	40.5	39.2	39.4	37.9	35.0
Change	−0.26	−0.14	−1.26	0.16	−1.43	−2.91
of which due to:						
Change in representation rates	0.04	−0.38	−0.91	0.12	0.24	−1.67
Change in structure	−0.03	0.24	−0.27	0.07	−1.61	−1.40
Interaction	−0.26	0.00	−0.08	−0.02	−0.06	0.16
Japan						
Earlier year	25.1	23.0	23.3	23.3	22.4	
Later year	23.0	23.3	23.3	22.4	22.5	
Change	−2.08	0.22	0.04	−0.86	0.08	
of which due to:						
Change in representation rates	−1.42	0.03	0.02	−0.81	0.25	
Change in structure	−1.09	0.18	0.00	−0.05	−0.17	
Interaction	0.42	0.01	0.01	0.01	0.0	
Norway						
Earlier year	49.1	47.4	46.0	46.8	47.8	
Later year	47.4	46.0	46.8	47.8	48.3	
Change	−1.73	−1.45	0.87	1.02	0.44	
of which due to:						
Change in representation rates	−1.91	−1.29	0.86	1.46	−0.11	
Change in structure	2.96	−0.16	0.02	−0.48	0.50	
Interaction	−2.78	−0.01	−0.02	0.04	0.06	
Sweden						
Earlier year	39.6	42.5	42.2	42.4	42.2	
Later year	42.5	42.2	42.4	42.2	41.1	
Change	2.97	−0.30	0.20	−0.21	−1.09	
of which due to:						
Change in representation rates	5.54	−0.17	0.38	0.16	−0.64	
Change in structure	0.61	−0.12	−0.19	−0.31	−0.44	
Interaction	−3.18	0.00	0.00	−0.06	0.00	
United States						
Earlier year	37.9	42.4	42.2	41.6	41.1	
Later year	42.4	42.2	41.6	41.1	40.6	
Change	4.56	−0.23	−0.56	−0.54	−0.54	
of which due to:						
Change in representation rates	4.41	−0.11	−0.52	−0.33	−0.27	
Change in structure	1.98	−0.12	−0.03	−0.20	−0.26	
Interaction	−1.83	0.00	−0.01	−0.01	−0.02	

a) Based on data at the one-digit ISCO level. For the method of calculation see the Annex to this chapter.
Source: ILO Yearbook of Labour Statistics, various issues.

Table II.6. Industrial data: Decomposition of changes in DI index[a]
Percentages

	Period covered					
	1970-76	1976-77	1977-78	1978-79	1979-80	1980-81
Australia						
Earlier year	33.30	33.00	32.80	32.00	32.60	32.90
Later year	33.00	32.80	32.00	32.60	32.90	31.00
Change	−0.33	−0.16	−0.88	0.63	0.34	−1.94
of which due to:						
Change in representation rates	−1.36	−0.10	−0.86	0.76	0.30	−1.99
Change in structure	1.40	−0.05	0.01	−1.58	0.05	0.04
Interaction	−0.37	−0.01	−0.02	1.45	−0.01	0.02
Belgium						
Earlier year	33.40	34.30	34.90	35.10	35.00	35.60
Later year	34.30	34.90	35.10	35.00	35.60	35.20
Change	0.87	0.71	0.12	−0.04	0.60	−0.49
of which due to:						
Change in representation rates	0.23	0.51	−0.09	−0.21	0.60	
Change in structure	1.02	0.22	0.24	0.19	0.02	
Interaction	−0.38	−0.02	−0.04	−0.02	−0.02	
Germany						
Earlier year	27.80	28.60	28.50	28.20	28.50	28.30
Later year	28.60	28.50	28.20	28.50	28.30	28.70
Change	0.85	−0.19	−0.21	0.26	−0.17	0.39
of which due to:						
Change in representation rates	0.59	−0.08	−0.23	0.21	−0.16	−0.45
Change in structure	0.12	−0.11	0.01	0.05	−0.02	0.12
Interaction	0.14	0.00	0.01	0.00	0.01	0.72
Norway						
Earlier year	39.90	38.20	38.70	39.40	38.10	
Later year	38.20	38.70	39.40	38.10	38.30	
Change	−1.57	0.44	0.68	−1.28	0.16	
of which due to:						
Change in representation rates	−3.44	0.01	0.55	−1.08	0.19	
Change in structure	2.69	−0.32	0.19	−0.17	−0.02	
Interaction	−0.83	0.76	−0.06	−0.03	0.00	
Sweden						
Earlier year	41.60	39.40	39.60	38.80	38.50	38.60
Later year	39.40	39.60	38.80	38.50	38.60	39.40
Change	−2.21	0.23	−0.81	−0.33	0.12	0.76
of which due to:						
Change in representation rates	−1.80	0.06	−0.83	−0.44	0.20	0.66
Change in structure	−0.20	0.21	0.04	0.11	−0.08	0.12
Interaction	−0.21	−0.04	−0.02	0.00	−0.01	−0.02
United Kingdom						
Earlier year	30.60	33.50	33.30	33.50	33.80	34.10
Later year	33.50	33.30	33.50	33.80	34.10	34.50
Change	2.91	−0.20	0.18	0.36	0.25	0.43
of which due to:						
Change in representation rates	2.54	−0.06	0.13	0.25	0.13	0.34
Change in structure	0.74	−0.14	0.05	0.11	0.13	0.13
Interaction	−0.37	0.00	0.00	0.00	−0.01	−0.04

a) Based on data at the one-digit ISIC level. For the method of calculation see the Annex.
Source: OECD, *Labour Force Statistics*, various issues.

sector coupled with a corresponding change towards more tertiary, white-collar jobs. Women have shared in this movement to a greater extent than men, and might have been expected to become more heavily concentrated into the tertiary sector, increasing measured segregation as a result. For occupations there is not much evidence of any such structural effect. The structural and compositional effects frequently work in the same direction. But, for the industrial data there is a clear tendency for the structural effect to increase overall segregation by industrial sector.

Despite the variability in the trends, an examination of the CFRs in each major occupational and industrial grouping reveals a remarkably similar pattern across all Member countries: women tend to be concentrated in clerical and service occupations and men in production and transport occupations[9].

3. REVIEW OF COUNTRY STUDIES

The very aggregate approach above has the advantages of avoiding excessive complexity while demonstrating the major dimensions of occupational segregation, and it is also able to cover the recent recession and present data on a relatively uniform basis across countries. But gaps are left and detailed studies offer the possibility of filling many of them.

In the first place it is important to know the extent to which measured segregation increases if a more detailed classification is used.

In the second place, detailed data allow the study of individual occupations and may even encompass qualification or skill level, position in hierarchy, numbers of subordinates and industrial sector. This may allow a typology of segregated occupations to be constructed. Segregation may be approached not only from the viewpoint of summary indices but also from studies of the number of occupations disproportionately performed by one sex. Having done that, it may be possible to gauge the extent to which change is due to men entering occupations previously dominated by women or *vice versa*.

Third, the changes in segregation may be linked to the trends in the employment and unemployment of men and women. This may very usefully include studies of occupational segregation within groups entering the labour market, since the flows into and out of employment have a most important part to play in changing the pattern of occupational segregation. A very relevant aspect of the changes in the structure of employment is occupational segregation within the newly emerging occupations.

The studies are primarily statistical analyses of the distribution of men and women within occupational groups. They are based on different types of data source, use different occupational classifications and slightly different statistical methodologies. Nevertheless, while international comparisons are impossible, the aim has been to produce a synthetic account of all available studies. It must be remembered, however, that conclusions based on evidence from one country do not necessarily apply to another.

A. Calculations of Segregation at a Detailed Level

The detailed country studies reveal a high degree of segregation within virtually all the main occupational groupings.

For Australia[10] it is reported that within the category of professional, technical and related workers in 1980, the overall coefficient of female representation (CFR) was 1.24. This indicates that, overall, women were slightly over-represented in that category. However, a detailed study involving sixty occupational groups showed that there was further segregation

within this category: for example, the occupational subgroup including the nursing profession had a CFR of 2.55, indicating a very high degree of over-representation, whereas the occupational subgrouping comprising architects, engineers and surveyors had the very low coefficient of 0.05.

Over the full range of occupational groupings in Australia, high coefficients (indicating a relative over-representation of women among those employed) were also observed for book-keepers and cashiers; stenographers and typists; telephone and telegraph operators; tailors, cutters and furriers; housekeepers, cooks and maids; barbers, hairdressers and beauticians; launderers, drycleaners and pressers. Very low coefficients (under 0.5) were observed for administrative, executive and managerial occupations (a value of 0.02 in 1980); farmers, fishermen and timber cutters; miners and quarrymen; two of the sales occupations; four of the seven occupational groupings in transport and communications; ten of the twenty tradesmen and production process worker occupations; chemists, physicists and geological occupations; and the legal, fire brigade and police occupations.

These Australian results thus indicate a substantial increase in measured segregation on moving from the one-digit classification level to the two-digit classification level. A Swedish study by Jonung reports that measured segregation was increased markedly by going one stage further, to the three-digit level. For 1975, the calculated dissimilarity indices from the detailed Swedish census data were 43.6, 59.8 and 70.3 at the one-, two-, and three-digit levels respectively[11]. This indicates a high degree of segregation even within the groupings used in the two-digit level classification.

This Australian and Swedish evidence, which could be paralleled by similar evidence from other countries, illustrates both the magnitude of the phenomenon of segregation and its extreme pervasiveness.

In addition, the material available from the country studies confirms that there has been no major decline in segregation over the past decade, as appeared to be the case from the aggregate data. Indeed, Jonung reports that at the three-digit level the reductions in segregation over the periods 1960-70 and 1970-75 were smaller than at the aggregate one-digit level, implying that segregation within the broad occupational groups had increased[12]. This is a disturbing result, since it may indicate that segregation at the finest levels, involving status and pay differentials, may be not only more pronounced but also more entrenched than segregation observed from a broader perspective.

The detailed studies do not, in general, cover the recession following the second oil shock. However, the study by Selby-Smith[13] shows that the steady decline in measured segregation in Australia at the two-digit level was reversed in the two years following the first oil shock of 1973. It is interesting that during the next year after the trough of the recession, between 1975 and 1976, the measure of segregation decreased quite sharply (from 84.2 to 81.4, using the WE index, as specified above).

Some of the detailed studies indicate that segregation appears to have fallen much more noticeably when an industrial classification is used than when an occupational classification is employed. Indeed, Eder reports a quite noticeable drop in segregation by industry coupled with a virtual stagnation in segregation by occupation over the period 1971-81 in Austria[14]. This tends to contrast with the results reported earlier and illustrates the fragility of conclusions based on trends in aggregate data.

B. A Detailed Analysis of Changes in Occupational Structure

A method of decomposing the changes in the summary indices to gain greater insight into the process of change is to note that the change from year to year may be regarded as the sum

of the contributions from each category in turn[15]. Taking this approach, Selby-Smith notes the lack of any very clear pattern[16]. The year-on-year changes showed that there were some occupational groups where the contribution to the index had increased and others where it had decreased, regardless of whether the overall summary index was increasing or decreasing.

However, it was clear that some categories dominated the changes in any given year and, in the main, the same occupational categories dominated each and every year. These dominant categories included the three clerical occupation groups; the proprietors and shopkeepers category (which includes shop assistants); farmers and farm managers; farm workers; housekeepers, cooks and maids; and caretakers and cleaners. All but two of these occupational groups were categories where women were proportionately over-represented (coefficient of female representation greater than unity) and all were comparatively heavily weighted. However, despite their consistently major impact, the direction of this impact often ran counter to that in the overall index. Selby-Smith was thus unable to find any way in which the behaviour of key occupational groups could be used to explain or characterise the changes in segregation. The pattern of change seemed to be extremely complex.

C. Analyses by Individual Occupations

Another approach to the problem of segregation is to discover precisely what are the proportions of men and women employed in particular occupations.

Jonung notes that the most common occupations for women "often relate to the work tasks women also have at home – care of children and sick persons, education and training, cleaning and cooking". Using the Swedish census classification, containing about 270 occupations, it was found that the five most common occupations for women in 1975 were those of "secretary", "nurse's aid", "sales worker", "cleaner" and "children's nurse". The proportion of women working within these five occupations out of the total of 270 steadily increased over the period after 1960 to reach slightly more than 40 per cent in 1975, a remarkably high figure[17].

Eder, too, found some indication of a tendency towards an increasing concentration of women in certain occupations. In 1971, 52 per cent of female wage-earners and salaried employees in Austria were found to work in six (out of 75) occupational categories. In 1981, 63 per cent worked in the same six occupational categories. While it must be noted that these were growing occupational categories, the female share of them also grew[18].

The concentration of male employment into a small number of occupations appears to be much lower. The Swedish study indicates that only 28 per cent of men worked in their five most common occupations, which mainly belonged to the manufacturing industry. However, in company with other analysts, Jonung (1983) notes that this may partly be because men's jobs have historically been better identified and more carefully categorised than women's. This might be considered to be the result of discrimination within the statistical apparatus itself. It may also be due to a higher degree of specialisation within traditional male employment.

A similar set of results is reported in the French study by Huet et al.: 62 per cent of the female workforce were found to be in the sixteen most "female" occupations out of fifty-seven occupations, while thirty of the most "male" occupations needed to be taken before that percentage of the male workforce was reached[19].

Another important (though unsurprising) finding is that the most common occupations for women contain very few men. Indeed, some of the five most common occupations listed above for Sweden contain over nine women for every man. Conversely, women are very poorly

represented in the most common occupations for men. In addition, occupations containing equal numbers of men and women are rare. In 1975, only 6 per cent of women worked in occupations where the numbers of women were roughly equal to the numbers of men (between forty and sixty women for every hundred employed). This pattern was observed to have remained fairly stable, despite the increase in female participation. However, occupations pursued almost entirely by men or by women were less common in 1975 than previously.

The picture this reveals for Sweden is that the extreme cases of segregation have been slightly attenuated. Women have been able to enter many occupations previously confined largely to men, but they have done so in relatively small numbers. Evidence for Austria, quoted below, shows that women have increased their share of many occupations requiring high qualifications, though possibly not high-level management occupations. At the level of individual high-status occupations Jonung reports that between 1960 and 1975 women increased their share of physicians from 18 to 20 per cent, dentists from 27 to 30 per cent, prosecuting attorneys from 4 to 11 per cent, court lawyers and judges from 12 to 16 per cent while the share of women among university teachers remained the same, at 20 per cent. However, "in the various fields of engineering, women's share has increased very little and ranges between one and five per cent"[20].

Using a statistical technique involving the decomposition of the dissimilarity index into a first part due to occupations where women are relatively under-represented and a second part due to occupations where women are relatively over-represented, Jonung found that 75 per cent of the fall in the index between 1960 and 1970 could be attributed to men moving into occupations where women were over-represented. Men's movements still contributed more than proportionately to the change in the index between 1970 and 1975 but the change was then more evenly distributed. However, refining the procedure to remove the effect due to structural changes in the labour market allowed Jonung to reach the conclusion that looking purely at the effects due to changes in sex composition, the reduction in the index was as much due to women moving into traditionally male occupations as men moving into traditionally female occupations. Jonung contrasts these results with Hakim's conclusion that such de-segregation as had been observed in the United Kingdom was primarily due to men entering female jobs[21].

D. Characteristics of Male and Female Employment

The French study by Huet *et al.* demonstrates that for fifty-seven categories of the French PJ occupational classifications, the characteristics of female representation may be summed up very simply: occupations employing a relatively high proportion of women tend to be the lower-skilled jobs in the services sector[22].

More precisely, the French study calculated the female share of employment in each of the fifty-seven occupations groups and then constructed a sample model in which this share was expressed in terms of two variables: first, whether the occupation was considered to be an "industrial" or "services" type of occupation; and second, the level of occupation qualification on a fourfold scale (engineers and senior executives, technicians and supervisory personnel, skilled manual and non-manual workers, and unskilled manual and non-manual workers). The fit of this model was remarkably good – 67 per cent of the variance was explained. (If the figure had been 100 per cent, this would have meant that the level of female employment in each occupation was uniquely determined by the two variables concerned). As the French study notes, this high figure is indeed a remarkable result. The occupational classification used was designed to delineate occupations in the most precise and economical way. It was not deliberately designed to correspond to the pattern of male and female representation.

E. Level of Qualifications and Occupational Status

The Austrian study by Eder includes an analysis of the change in the distribution of women by level of occupational qualification over time. Table 7 of that study indicates that over the period 1972-80 the distribution of women according to qualification level shifted. More women were employed as salaried employees and, within this category, the proportion of women with medium and high occupational qualifications rose while the proportion of women with low qualifications decreased. This trend corresponds to the trend towards employment at higher qualification levels observable for the total workforce (indicated in Table 8 of the study) in which women took a slighly higher post than men. At the same time Eder notes that the proportion of women wage-earners classed as skilled or semi-skilled had fallen slightly[23].

A comparison of these changes with those seen for the total labour force revealed that, as expected, women had taken a larger part in the general structural change from blue-collar to white-collar working than men and, within the category of salaried employees, had enjoyed a faster movement towards higher qualifications than men. However, they had lost ground to men in the skilled wage-earners group, where men, unlike women, increased their representation over the 1970s. The overall picture of female qualification levels thus presents a polarisation. Female shares have increased in the lowest and highest qualification levels (unskilled wage-earners and semi-skilled wage-earners on the one hand, salaried employees with medium and with high and executive qualifications on the other) and decreased in medium qualification levels (auxiliary salaried and salaried employees with low qualifications).

F. Occupational Distribution of Men and Women within Industrial Sector

The French study by Huet et al.[19] carries the analysis of the characterisation of female employment further than any of the other studies in the direction of examining whether the same occupations have a similar distribution of employment by sex across the different industrial sectors. This allows some useful inferences to be drawn about the reasons for an employer's choice between male and female labour at the time of recruitment. The particular approach is possible in France because French employment surveys regularly provide a cross-classification of a substantial part of the employed by sex, sixty occupational categories and forty industrial categories, simultaneously[24].

It will be remembered that an analysis of the female share of each of the fifty-seven occupational categories had concluded that most of the variation from the average could be explained by noting that the female employment share was higher in the so-called "services" occupations and lower for the higher occupational qualification levels. However, this did not explain the whole story. Other factors clearly intervened as well, including the way in which occupations are distributed across the industrial sectors.

Certain sectors have higher or lower levels of the female share of employment than can be explained by their occupational structure. Indeed, certain occupations have a different female share depending on the sector: this could be a result of the occupation itself being in some way different according to the sector. Certain similar jobs may be given higher skill ratings in some industries than in others because of greater union pressure for higher pay rates in one industry than another. However, Huet et al. argue that there is a residual which represents real differences between the sectors. This is thought to be linked to differences in working conditions and production processes.

Across the various sectors, the conditions of work in the firms in that sector depend partly on the type of production process. This is particularly true in the manufacturing sector. Partly

on the basis of work carried out by Cézard, Huet *et al.* argue that the proportion of women in each occupation within a given sector can be expected to vary according to whether firms produce in small batches or long runs, have a high degree of mechanisation or automation, are geographically concentrated or consist of larger or smaller plants. Again, working conditions are important, where working conditions are taken to include time constraints (hours worked, need for shift work or night work) and the physical demands of the work. These depend to some extent on the type of production process. However, as Huet *et al.* point out, the barriers to employment of women in certain jobs requiring high levels of physical strength can frequently be removed by simple redesign of those jobs. Others, such as the use of shift work or night work, may be difficult to change without affecting profitability. For reasons connected with the general perception of the roles of men and women within society, men are often chosen to do supervisory jobs, while women are chosen for cleaning work or repetitive work, of the type required by certain types of production technology. Evidence is cited that "the reason given by employers in the electrical and electronic assembly industries for the large-scale employment of women is that women tend to be more patient with monotonous tasks; this "quality" is also the justification put forward by bank managers for keeping women in unskilled jobs which they cannot find men to fill"[25].

In the service sector, work situations are comparatively alike and this goes some way in explaining why the proportion of women in its sub-sectors is very much what might be expected given the ocupational structure of those sub-sectors.

Finally, the overall wage level in an industry is important. The industries with the highest proportion of women are also those paying the lowest wages for a given level of skill.

A careful study of patterns of female representation in the different occupations and different sectors together leads to the conclusion that the process by which women enter new fields of employment has the following characteristics: in sectors where there is a high proportion of women they tend to work their way into all occupations, and once they are in the majority in a particular occupation they tend to work their way into all sectors of activity through that occupation[26].

G. The Links between Trends in Occupational Segregation and Trends in Employment and Unemployment

In the discussion of aggregate indices of segregation, a statistical technique was adopted to divide changes in the index of segregation into one part due to the change in employment structure, a second part due to the change in female representation within the broad employment categories used, and an interaction term (see above, Section 1-D). The national studies allow this type of analysis to be pursued at a more detailed level, while also permitting links to be made between occupational segregation and several other of the major structural changes in employment outlined in Chapter I.

The national studies tend to indicate that structural changes in the labour market, mainly involving the expansion of occupational areas in which a high proportion of women are already employed, have worked in the direction of increasing segregation.

The Swedish study by Jonung, using a slightly different procedure to that used here, shows a consistent small structural effect, tending to increase segregation, on the basis of the detailed Swedish data. For the most segregated Swedish employment category "work in technology, natural sciences, social sciences, arts, letters and fine arts", the great inflow of women has not resulted in any reduction in segregation. In "administrative work", the major occupational group ranked second according to the level of segregation, the degree of segregation was found to have increased despite the inflow of women. This was explained by

noting that women had reduced their relative share within private business administration while entering public sector administration. Clerical work also showed increased segregation. Indeed the major reason for the overall fall in the level of segregation was reduced segregation within manufacturing occupations and within transport and communications occupations. Thus it could be concluded that segregation appeared to be declining within contracting sectors of the economy while increasing within the expanding areas of the economy[27].

However, this conclusion is not echoed in the French study by Huet *et al.* This divides occupations into two broad groups; industrial and service occupations (which have seen the vast bulk of female entry). The index of segregation used increases a little for industrial occupations taken as a whole but falls for service occupations, thus showing the opposite pattern to the Swedish results[28]. (While it is quite possible that these differences between the French and Swedish studies reflect differences in national experience it would be premature to draw this conclusion on the basis of these data alone.)

Segregation may also be linked to the rise in part-time working. The major share of part-time employment in the net increase in female employment has been well documented (see Chapter I). Since the demand for part-time work tends to be concentrated in relatively low-status jobs in the service sector, part-time work may be an important factor tending to increase segregation[29]. This point is made by the Australian study by Selby-Smith, which notes that the occupational groups exerting the most dominant effect on year-on-year changes in segregation have a high proportion of part-time workers, and that 75 per cent of the net increase in female employment between 1972 and 1980 has been in the part-time category[30].

Although women change occupations, especially if given retraining opportunities, the male and female new entrants into the labour market have an important part to play in the movement towards a more desegregated labour market. But the case of female part-time workers shows that the new entrants may be unable to produce such an effect, for they are often women constrained in their employment opportunities. It might be expected that among young men and women entering the labour market on a theoretically equal footing for the first time there would be clear evidence of a desegregating effect, for as Jonung points out, in the younger age groups there are smaller differences between the sexes in such areas as educational level, work experience and on-the-job training, all factors which have been cited as factors behind occupational segregation by sex. Moreover, we might expect to see more positive attitudes towards non-traditional occupations among young women and a more favourable attitude to integration among young people as a whole.

The evidence presented by Jonung does not bear this out, however. In the first place she finds that calculations of the dissimilarity index gave roughly the same value for each age group. In the second place she finds that while the employment structure of young and older men differs markedly this is not the case for women. "Young women ..., to a larger extent than is the case for young men, compete in the same labour market as adults of the same sex." She also quotes a study by Reubens to the effect that dissimilarity indices for the three age groups 15-19, 20-24 and 25+ "were very close" for the United States and for the United Kingdom, while in Germany the figures indicated that the labour market was more segregated by sex for young people than for older people. Overall Jonung concludes that "no strong trend towards reduced segregation coming through the entry of the younger generation into the labour market can so far be discerned"[31].

Another important and useful way of looking at inflows into the labour market is to study the sex composition of newly-emerging occupations. Evidence here is limited, but some is contained in the French study by Huet *et al.* which notes that the new and rapidly growing high-status occupation of analyst-programmer has a relatively high proportion of women, and

that this relatively high proportion is found in all industrial sectors where the occupation has become implanted. However, the study cautions against any conclusion that there is, in general, less discrimination against women in new occupations, since the same favourable pattern is not seen for certain other new occupations, for example machine operators in firms with continuous production processes. Observing that analyst-programmers are often employed in administrative establishments already employing a high proportion of women, the authors speculate that women may have easier access to new occupations when these are in areas where women are already well represented. Drawing on all this and the other evidence cited above concerning the pattern of female distribution by occupations within sectors, Huet *et al.* conclude that "to spread the female labour force more evenly it would be desirable to begin by introducing women into a new occupation in sectors where women are already well represented. Furthermore, this fits in with the experiments made by continuous training institutions or firms to introduce women into non-traditional jobs. These show that it is preferable to consolidate the skilled female work force and prepare firms to receive new female workers"[32].

Finally Jonung provides a way of using the overall net change in male and female employment in Sweden to put the observed movements in the segregation indices into perspective. Her calculations indicate that if the net addition between 1960 and 1975 to Swedish female employment had all entered previously male-dominated occupations, while the net fall in male employment had occurred in male-dominated occupations, the dissimilarity index would have fallen from 74.5 in 1965 to 48.6 in 1975, whereas in fact it fell only to 70.3 per cent[33]. It would thus be a major understatement to say that the potential for desegregation theoretically offered by the overall change in the numbers of men and women in employment has been largely unrealised.

4. SUMMARY OF THE EMPIRICAL RESULTS

Aggregate analyses can provide only a very crude first approximation to the measurement of occupational segregation by sex but they do allow a comparative analysis of different countries over time, may provoke interesting questions and may allow certain useful conclusions to be drawn. It is clear that the overall level of occupational and industrial segregation by sex is high even when measured at this level of aggregation in all countries. However, the level varies from country to country. There appears to be some evidence of an overall decline in occupational segregation at this aggregate level, no matter which of the two indices chosen is used. But it does seem to be very slow and may not be present at all for some countries. For the industrial data the results are much less clear and there is no such general pattern. Nevertheless, it is apparent that, measured in this way, segregation by sex by industrial sector is less pronounced than by occupational group.

The aggregate results also include a decomposition of the changes over time isolating the effect of structural changes in the labour market from changes in the relative share of women inside the different occupational groups and industrial sectors. The reason for making this analysis is as follows. If women are strongly concentrated in growing parts of the economy (and to a large extent they are) this by itself will, other things being equal, tend to increase overall, measured segregation. The analysis attempts to separate out this effect. Now for occupational groups, there appears to be little evidence that any such structural effect is strong: the structural and compositional effects (that is the effects of changes in the composition of employment by sex within the broad groups) frequently work in the same

direction. However, for the industrial data, there is a clear tendency for the structural effect to increase overall segregation by sex. (This perhaps explains why no clear trend over time can be observed in the indices based on the industrial data.) The results of the aggregate analyses are broadly confirmed and considerably extended by the material available in the various national studies. It must be emphasized, however, that this review is based on studies for comparatively few countries.

The detailed national studies do indeed confirm the high degree of occupational segregation indicated by the aggregate results and also the slow rate of change. Indeed, the finer the level of detail, the greater occupational segregation is found. The indices increase rather quickly with the detail of occupational classification and, at least in Sweden, the more detailed the occupational classification, the less change over time is seen in the index. This indicates not only the magnitude of the phenomenon of segregation and its extreme pervasiveness, but also that segregation is deeply entrenched.

Looking at individual occupations, or very fine occupational categories, it is apparent that a very high proportion of women work in very few occupations. Despite the overall tendency for some decline in segregation across broad occupational groups, certain individual occupations seem to be absorbing a higher and higher proportion of women. Thus the concentration of women into a very few occupations is increasing. For men this is not the case. To some extent it may be argued that this is because women's occupations are not so carefully delineated as men's, but this cannot account for the whole of the difference between the two sexes.

Women have now entered the vast majority of occupations, but in many they are still present in very small numbers. The general consensus amongst the Working Party members is that such reductions in occupational segregation that have been observed are due rather to men entering occupations previously dominated by women than by women entering occupations previously dominated by men. However, the statistical evidence is inconclusive. At a detailed level, it is noteworthy that few occupations are shared equally between men and women.

The detailed French analysis indicates that jobs done by women are still very largely the lower-level jobs in services. However, the proportion of women in a given occupation also depends on the industrial sub-sector concerned. This is particularly true for the manufacturing sector since in that sector the production process is organised in different ways, involving different degrees of mechanisation, different working conditions and different wages for a given level of skill, and all these seem to be factors which influence the level of female employment.

The country studies also appear to confirm that structural changes in the labour market work towards increasing segregation, though there are different views about the way that this is occurring. Some evidence suggests that the rise in part-time working may be associated with increasing segregation. On the one hand, comparatively few high-status jobs can be performed on a part-time basis. On the other, part-time work appears to be concentrated in occupations in which women are over-represented. This is not to say, however, that part-time work is a deliberate device used by employers to segregate the labour market by sex. It is more likely that it is mainly an adjustment of labour demand to both labour supply and the special characteristics of employment in the service sector.

One very important factor to consider is the influence on segregation attributable to new entrants into the labour market and new professions. The only evidence available seems to imply that segregation among young people is as great as among older people. This is a rather disappointing result, given the ostensible improvement in the level of educational qualifications of young women relative to young men that has occurred over the past two decades.

As regards new occupations, it may be, as is suggested by the study for France, that women have been able to enter certain well-paid new jobs in the service sector and other areas where women were already well represented, but have had difficulty in entering such new occupations in the industrial sector, where they are generally not well represented.

5. POLICY CONCLUSIONS AND POLICY DIRECTIONS

The empirical evidence above suggests that some progress towards desegregation of labour markets has been achieved in recent years. There are several reasons why it has not been more rapid. On the one hand, attitudes are slow to change and the labour market is relatively rigid. On the other hand, the rise in the population of service-sector jobs and the increased proportion of part-time employment, structural changes linked to the increased participation of women in the labour force, have tended to increase overall occupational segregation. It is significant that those countries with the highest levels of female participation both tend to have a relatively high proportion of employment in the service sector and in part-time jobs, and also tend to exhibit a relatively high level of occupational segregation.

Policies to reduce occupational segregation in the future are likely to have to operate in the context of a continuing trend towards a larger service sector and a greater share of part-time working in employment as a whole. Part-time jobs may continue to be taken by some women seeking to enter the labour market, even though they are likely to be confined to a restricted number of relatively low-level occupations with poor career prospects. The service sector will no doubt continue to offer the bulk of employment opportunities for women. High unemployment, expected to continue for some time to come, at least in Europe, may put pressure on women to accept such jobs. Special efforts may thus be needed to help them to move to other areas, where employment opportunities may be greater.

Another general point emerging from an analysis of overall trends in employment and unemployment is the vulnerability to long-term decline and cyclical sensitivity of employment in older industries within the manufacturing sector. Clearly, an active labour market policy designed to reduce overall labour market segregation by facilitating the access of women into jobs where they are under-represented will need to take this vulnerability into account and will aim to create opportunities for new entrants in expanding areas offering relatively good prospects.

Detailed empirical evidence indicates that it is much easier for women to enter high-level positions in occupations or sectors where a significant number of women are already working. Newly-emerging higher-level occupations offer an important opportunity for women to establish themselves before sex-stereotyping occurs, but here again there is evidence that insertion is easier if women are already present in the working environment concerned.

Finally, there is a reminder that simply improving the access of men and women into jobs traditionally performed by the opposite sex is not sufficient. Affirmative action policies are required to help women to take up the new opportunities. There is evidence that some reductions in segregation have been caused rather by men entering traditional "female" jobs than women entering traditional "male" jobs. It may be that for reasons discussed elsewhere in this report men have tended to enter at a relatively high level within the hierarchies. Thus in aiming to reduce horizontal segregation (between types of job) it may be necessary to guard against an increase in vertical segregation (between different levels in the same type of job). Training in managerial skills for women may be one way of achieving this.

Just as many factors combine to produce and perpetuate occupational segregation, so it is necessary to consider a wide range of government policies in order to combat it. The policy discussion below will begin by considering education and training and then proceed to examine family responsibilities and labour market discrimination. The emphasis will be first on criticising existing policies, many of which tend to reinforce discrimination, and second on analysing ways in which these effects may be controlled or reversed, in the context of progress towards a more equitable and efficient labour market. All action in this area needs to be coordinated with action to reduce pay differentials.

A. Education and Training

The current content of the various education and training programmes tends to channel young men and women into different occupations. The differences between the curricula choices of boys and girls and between their levels of attainment in the various subjects and the attitudes of teaching personnel are analysed in detail in Chapter V. Moreover, fewer girls than boys pursue the vocational links of study. In addition, training programmes for young people are strongly segregated by sex and act as a major part of the process by which men and women are channelled into different types of jobs. Indeed, a report by the authorities of Denmark concluded that occupational training patterns might be more important for explaining occupational segregation than differences in educational qualifications[34]. This is not to say that women are less willing or less able to benefit from training programmes than men. To take one example, the effects of training under the United States CETA Program, as measured by its success in raising the earnings of participants, has been found to be consistently higher for women than for men[35]. Rather, the type of training given to women is at issue, since it limits the occupations open to women. For example, very few women indeed become apprenticed. Relatively few women are given on-the-job training, being generally assigned to classroom programmes[36].

Instead of reinforcing segregation, training programmes can be used to weaken it, both by removing the bias towards increased segregation noted above and through positive action to permit women to enter higher-level jobs. Since training policies of this kind are best seen in the context of an overall labour market strategy for attacking occupational segregation by sex, they will be taken up below.

B. Family Responsibilities and Employment

Despite the changes in the working patterns of women, documented in Chapter I, which have led to a higher level of labour force participation and a more permanent attachment to the labour market, the main burden of child care and household chores is usually borne by women. This limits the ability of women in certain age groups who have such responsibilities to take up some types of work and may thus contribute to the segregation of women in jobs with less opportunity for advancement. When children are born in a family this is frequently accompanied by an interruption in the career of the mother, which may have deleterious effects on employment prospects if these depend strongly on continuous service or on keeping abreast of current knowledge.

Measures aimed at enabling people to reconcile their working and family life can be very important both in promoting the employment of women with dependent children and in overcoming labour market segregation. This does not mean, however, that such measures should be applied only to women, but rather that they should facilitate a more even sharing of familial duties between the sexes. Three types of measure are relevant in this context: *i)* the organisation of working time and working conditions, *ii)* maternity leave and leave for family

reasons for both parents, and *iii)* improved facilities for the care of children and other dependants. When applied properly they should ensure that the household is free to choose how to divide its total resources of time between the market place and the home in such a way that both the household and, more importantly, children are allocated sufficient time during their most important formative periods with minimal prejudicial effects on the employment and career prospects of either parent.

Swedish experience suggests that the availability of parental leave for child care, at a level which might be described as generous compared with that of other countries, has facilitated a more stable labour force attachment among women in Sweden. Although the overall occupational segregation of women in Sweden is high, this stability provides a good basis for mothers to enter non-traditional jobs requiring more stable labour force attachment and with correspondingly better career prospects.

C. Anti-discrimination Policies in the Labour Market

Women in the labour market may be subject to several types of discrimination, often summarised under the terms "direct" and "indirect" discrimination, terms which are defined in the Introduction to this chapter. This discrimination has been attacked in various ways, by legislation designed to render direct discrimination illegal and by affirmative action to enable women to enter a wider range of jobs.

Policies designed to counter direct discrimination are designed to remove barriers which have prevented the full integration of women in the labour market and restricted their access into higher-level jobs. The relevant legislation, often linked to equal pay legislation, may prohibit discrimination against women with respect to terms of employment including recruitment, promotion, dismissal, training opportunities and conditions of employment. In some countries legislation of this type has been in force for many years, in others it has been enacted only fairly recently.

Anti-discrimination legislation has a double role to play in an overall programme to reduce occupational segregation. In the first place it has a direct effect. Certain overt causes of discrimination are removed (though there is a danger that they may initially be rendered covert) and certain job opportunities are opened up for women to enter. Second and perhaps more importantly, legislation helps to change attitudes by indicating the disapproval of society for such discriminating behaviour and by legitimising women's struggles for equal treatment and opportunity.

There is no doubt that legislation has had a significant effect in reducing occupational segregation and that support from a strong legislative framework is of great importance for future progress. Anti-discriminatory legislation operates on a case-by-case basis and, partly for this reason, despite remarkable progress made in many individual cases, aggregate empirical evidence is unable to show any very major change in occupational segregation consequent upon the passage of anti-discriminatory legislation. This applies not only to the aggregate evidence presented in this chapter, but also to some detailed studies carried out by surveys of enterprises at the workplace level, for example Glücklich, who concludes that the United Kingdom Sex Discrimination Act appeared to have had little impact on the extent of sex segregation found within occupations, and the occupational distribution of women seemed to have remained unchanged[37]. While it is thus difficult to arrive at a balanced assessment after a relatively short period of operation, it appears that after the passage of legislation of this kind overall changes in working practices or in training or promotion procedures have occurred relatively slowly and in a piecemeal fashion.

An important reason why anti-discrimination legislation has not been more successful is the slowness of attitudes and employers' perceptions to change. For example, a view that men are more suited to heavy manual and physically stressful jobs and women to jobs requiring physical dexterity and the capacity to cope with monotony, is not readily altered by legislation. Even when such perceptions persist, it might be perfectly possible and straightforward to redesign operating procedures so that the manual lifting of heavy weights is unnecessary or so that jobs are less monotonous. However, employers may not wish to incur what they may perceive as short-term costs in changing established employment practices in spite of the potential longer-term benefits of using the workforce more efficiently. Nonetheless, attitudes are changed by the presence of legislation and its resolute application, if only because the costs of circumventing it cumulate over time.

There are also problems of communication – clearly made more difficult if there is lack of basic goodwill towards the spirit of the legislation. Simply-framed legislation may be relatively easy to circumvent while more complex legislation may be difficult to understand. While the personnel branches of large firms may be fully informed about the legislation, decisions about hiring and, above all, about operating practices may be made by hard-pressed line managers who have much less time or inclination to become fully conversant with new legislation. Again it may be difficult for women to understand their rights and to make their voices heard. For women seeking to change the *status quo,* there is also a cost in the shape of potential disapproval by fellow male workers and by management.

In presenting their case for more equal treatment, women may seek the support of unions. But unions may find it more difficult to be progressive in this field because in most cases their membership is still largely male and, reflecting the distribution of power in society, the union hierarchy is dominated by men. Thus the democratic process operating inside trade unions on behalf of their members may tend to result in a relatively unhelpful attitude towards occupational segregation. Traditionally, craft unions in particular have opposed the entry of women into male occupations because of fears that overall wages would then fall.

The public sector offers (and has offered for some time) a special opportunity for improving the position of women, and has been able to act as an exemplar for other sectors. Not only is the public sector more under the control of the government but financial costs are less easily used as an argument against the application of the legislation. Posts are classified more carefully so that candidates may be chosen more objectively and promotion given on the basis of merit rather than sex. Protest against unfair treatment may be more effective. Nevertheless, progress still needs to be made in the public sector of many countries, since women are often observed to be better qualified than men, at equivalent levels in the hierarchy. In addition, the public sector has generated large numbers of part-time jobs and these are very often filled by women. These jobs are often better protected than similar jobs in the private sector but the fact that they are generally restricted to a small range of jobs and often filled by women still tends to increase segregation. In the United States there is a special programme: the "Federally Employed Women" Program, designed to improve the situation of women in the federal government. Furthermore, there are equal opportunities officers in each government agency.

Within the public sector, national authorities have a very special opportunity to attack discrimination in Public Employment Services, where sex-linked views about appropriate skills and opportunities for men and women may be found among clients, both job-seekers and employers, and among the staff of the offices themselves. As part of the general process of changing attitudes and inserting women into non-traditional jobs, special resources and directives may be given to public employment offices. In Austria and Denmark, equal opportunities consultants have been appointed on an experimental basis to work within the

public employment service for this purpose. Norway has had such consultants since 1975. In Canada affirmative action within the public sector has built on existing equal opportunity programmes, putting heavy emphasis on moving women into a selected number of senior management positions.

Action within the labour market needs to go beyond anti-discrimination policies to a positive effort to enable women to enter non-traditional jobs by means of affirmative action programmes. Apart from the direct advantage to the women concerned, these policies embody a "demonstration effect": the presence of women, in sufficiently large numbers, performing successfully in non-traditional jobs, paves the way for more women to enter those jobs. To the extent that prejudice is based on ignorance, such a demonstration should be effective. But, it may be less so against deeply entrenched attitudes or male self-interest. This may be part of the explanation of persisting occupational segregation.

There are several ways in which affirmative action policies may be framed. Firms may be required to analyse the distribution of their employees by sex and thus bring occupational segregation to light. Action of this kind also may extend to union hierarchies. Firms may be encouraged to design new personnel policies to facilitate internal and external recruitment of women to higher-level positions and increase the number of training programmes designed to prepare women for forthcoming opportunities. In some countries, part of this may be "positive discrimination", in which women are given preferential treatment when in competition with men in cases where the qualifications of the candidates are equal. Policies of this kind have had a major impact in certain areas.

A further development of affirmative action involves the use of quantified goals and targets. These goals or targets may be indicative or fixed. Usually they take account of the supply of suitably qualified women. Quantified goals and targets have been used in the public sector in some countries and by some private employers. They have made a useful contribution to the promotion of women to higher levels and to women's participation in a wider range of jobs.

D. Affirmative Training Programmes

Training programmes are an essential part of any effective strategy to break down job segregation. They have been the subject of Panel 3 of the OECD Manpower Measures Evaluation Programme, "Manpower Measures to Even out Sex Imbalances", in which several Member countries have participated. A general point is that such programmes cannot be expected to show major progress unless they receive adequate funding. While many countries' programmes could be cited, two examples only have been selected below, for reasons of brevity.

In Sweden, special training is provided for women entering the labour market within the system of selective labour market policies. There are also regional employment quotas, training subsidies and the provision of relief work in non-traditional occupations. The courses available include both classroom training and practical experience in working in largely male environments (under the "Working Life and Training Programme"). Wage subsidies are used to encourage employers to give women on-the-job training in such occupations.

In the United States, a variety of U.S. Labor Department initiatives have been designed to help women seeking to move from highly-segregated job categories into other fields. These programmes have been developed by the Bureau of Apprenticeship and Training with assistance from the Women's Bureau and are funded by the Manpower Administration. Their success has been attributed to the systematic approach involved. This included not only

training *per se* but also special attention to the recruitment, orientation, counselling, tutoring, job development, placement and follow-up of women, as well as help in dealing with the physical conditions of the jobs which the trainees entered.

The broad conclusion to be drawn from the Panel so far is that training programmes designed to combat occupational segregation must not only avoid reinforcing the current segregation in the labour market but must also be designed to meet the special needs of women and be part of an integrated system to facilitate their integration into non-traditional jobs carefully chosen in the light of labour market conditions and, of course, the abilities, experience and motivation of the women concerned.

To the extent that women are able to benefit from existing training programmes, their access to them may be improved by easing entrance requirements (such as age limits or unnecessary educational requirements), giving them priority access or, as in Sweden, by means of wage subsidies to employers giving on-the-job training to women in non-traditional occupations. Whether the training involved is found in existing schemes or in schemes especially developed for women, special account must be taken of family responsiblities, in order to circumvent the time and mobility constraints that many women may have.

Moreover, the special training needs of women must be noted. Women seeking training for non-traditional jobs will present a wide range of different existing skills, qualifications and work histories. Many will be re-entrants to the labour market, having useful skills and qualifications which need to be revived and updated. The same will apply to other women, employed in segregated occupations, who have been unable to make use of the full range of their skills and qualifications in their work. All, including young women entering the labour market, may need to acquire new skills. And very many will benefit from counselling to raise their levels of aspiration. This may apply particularly to those with relatively high levels of qualification, especially young women entering the labour market for the first time, whose potential skills are apparently underused to an even greater extent than those of older women, given the empirical finding that occupational segregation is as high among young people as among older workers. Nevertheless, training programmes to enable maturer women to change their occupations are important as well.

The precise skill content of the training programme must depend on the jobs which are being targeted. All programmes face budget constraints and it is desirable for them to produce results within a relatively short time. Bearing in mind the structural changes in the economy, it may be best to aim to facilitate the insertion of women into non-traditional jobs in expanding sectors of the economy. In order to provide the maximum "demonstration effect", some countries have targeted occupations in which the representation of women is very low. This also has the attraction of targeting a relatively small number of jobs. However, since studies have suggested that women experience considerable difficulty in establishing themselves in occupations where there are very few women, it may be better to aim at occupations where the proportion of women, though low, is significant. Newly emerging occupations, for example those connected with new technology, often have the double advantage of being at a relatively high level of status and remuneration and also being relatively free from sex-stereotyping. Thus, one important area for special training for women is to develop skills needed for jobs created by new technologies. (And this is all the more true to the extent that clerical jobs traditionally carried out by women are threatened by this very same technology.) Nevertheless, it still seems important to ensure the presence of a certain number of women in the overall working environment.

To be most effective, the programme should not end with training but should actively aid women's insertion into the target, non-traditional jobs. Once they have entered those jobs they may need further counselling and training support to allow them to gain sufficient work

experience to become fully established, obtain promotion within the hierarchy and exercise professional or geographical mobility.

Despite all the help that training programmes can provide, it may still be very difficult for women to enter certain occupations and very high motivation may be required. The experience in France has shown that women entering new occupations are indeed highly motivated and obtain considerable personal satisfaction from the challenge.

All the above has been concerned with measures for women. However, segregation may also be reduced by encouraging men to enter occupations where they are under-represented. While this may have the danger that they will enter rather high-level occupations or posts at a relatively high level within occupational hierarchies, the presence of male workers in an occupation may also raise the general, relative level of wages in that occupation, benefiting female workers. Effects such as this are discussed in Chapter III.

All training programmes need to be properly evaluated and followed up. In practice, however, many measures and initiatives are wound down once the allocated resources have been spent, are remodelled or subsumed into different programmes. When they are evaluated, this is frequently done simply in terms of the earnings of participants versus those of a control group. This is unsuitable in the present context: evaluation of training programmes also needs to include the type of job entered and the effects on occupational segregation.

Annex

MEASURING OCCUPATIONAL SEGREGATION

The Basic Approach

Complete equality in the labour market could be taken to require an equal number of men and women within each occupation in the labour market. This is clearly impossible while the participation rates of men and women are different and the female share of paid employment is less than 50 per cent. The comparative level of female labour force participation, documented elsewhere, must therefore be taken into account. Another important element which may be considered separately is the degree to which men and women are affected by unemployment. This is again documented elsewhere. The present analysis is confined, as conventional, to the *relative* difference between men and women in the paid labour force.

For any given employment category for which we have data on the number of men and women, *prima facie* statistical evidence of segregation will be taken to exist if we find a difference between the female share of employment in that category and the female share of total employment. The statistical description of labour market segregation will thus consist of a set of so-called "coefficients of female representation" (CFRs) defined as the ratios of the share of women in a given employment to the share of women in total employment. If the CFR is greater (less) than one, women will be said to be over- (under-) represented in that employment category. Similarly, we may define coefficients of male representation (CMRs).

It may also be noted that it is possible to look at segregation *within* labour markets segments, for example the market for workers with a particular qualification. In this case the female share of an employment category within the segment would be examined with reference to the overall female share within the relevant labour market segment.

Implicit in this overall approach are a number of questions, which were only partly dealt with or even left to one side in the 1980 OECD report *Women and Employment*. Accordingly, a study, "The Measurement of the Concentration of Female Employment", was commissioned from Dr. Elisabeth Garnsey and Roger Tarling, of the Department of Applied Economics of the University of Cambridge, United Kingdom, to examine certain issues in depth. This report was discussed at a meeting of the Working Party in June 1982 and what follows draws on the report and the discussion.

Definition of Employment Categories

The first question to ask concerns the definition of employment categories to be used in the evaluation of segregation. Labour markets are known to be segregated by geographical, industrial and occupational barriers, and labour market data often embody the corresponding disaggregations. This provides a natural way to proceed, although the statistical classifications may not correspond to the true boundaries of the labour market segments. Within employment categories defined in such a way there may also be segregation by level of responsibility, by the type of working arrangements and by level of pay, as discussed in Chapter III. For example, most senior jobs are carried out by men, even within a given occupational and industrial group. Legislation may prevent women from working at night.

Thus, for a complete description of segregation, it is necessary to use a multivariate classification, including a wide range of variables. This is what is done in some of the national studies surveyed in this report. Again, it may be useful to consider sub-sections of labour supply in order to discover evidence of segregation of particular types of male and female labour supply within the different occupations. For example, one might look at the segregation of highly qualified men and women within the various high-status occupations.

Level of Detail of the Classification

Having defined the type of categories to be considered, it is necessary to determine how detailed the classification should be. This is very important. It is true, for example, that in the professional and technical group[38] the CFR is often found to be above unity in OECD countries, showing that in proportion to their numbers in employment as a whole, women are rather over-represented in this group. But a more detailed occupational breakdown would reveal that within this group women are highly segregated into different occupational sub-groupings, including nursing, where they are indeed highly over-represented, and engineers, where they are very markedly under-represented. As the occupational classification is made finer, so more and more extreme CFRs will be seen[39] and more and more extreme cases of occupational segregation will be revealed. This also applies if status level is introduced into the occupational classification.

In practice, there is a limit to the level of detail which can be used. To begin with, most data are obtained from sample surveys, which do not allow an analysis beyond a certain level owing to their lack of precision. However, even if a complete census of employment is taken, so that such problems are avoided, it is not meaningful to go beyond a certain level of detail. This is because when the numbers in the categories become small, extreme values of the coefficients of female representation may not indicate any underlying tendency towards segregation in the labour market. (If a given new occupation were so small that it contained only two people both of whom were women, this by itself would not be much indication of any tendency towards segregation within that occupation.)

Provided the numbers in each category remain fairly large, there are no technical reasons why, given a sufficiently precise and detailed source of data, an analysis of this type should not be carried out at a very detailed level to expose the full dimensions of labour market segregation. However, on the other hand, a very large amount of data may make it difficult to grasp the overall situation and, in practice, studies are often done at a relatively aggregate level in order to provide simpler results.

Very aggregate approaches using broad classifications are open to criticism, not only on the grounds that they obscure segregation at more detailed levels but also on the grounds that the aggregate statistical classifications used will not reflect the true pattern of segmentation of the labour market adequately. Nevertheless, provided these limitations are recognised, they may draw attention to policy issues. Segregation observed at the aggregate level is certainly indicative of segregation at a more

detailed level. A careful analysis of changes in the measures over time may allow useful, broad conclusions to be drawn.

There are several different ways in which the information contained in the coefficients of female representation may be analysed and summarised. We may analyse whether men and women are found in every employment category, and list the employment categories in which men and women are most highly concentrated. We may also attempt to summarise all the coefficients by combining them into a summary index of segregation.

Summary Indexes of Segregation

Summary indicators cannot of course represent complex economic and social processes adequately. As Garnsey and Tarling point out, they "inevitably conflate information which is relevant to the issue in question". They also give no direct way of deducing the causal mechanisms at work. For example, using summary indices of segregation on their own does not allow the effects of equal opportunity legislation to be readily distinguished from changes in employment structure affecting job opportunities for women. There is also the question of which type of summary index to use, and here there is indeed a wide choice, since all of the various indices of concentration that have been called into play from time to time may also be used in this context.

In the OECD report *Women and Employment* (1980), calculations were presented of an index of segregation defined as the average absolute difference between the coefficients of female representation and unity. The average was weighted by the employment size of the economic sectors[40]. (This index will be referred to as the WE index representing *Women* and *Employment*.) The WE index was calculated for the following categories; industrial sectors (at the ISIC major division level and at the division level for manufacturing only) and occupational groupings (ISCO major group level). Subject to the important caveats mentioned above, Garnsey and Tarling broadly endorsed this index of segregation.

The WE index has also been used by several other authors, for example Selby-Smith[10], who points out that it has the advantage that it may be interpreted as twice the minimum proportion of women who would theoretically have to exchange occupation with men *keeping the occupational structure constant* in order for all the CFRs to become unity and for segregation to disappear. In practice, segregation will not of course be removed in this way, since few people change occupations. Nevertheless, this simple way of picturing the divergence between the actual distribution of women by occupation and a situation without segregation does provide some extra justification for the use of the WE index[41].

On the other hand, the WE index has drawbacks and is indeed not the most common index used in the segregation literature. Its most serious disadvantage is that it does not lie between zero and one, as is usual for indices of concentration and inequality. In fact, its maximum value is two minus twice the employment share of women[42] and so it depends on the female share of employment. Again, it is not symmetrical for men and women, giving a different value if calculated for men or for women. (The corresponding index for men would simply involve replacing the CFRs with CMRs.) Partly for these reasons, another very similar index has been widely used in the literature. This is the so-called dissimilarity index, referred to in this report as the DI index, which relates women's share of each employment category not to the total numbers employed in that category but to the share of men in that category[43].

Once again, the value of the DI index is zero when there is no segregation but it takes a maximum value of one when there is total segregation (a situation where each employment category is entirely filled either by men or by women).

There is also a possible interpretation. The index is equal to the minimum proportion of women who would need to change employment categories in order for segregation to be removed assuming that the members of the other sex retained their jobs[44]. (It will be recalled that in the WE index the interpretation involved a hypothetical exchange of jobs between men and women.) Now this interpretation of the DI index presents an even less reasonable model for what might happen in practice than that involved in the interpretation of the WE index. If, say, one of the employment categories is nurses, and only 0.001 per cent of men work as nurses, this interpretation requires us to imagine women virtually abandoning the nursing profession so that only 0.001 per cent of women remain working in it, reducing the nursing profession to a minute fraction of its present strength. Thus, it is better to regard this index simply as a

statistical measure of the differences between the distribution of men and women across occupations.

The two indices, WE and DI, are related to each other as follows:

$$WE = 2 \times DI \times (1-N_f/N),$$

using notation outlined in note 39, so that the WE index may be interpreted as twice the value of the dissimilarity index times the proportion of employment not held by women.

Owing to the more convenient statistical properties of the dissimilarity index, DI, together with its wider usage in the literature, results are presented above for both indices. It is stressed that these measures are descriptive and not normative. In other words they act, at best, rather like a thermometer. The fact that one temperature is higher than another does not imply that it is "better" or "worse". That can only be decided by reference to a value judgement.

Given two separate years, the change in the value of either the WE or the DI index may be decomposed into a part due to the change in representation rates within employment categories, a part due to the change in employment structure and an interaction term. It is clear that in general the index will change if the female representation rates within each employment category change. Again the index will change, in general, if the employment structure changes. For example in the case of the DI index, if the categories where the CFRs and CMRs are farthest apart show an increase in employment share, the DI index will also increase, indicating a rise in measured segregation.

In principle, it might be considered useful to know the degree to which occupational segregation, as measured by the index, would have changed if the employment structure had remained constant. However, it is not possible to know this since the change in representation rates within one or more of the categories may itself be partly dependent on factors linked to the change in employment structure. Nevertheless, the results of a statistical decomposition of the change in the index may be useful, provided that it is realised that any straightforward interpretation of the decomposition must be based upon the assumption that the two factors, changes in representation rates and changes in structure, are more or less independent of each other.

Even when a purely statistical decomposition is adopted there is the problem that there is no unique decomposition. The problem is analogous to the well-known problem of choosing the year or years to supply the "weights" to use in the construction of a price index. The approach adopted here is to begin with the earlier year and calculate first the value of the index that would have been found for the second year if the representation rates had changed but the structure kept constant, and second, the value that would have been found for the second year if the structure had changed but the representation rates held constant. The first calculation gives the part of the change in the index to be attributed to the change in structure while the second gives the part to be attributed to the change in representation rates. There is a remainder, which is attributed to interaction between the two factors, that is, the extra effect of the two factors operating together[45]. Naturally, if the interaction term is large by comparison to the other two terms, the usefulness of this statistical decomposition is greatly reduced.

NOTES AND REFERENCES

1. See OECD, *Women and Employment,* Paris, 1980, Part Two.

2. *Ibid,* p. 129.

3. For a recent analysis see the research quoted in "Women's Employment and Unemployment", *New Zealand Labour and Employment Gazette,* December 1982, pp. 1 and 4.

4. Arrow, K., "Comment I" in Blau, F. and Jusenius, C.L., "Economists' Approaches to Sex Segregation in the Labor Market: An Appraisal" in M. Boxall and B. Reagan (eds.), *Women and the Workplace,* Chicago, University of Chicago Press, 1976, pp. 181-199.

5. Blau and Jusenius, *ibid.*

6. Bergman, B.R., "The Effect on White Incomes of Discrimination in Employment", *Journal of Political Economy,* Vol. 79, 1971, pp. 294-313.

7. Hakim, C., *Occupational Segregation,* U.K. Department of Employment, Research Paper No. 9. 1979.

8. Gordon, D.M., "Comment II" in Blau and Jusenius, *op. cit.* in note 4.

9. OECD, *Women and Employment, op. cit.*

10. Report on *The Concentration of Female Employment in the Australian Labour Market 1972-1980,* commissioned for the Working Party on the Role of Women in the Economy from J. Selby-Smith of the Australian National University.

11. Jonung, C., *Patterns of Occupational Segregation by Sex in the Labour Market,* Nationalekonomiska Institutionen, Lunds Universitet, Meddelande 1983:89, p. 11.
(Also forthcoming in *Discrimination and Equalization in the Labour Market: Employment Policies for Women in Selected Countries,* Günter Schmid (ed.), International Institute for Management, Wissenschaftszentrum, Berlin).

12. Jonung, *Ibid.*

13. Selby-Smith, *op. cit.* in note 10.

14. Eder, A., "Concentration of Female Employment in the Austrian Labour Market: 1970-1981", in collaboration with C. Bohm, Austrian Federal Ministry of Social Affairs, mimeo, January 15th, 1983. (German version in print; English version forthcoming.)

15. The formula for the WE index, given in note 40, shows that it is the sum of terms representing the contributions of each of the employment categories to the overall index. Between any two years the size of each contribution will change and the sum of these changes will be equal to the overall change in the index.

16. Selby-Smith, *op. cit.* One factor which may be playing an important role here is sampling variability, since the data used in the study were derived from a comparatively small sample survey.

17. Jonung, *op. cit.* in note 11, p. 9.

18. Eder, *op. cit.* in note 14.

19. Huet, M. *et al.*"La Concentration des emplois féminins", *Economie et Statistique,* No. 154, 1983.

20. Jonung, *op. cit.* in note 11, p. 21.

21. *Ibid.,* pp. 20-21; and Hakim, *op. cit.* in note 7.

22. Huet *et al., op. cit.*

23. Eder, *op. cit.* in note 14.

24. Huet *et al., op. cit.* in note 19. Small enterprises and the public sector are unfortunately excluded.

25. Cézard, M., "Les qualifications ouvrières en question", *Economie et Statistique,* No. 110, April 1979; Huet *et al., op. cit.* in note 19.

26. Huet *et al. Ibid.*

27. Jonung, *op. cit.* in note 11, pp. 17-18 and Table 4.

28. Huet *et al., op. cit.* in note 19.

29. Trends in part-time employment are described in Chapter IV of the *OECD Employment Outlook,* Paris, 1983. It may be noted that when just one year is concerned the fact that women work part-time more often than men may have no effect on occupational segregation, in the sense that the index may be unchanged if recalculated in terms of full-time equivalents. This point is made by Hakim (note 7).

30. Selby-Smith, *op. cit.* in note 10.

31. Jonung, *op. cit.* in note 11, pp. 22-23; B.G. Reubens (ed). *Youth at Work: An International Survey,* N.J. Totowa,: Allenheld and Osmun, 1983.

32. Huet *et al., op. cit.* in note 19.

33. Jonung, *op. cit.* in note 11, p. 28.

34. "Report on the Employment of Women", paper submitted by the Danish authorities to the High Level Conference on the Employment of Women, held at OECD Headquarters, Paris, on 16th and 17th April 1980.

35. Bassi, L.J., "The Effect of CETA on the Postprogram Earnings of Participants", *The Journal of Human Resources,* XVIII, 4, 1983; pp. 539-556.

36. Hoy, M., and Lampe, G.L., *Women in National Training and Employment Programs,* Conference Paper No. 13, (Conference on Women in the Australian Labour Market, Canberra, August 1982), Australian Bureau of Labour Market Research, August.

37. Glücklich, P., "The Effects of Statutory Employment Policies on Women in the United Kingdom Labour Market" forthcoming in *Discrimination and Equalization in the Labour Market: Employment Policies for Women in Selected Countries,* Günter Schmid (ed.), International Institute for Management, Wissenschaftszentrum, Berlin.

38. International Standard Classification of Occupations, Major Group 0/1.

39. Indeed if:

N_{fi} is the number of women in employment category i,
N_{mi} is the number of men in employment category i,
N_f is the number of women in total employment,
N_m is the number of men in total employment
N_i is the number of persons in employment category i,
k is the number of employment categories, and
N is the total number of persons in employment,

then the CFR for category i is

$$\frac{N_{fi}}{N_i} \bigg/ \frac{N_f}{N} = \frac{N_{fi}}{N_f} \bigg/ \frac{N_i}{N}$$

and the CMR for category i is

$$\frac{N_{mi}}{N_i} \bigg/ \frac{N_m}{N} = \frac{N_{mi}}{N_m} \bigg/ \frac{N_i}{N} .$$

If category i is divided into $i(1)$ and $i(2)$,

where $\qquad N_{fi}(1) + N_{fi}(2) = N_{fi}$

and $\qquad N_i(1) + N_i(2) = N_i$

then max

$$\left\{ \left[\frac{N_{fi}(1)}{N_i(1)} \bigg/ \frac{N_f}{N} - 1 \right] , \left[\frac{N_{fi}(2)}{N_i(2)} \bigg/ \frac{N_f}{N} - 1 \right] \right\} \geqslant \left[\frac{N_{fi}}{N_i} \bigg/ \frac{N_f}{N} - 1 \right]$$

and equality obtains if and only if

$$\frac{N_{fi}(1)}{N_i(1)} = \frac{N_{fi}(2)}{N_i(2)} = \frac{N_{fi}}{N_i} .$$

40. Using the notation outlined in note 39 above, the formula for the WE index is:

$$\sum_{i=1}^{k} \left[\frac{N_{fi}}{N_i} \bigg/ \frac{N_f}{N} - 1 \right] \cdot \frac{N_i}{N} \times 100\%$$

It may also be written as

$$\sum_{i=1}^{k} \left[\frac{N_{fi}}{N_f} - \frac{N_i}{N} \right] \times 100\%$$

and can thus be seen to be the sum of the differences between the female share of each employment category and the total share of each category added up without respect for sign.

41. In fact Selby-Smith (1982) favours an index which is half the WE index, avoiding the introduction of the factor 2 in the interpretation. Despite the advantages of this, the original WE formulation has been retained in this chapter for easier comparison with the earlier report. In many cases interest lies in the proportional change in the index and in that case it makes no difference whether the factor 2 is present.

42. This can be seen to be intuitively reasonable since the lower the employment share of women in employment the smaller their influence on the occupational distribution and the higher the proportion of women that may have to be redistributed in order to remove segregation.

43. The formula for the index of dissimilarity DI is

$$\frac{1}{2} \sum_{i=1}^{k} \left[\frac{N_{fi}}{N_f} - \frac{N_{mi}}{N_m} \right] \times 100\%$$

It is seen to be symmetrical for males and for females.
It may also be written as:

$$\frac{1}{2} \sum_{i=1}^{k} \left[\frac{N_{fi}}{N_f} \bigg/ \frac{N_i}{N} - \frac{N_{mi}}{N_m} \bigg/ \frac{N_i}{N} \right] \cdot \frac{N_i}{N} \times 100\%$$

showing that it is half the weighted sum of the absolute differences between the male and female coefficients of representation.

44. The same statement holds if the word "women" is replaced by "men", reflecting the symmetry of the index.

45. Writing SEX, STR (structure) and INTER (interaction) for the contributions to the change in the DI index between years 0 and 1, the formulae used are as follows:

$$\text{SEX} = \frac{1}{2} \sum_{i=1}^{k} (D_i^1 - D_i^0) \cdot S_i^1 \times 100\%$$

$$\text{STR} = \frac{1}{2} \sum_{i=1}^{k} D_i^1 \cdot (S_i^1 - S_i^0) \times 100\%$$

$$\text{INTER} = \frac{1}{2} \sum_{i=1}^{k} (D_i^2 - D_i^1) \cdot (S_i^1 - S_i^0) \times 100\%$$

where

$$D_i = \left[\frac{N_{fi}}{N_f} \bigg/ \frac{N_i}{N} - \frac{N_{mi}}{N_m} \bigg/ \frac{N_i}{N} \right], \quad S_i = \frac{N_i}{N},$$

and D_i^1 refers to the value of D_i in year 1, etc.

It will be found that $DI^1 - DI^0 = \text{SEX} + \text{STR} + \text{INTER}$.

Chapter III

MALE AND FEMALE EARNINGS DIFFERENTIALS IN OECD COUNTRIES

1. INTRODUCTION

This chapter highlights the main points of analysis and the conclusions of an unpublished OECD study of international and national earnings statistics. It provides a statistical overview of male and female earnings differentials based on yearly, weekly, hourly, sectoral and, wherever possible, occupational breakdowns. This chapter will not deal with employment discrimination, that is, unequal job opportunities for men and women with similar qualifications.

The chapter is structured along the following lines: first, it gives an overview of the gender earnings differentials in the OECD countries; second, it reviews several possible methodologies; third, it isolates and discusses a series of factors in terms of their impact on male-female earnings differentials. Fourth, in a section on policy conclusions it attempts to highlight three areas of policy that may help to narrow this earnings gap.

In OECD countries women earn, on average, about 20-40 per cent less than men although the earnings differentials have narrowed somewhat in the last decade. The actual size of the earnings differentials and their change over the last ten years vary across countries (Table III.1). Moreover, even within each country, the differentials vary according to the type of employment (manual or non-manual, full-time or part-time), the industrial sector and the occupation. The Scandinavian countries emerge as those with the least difference between male and female earnings. Australia, Ireland and the United Kingdom female earnings increased most in comparison with male earnings. In contrast, Germany and France show a relatively slow increase in the period considered.

Pay differentials by sex tend to be smaller for manual and part-time workers than for non-manual and full-time workers. Differentials are also smaller in low-pay industries and occupations where women are generally over-represented than in sectors and jobs which offer higher pay and good promotion possibilities, in which male workers are still represented to a much greater extent than female workers (see Chapter II).

2. METHODOLOGICAL APPROACHES

Wage differentials represent a complex phenomenon difficult to define and to comprehend. In broad terms, a distinction can be made between factors which influence the demand side of the labour market, such as personal characteristics and employer preferences, and those which influence the supply side, including workers' preferences and constraints.

Table III.1. **Average hourly earnings in non-agricultural activities of women workers as percentage of those of men in OECD countries, 1970-82**

	1970	1973	1975	1979	1980	1981	1982
Australia	65.2	76.5	83.7	85.5	86.0	86.2	—
Austria	68.4	69.6	68.0	72.0	—	—	—
Belgium	66.7	68.8	71.2	69.7	69.4	71.6	—
Canada	n.a.	n.a.	n.a.	n.a.	74.7[d]	—	—
Denmark	72.4	79.2	83.2	84.7	84.5	84.5	84.1[a]
Finland	70.3	71.7	72.6	75.3	75.4	76.3	76.7[b]
France	—	78.8	78.7	79.2	79.2	80.4	—
Germany	69.2	70.3	72.3	72.6	72.4	72.5	72.6[c]
Greece	n.a.	n.a.	n.a.	n.a.	67.8	67.2	—
Ireland	56.2	59.9	60.9	66.6	68.7	67.6	—
Italy	74.2	78.3	78.7	83.2	83.2	83.9	—
Luxembourg	57.0	58.1	63.3	61.7	64.7	63.5	—
Netherlands	73.3	76.1	79.5	77.4	77.9	77.0	—
New Zealand	—	—	73.8	78.0	77.2	77.8	76.8[b]
Norway	75.1	76.2	78.0	80.5	81.9	82.6	—
Portugal	n.a.	n.a.	n.a.	87.9	n.a.	n.a.	—
Sweden	80.0	—	84.8	89.1	89.8	89.9	—
Switzerland	62.8	66.5	66.7	66.6	67.3	68.2	66.3[b]
United Kingdom	60.1	62.5	67.6	70.7	69.7	69.5	—

a) First quarter.
b) Second quarter.
c) April.
d) All activities (estimated).
n.a. Not available.

NOTES

Australia	:	Adult wage- and salary-earners, excluding managerial staff. Including forestry, logging, fishing and hunting. October of each year, with exception of 1981 which refers to May.
Austria	:	Wage-earners in manufacturing and mining. Statistics of the Austrian Chamber for Wage-earners and Salaried Employees.
Belgium	:	Wage-earners, excluding apprentices. Mining, manufacturing and construction only. October of each year.
Canada	:	Estimate based on full-year earnings of all workers, and the number of male and female full-time and part-time workers and their average weekly hours.
Denmark	:	Wage-earners aged 18 and over. Manufacturing, construction and parts of ISIC major divisions 4, 6, 7, 8 and 9.
Finland	:	Wage-earners in mining, manufacturing and public utilities (ISIC 2-4).
France	:	Wage-earners aged 18 and over. Excluding mining, quarrying, public utilities, the public sector and private domestic service. October.
Germany	:	Wage-earners, including foremen, but excluding apprentices. Based on payroll data for January, April, July and October. Including family allowances paid directly by employer. Excluding services.
Greece	:	Wage-earners in manufacturing.
Ireland	:	Adult wage-earners in manufacturing. September.
Italy	:	Wage-earners in industry. October.
Luxembourg	:	Wage-earners, excluding apprentices, foremen and supervisors. Industry. October.
Netherlands	:	Adult wage-earners. Prior to 1977 excluding services. October.
New Zealand	:	Wage- and salary-earners, including juveniles. Including forestry and logging.
Norway	:	Adult wage-earners in manufacturing.
Portugal	:	Daily earnings of unskilled personnel.
Sweden	:	Adult wage-earners in mining and manufacturing.
Switzerland	:	Wage-earners. Excluding overtime payments. Including horticulture and forestry. Excluding ISIC 2, 8 and 9.
United Kingdom:		Adult wage-earners. Excluding coal mining, commerce and ISIC major division 8. October.

Sources: ILO, *Yearbook and Bulletin of Labour Statistics;* National statistics for Austria, Finland, Norway and Sweden.

While the focus is generally on the demand side of the market, there is a recognition that feedback effects may influence the supply side[1].

The theory of Professor Gary Becker assumes that discrimination is partly due to the tastes of employers who prefer to accept women only at lower wages than men, demand higher qualifications for women than men doing the same work or exclude women from higher-paying jobs. More precisely, if a woman could be hired at wage w, the discriminatory employer behaves as if the wage were $w(1 + d)$, where d, a positive number, is the employers' "discrimination coefficient" for the job concerned. In a free and competitive labour market, the presence of discriminatory employers will tend to lower women's wages relative to men's. However, the most discriminatory employers will be placed at a cost disadvantage compared with the least discriminatory since their tastes will lead them either to hire male workers who are less well qualified than female workers available at the same wage or to hire over-qualified female workers. They will therefore need to sacrifice profits to maintain their desired level of discrimination and could go out of business. Becker points out that this may not happen if they enjoy a monopolistic situation in product markets, leading him to predict that, in general, monopolistic industries should discriminate in employment more than competitive ones. In perfectly competitive labour and product markets, wage discrimination should tend to disappear unless all employers are discriminators.

An alternative approach is the dual labour market theory which characterises the economy in terms of a primary and a secondary segment. Prime-age white males are seen to be in the high-paying, stable primary-market jobs whereas women, youths and minorities are concentrated in the low-paying, insecure secondary-market jobs. Little possibility of advancement has a negative impact on worker behaviour in the secondary market in terms of job performance, absenteeism, etc.

Radical economists view the segmentation of the labour market as a deliberate attempt on the part of capitalists to keep the labour force divided, thereby preventing the formation of a cohesive group of workers that will challenge management. Here, discrimination is a direct outcome of a profit-maximising approach on the part of the employer.

Given these theoretical approaches, many attempts have been made to measure pay discrimination, with much resulting controversy over their accuracy. Yet even the most conservative estimates indicate a considerable degree of pay discrimination against women and minorities.

A cautionary note concerning the data must be struck. Precise inter-country differences are difficult to establish due to the extremely heterogeneous nature of available data. For example, information on total male and female earnings on a full-time basis for the whole economy exists for only a few countries. If statistical information is available, there are large differences in coverage. Some data may refer to adult workers only while others include juveniles and apprentices. The different time intervals covered by the data are a major problem since the interval covered may be a week, a month or a year. The degree of comparability always increases when earnings of the same type can be considered, but this is difficult to do in practice. The fact that available statistics often refer to only medium and large establishments, thereby excluding smaller ones, is also a problem since the pay disadvantage for women tends to be larger in small undertakings, as minimum wages and equal pay legislation are more difficult to enforce given the relative lack of union pressure at this level[2].

This chapter reflects the method of the OECD's unpublished study which assesses the effect of some worker-related and job-related characteristics of male and female workers on their relative pay level. The method is fairly compatible with the disparities of earnings data in different countries and consists of a systematic comparison of the total relative female pay

71

level (weighted average) and relative female pay levels in various distributional breakdowns using their unweighted average. Three sets of factors will be focused on, namely, institutional, economic, and compositional or distributional.

3. EXPLANATORY FACTORS RELATED TO MALE-FEMALE EARNINGS DIFFERENTIALS

Factors which attempt to explain male-female earnings differentials can be broadly grouped under two categories of discrimination: direct and indirect. The OECD's report on *Women and Employment* defines direct discrimination as occurring when individuals fail to obtain particular jobs or training opportunities because of their sex. Indirect discrimination occurs when systems of recruitment, training, promotion and pay favour one sex above the other, and also involve the specification of rules which one sex can comply with more easily than the other[3]. In many Member countries most direct discrimination has been alleviated, yet not necessarily eliminated, given that the equal value concept is not a part of most countries' equal pay legislation framework. Indirect discrimination is due to the social, economic and institutional forces which have produced and sustained sex segregation and have defined women's role in the labour market as peripheral and secondary.

The perpetuation, yet reduction, in the male-female earnings gap over the last decade seems to be due to a number of causes related to institutional, economic and compositional or distributional factors.

A. Institutional Factors

Many OECD countries in the 1970s adopted equal pay legislation as part of a wider policy approach to inequality[4]. Generally, one would expect an inverse relationship to exist between the relative level of female pay and women's employment since employers might respond to the rise in the cost of female labour by hiring less of it. In the case of the United Kingdom[5] and also in other OECD countries, this does not appear to have occurred. In all countries between 1970 and 1981, relative female earnings increased as did female employment relative to male employment.

There is still little evidence of the impact of legislation on pay inequities. The evidence provided by existing studies along with that provided by the gross trends in male/female earnings ratios over time seems to indicate a somewhat limited impact of the legislation, but there is an associated impact from the other legislation which follows[6]. It has also helped to clarify the earnings differential picture for policy-makers who are now involved in the drafting of new legislation that will further address labour market imbalances between the sexes.

The limited impact of equal pay legislation in some countries may be attributed to several causes. First, the restricted application of equal pay legislation to cases where the same or fairly similar work is being performed by men and women in the same establishment reduces its impact. As Agarwal has noted, the possibility of differential pay rates based on minor differences in job duties continues. Second, the legislation is limited to work and employees in the same establishment, but this does not affect an employer with women workers in one building and men in another. Most importantly, equal pay legislation only applies where women and men are employed in comparable jobs, but occupational segregation makes comparison difficult. Furthermore, lack of resources may have inhibited the full enforcement of equal pay laws once they were established.

72

A recent unpublished OECD review of equal opportunity policies emphasizes this last point in its conclusions. It notes that equal pay legislation falls short of countering sex-based wage disparities resulting from initial job assignment discrimination, i.e. men and women with the same human capital being assigned to predominantly "male" and "female" jobs. In short, equal pay legislation, while it has addressed the practice of overt earnings discrimination, can never be expected to equalise the overall average earnings of men and women (although this may vary according to centralised versus collective wage bargaining systems) given the existing segregation of the labour force by industry and occupation.

An important next step towards equality would be achieved if legislation were enacted that permitted a comparison of dissimilar jobs held by women and men using the principle of comparable worth as defined in ILO Convention No. 100 (1951) concerning the equal remuneration for men and women workers for work of *equal value*. This concept has been receiving considerable attention in many countries. In the Scandinavian countries, governments offered their support to collective bargaining partners at the beginning of the 1960s with the aim of abolishing special women's rates in collective agreements. In Sweden at present, female hourly earnings amount to 90 per cent of male hourly earnings, the difference being almost entirely accounted for by "worker characteristics" i.e. age, qualification, length of experience and working hours[7]. In Canada, the equal value/comparable worth criterion has been incorporated into legislation in the Canadian Human Rights Act of 1977 and is also included in the Canadian Labour Code[8]. At the present time, however, this legislation applies only to employers under the jurisdiction of the federal government (about 10 per cent of the Canadian labour force).

In other countries, progress towards the adoption of the comparable worth approach has been uneven. In Australia, there has been no progress towards the adoption of the comparable worth approach since 1972 although the Australian Conciliation and Arbitration Commission stated its acceptance of the principle of equal pay for work of equal value. In EEC countries, the comparable value implication of Article 119 of the Treaty of Rome, establishing the principle of equality of remuneration for women and male workers has been restated in many documents and Council Directives[9]. An *ad hoc* Working Group on equal pay and job classification was established by the Commission of the European Communities in 1979. In a 1981 report of the Working Group, post-classification and job-evaluation systems were singled out as the principal sources of existing discrimination[10].

In the United States, the Equal Employment Opportunity Commission requested the National Academy of Sciences to determine, through its Committee on Occupational Classification and Analysis, to what extent appropriate job measurement procedures existed and how the worth of jobs could be assessed[11].

Job evaluation does raise a number of issues of an economic, political and technical nature. It is difficult to determine the value of comparable work, and the cost of performing this lengthy and expensive task on throughout the economy is not negligible. Who should pay the cost is another politically charged consideration. There are many varieties of job analysis and none is neutral or "scientific" in character. Trade unions would have to be convinced of the usefulness of job evaluation techniques in order to support them, since, for a number of reasons, they have often resisted them in the past. Furthermore, in most countries only a small number of women are unionised or part of the industrial relations decision-making apparatus. It would also be important to include women with an understanding of equal pay problems on job evaluation committees, as job evaluation is always partly subjective. However, many obstacles are likely to arise, not least on the side of employers. Job evaluation may become a tool for assigning relative wages to different jobs in the labour market, as was indeed the case in Sweden. Employers may fear that these procedures would lead to an increase in low wages

and to a narrowing of wage differentials, thus adding to their difficulties in already depressed market conditions[12]. Notwithstanding these initial problems, job evaluation has led to positive results in several countries where enforced. In Canada, for example, a complaint by librarians and historical researchers in the public service yielded a settlement of $2.3 million in equalisation payments. A settlement of $1 000-2 000 per person was reached for nurses in penitentiaries who were paid less than male hospital technicians performing essentially the same work in health care centres.

B. Economic Factors

The growth of demand for specifically female labour resulting from the development of services, the growth of the public sector, and the expansion of welfare activities of various sorts[13] was strong enough to increase women's employment and to reduce some of the differences between male and female pay levels. This was especially the case in Europe where the rise in female labour supply frequently compensated for a decline in the male labour supply in the post-war period. In the United States and Canada, where both the male and female labour force had a relatively fast upward trend, women's employment grew considerably. In Australia, too, male and female labour supply increased substantially and there was a one-time increase in female pay relativities (from 65 to 78 per cent of full-time adult male earnings between 1972 and 1976) following the equal pay decision.

To the extent that male-female pay differentials are influenced by demand factors, they can be expected to react to cyclical fluctuations. Literature on earnings differentials suggests that in upturn periods the earnings gap narrows under the effect of high demand for labour, while during a recession it tends to widen[14]. In Table III.1, the 1970-82 period has been broken down into time segments corresponding to business cycle phases typical of most OECD countries during those years. In only a few countries does the theoretical pattern seem more or less discernable.

In most countries relative female earnings continued to grow during the first recessionary period of the decade as they did throughout the 1970s. In the United Kingdom, the first substantial increase in relative female earnings coincided with a fall in the real level of GDP and this sharp increase in relative wages was not related to the cycle[15]. This seems to apply, in general, to most OECD countries during the 1970s. There was a slight impact on female relative pay levels in some countries after 1979, but in the majority of countries female wages continued to grow. Apparently, in most OECD countries, other factors (institutional, structural, etc.) were stronger than the effect of the cyclical fall in (or low growth of) demand for labour.

C. Compositional and Distributional Factors

The question of male-female pay differentials is often analysed in the context of direct and indirect discrimination. In order to quantify the amount of discrimination or the *net* earnings differentials, theoretical adjustments were made for productivity-related factors such as age, length of experience, education, hours worked and other compositional factors. The net earnings differential was then taken to be the earnings that could not be explained by productivity factors.

This "human capital" approach has been widely utilised in many countries to explain women's participation patterns in the labour market and the phenomenon of male-female earnings differentials[16]. The method used in these studies is generally based on distribution indices or on multiple regression analysis, and has the merit that it can quantify most of the major compositional elements that affect the differences in male and female earnings.

74

However, the choice of factors examined is necessarily limited and somewhat arbitrary, which reduces the validity of the analysis and tends to different authors' arriving at widely different results. Also, human capital variables are of unknown quality as proxies for productivity differences, e.g. experience. In theory the link between concepts and indicators is often quite tenuous and, furthermore, to make the conclusion linking residuals and discrimination one requires the assumption that all relevant factors have been measured and that they are measured without error[17].

Given the methodological and practical problems of the above approach, this chapter will attempt to provide a more flexible method of assessing the effect of some worker-related and job-related characteristics of male and female workers on their relative pay level.

The following sections will examine several compositional factors that may help to shed light on male-female earnings differentials: first, hours worked; second, age and experience; third, educational qualifications, sector and branch of industry, and occupation.

Hours Worked

As was noted in Chapter I on Employment and Unemployment, over the past two decades there has been a fall in the average hours worked per person in all OECD countries though the rate of decline varies. Over the period 1960-81, there has been a decline of 20 per cent or over for several countries (Belgium, the Netherlands, Norway and Sweden), while Finland and the United States experienced declines of just over 10 per cent[18].

Table III.2. **Hours of work per week of full-time workers in selected OECD countries, 1970-81**

	1970			1981			Notes
	M (1)	F (2)	F/M (3)	M (4)	F (5)	F/M (6)	
Australia	43.5	39.4	90.6	40.9	38.4	93.9	Second year: 1980; non-agricultural activities
Belgium	45.1	42.7	94.7	43.1	41.1	95.4	First year: 1973; second year: 1979
Canada				43.2	38.0	88.0	Second year: 1980
France	47.8	43.5	91.0	45.0	42.0	93.3	First year: 1973; second year: 1979
Germany	43.5	40.2	92.4	41.6	39.4	94.7	First year: 1973; industry and construction
Ireland	49.7	40.9	82.3	49.1	40.0	81.5	First year: 1975; second year: 1979
Italy	43.2	40.2	93.1	41.9	38.6	92.1	First year: 1973; second year: 1979
Japan	43.6	39.8	91.3	41.7	37.8	90.6	First year: 1972; non-agricultural activities
Netherlands	42.8	41.3	96.5	40.7	40.0	98.3	First year: 1972; non-agricultural activities
Switzerland	45.8	43.6	95.2	44.6	42.6	95.5	First year: 1973; non-agricultural activities
United Kingdom	45.7	37.9	82.9	43.0	37.7	87.7	
United States				43.9	40.3	91.8	Second year: 1980

Sources: ILO Yearbook of Labour Statistics; Eurostat, Labour Force Sample Surveys, 1973 and 1979; National statistics.

In most OECD countries for which information is available, the difference in weekly hours worked by male and female full-time workers has tended to decline in the last decade (see Table III.2). Comparing the periods 1970 and 1981, the hours of work per week for male and female full-time workers have in general declined, though male hours per week have declined in greater absolute terms compared to female hours. Thus, the ratio of female to male hours of work per week has risen slightly in all countries listed in Table 2 with the exception of Ireland, Italy and Japan, which obviously contributed to a small extent to the narrowing of earnings differentials on a weekly or yearly basis.

A comparison of differences in hourly, weekly, monthly or yearly earnings suggests that women's pay disadvantage increases with the time unit considered. Table III.3 illustrates this for four countries where comparable series are readily available. This conclusion is especially evident in the United Kingdom where the differences in average hours worked by men and women are larger than in most other countries since men in the United Kingdom accrue a considerable amount of overtime[19]. It is perhaps hardly surprising that women's pay disadvantage is smaller on an hourly basis than on a weekly or yearly basis because, as was noted in Chapter I, more women work part-time and even when this is not the case, their hours of work tend to be shorter than those of full-time men.

A 1980 United Kingdom study[20] which examines the 1970 Equal Pay Act concludes that although legislation has been successful in equalising basic rates of pay in broadly comparable jobs, additional payments for shift-working, overtime, length of service and responsibility are causing differentials in total weekly earnings between men and women. Female versus male rates of job turnover and absenteeism are also frequently cited as explanatory factors concerning male-female earnings differentials. Results of studies, however, vary widely across countries and according to considerations of age, education (and other worker characteristics), job characteristics, and an examination of employer and statistical bias in counting turnover. Given this, general conclusion should be avoided without an examination of the specific context.

The question may be asked to what extent the simultaneous increase in female employment and relative pay was due to the fast rise in female part-time work[21], for in some of

Table III.3. **Hourly and weekly women's earnings as a percentage of men's in four OECD countries**

		1970	1973	1975	1979	1980	1981
Australia	H	65.2	76.5	83.7	85.8	86.0	86.2
	W	59.1	70.4	77.4	80.6	80.8	80.1
Germany	H	69.2	70.3	72.3	72.6	72.4	72.5
	W	62.7	64.9	67.2	68.3	68.5	68.8
Netherlands	H	70.8	72.4	74.3	77.9	78.2	77.4
	W	68.4	70.4	73.3	77.2	77.8	76.8
United Kingdom	H	60.1	62.5	67.6	70.7	69.7	69.5
	W	49.9	51.7	57.4	60.1	60.8	60.9

NOTES

Australia : Adult, full-time wage- and salary-earners, excluding managerial staff. Excluding agricultural and domestic services.
Germany : Wage-earners, including foremen, but excluding apprentices. Mining, manufacturing and construction.
Netherlands : Adult, full-time wage- and salary-earners in non-agricultural activities.
United Kingdom: Adult, full-time wage-earners. Excluding coal mining, commerce and ISIC major division 8. October.
Source: Communication of ILO Bureau of Statistics.

the countries where relative female pay levels had a fast rising trend, such as Australia, the United Kingdom and the Scandinavian countries, part-time work was also rapidly increasing. However, even when part-time employment is taken into account by using "full-time equivalents" for example, female employment appears to have grown considerably. Hence, the recent growth of part-time work does not seem fundamentally to alter the relationship between the growth of female employment and relative earnings discussed earlier.

Table III.4, for the year 1979 or 1980, indicates that in five OECD countries, women in part-time jobs work on average longer hours per week than men. They also, therefore, earn a higher proportion of male pay than they do on a full-time basis. In Australia, for example, women's weekly part-time earnings exceed those of men although on an hourly basis they are lower. Female-male pay ratios as shown in Table III.5 are generally higher than those appearing in tables referring to full-time workers. The main reason for this is that the high-status, high-pay jobs which push up male average earnings as compared to female earnings are rarely performed on a part-time basis. However, since the statistical base for the

Table III.4. **Average weekly hours worked by part-time workers in five OECD countries**

	Year	Male	Female
Australia	1980	14.2	16.8
Canada	1980	14.5	15.6
Germany	1979	21.5	21.6
Denmark	1979	15.8	21.8
United Kingdom	1980	18.3	20.0

Sources: National statistics. Eurostat, *Labour Force Sample Survey,* 1979.

Table III.5. **Earnings of part-time workers as a percentage of those of full-time workers in selected countries, by sex**

	Year	M	F	Notes
Australia	1980	104.5	107.1	Average hourly earnings of adult wage- and salary-earners excluding agricultural and domestic service.
France	1974	98.0	84.0	Estimated hourly earnings of employees in wholesale and retail trade, banking and insurance.
Sweden	1981	100.1	102.8	Hourly earnings of shop assistants.
		93.3	97.3	Earnings of office staff in trade sector.
United Kingdom	1980	81.9	81.2	Hourly earnings of adult workers *of which:*
			90.3	manual (excluding overtime)
			82.9	non-manual.
United States	1980	72.3	85.6	Estimated hourly earnings of year-round full-time and part-time workers.

Sources: National statistics. D. Baroin, "Le Travail à Temps Partiel en France", in J.P. Jallade, ed., *L'Europe à Temps Partiel,* Economica, Paris, 1982.

earnings data differs between countries, inter-country comparisons must be approached with a great deal of caution. Furthermore, the extent to which many women are involved in involuntary part-time work is another factor contributing to women's lower earnings as compared to men.

The situation also varies according to sector. In retail trade in the EEC, part-time women workers frequently earn more than part-time men workers. In the banking and insurance areas, women earn more in Germany and Denmark; but in France and the United Kingdom part-time women workers in the insurance sector have a greater earnings gap than full-time women. This disparity in earnings is likely to reflect differences in the organisational structure of the sector in question; for example, most part-time women workers are in segregated jobs that do not afford an easy comparison with jobs performed by men[22]. This limits the validity of any such inquiry unless an occupational breakdown is also available.

An additional point of interest is that in Australia hourly earnings of part-time workers – male and female – are higher than those of full-time workers as Table 5 indicates. In other countries, however, the hourly pay of part-time workers is lower than that of full-time workers. This is partly due to compositional factors: part-time jobs tend to require workers with lower average training, levels of skill, occupational status, weaker labour force attachment and so on, and hence lower hourly pay[23].

Age and Experience

As national data differ widely in coverage in this area, precise inter-country comparisons are difficult. In general, however, it can be concluded that pay tends to increase with age, but that women's pay increases much less than that of men. Furthermore, the younger age structure of the female labour force in most countries affects their average earnings since younger workers are less likely to be employed in higher-paid positions. Men earn more than women in every age group in general and the earnings gap increases with age. However, the overall male-female pay differential is greater than the average differentials at particular ages. Below the age of 20, male and female earnings are relatively close in all countries. Later on, especially after the age of 25 or 30, the gap starts to widen dramatically. *Relative* female earnings may either decline continuously with age, as in the case of France for 1975, or they may reach a minimum at a point in mid-age corresponding to the peak of male earnings, reached usually between 40-49. After that, the gap again tends to narrow as average male earnings decline faster than female earnings.

The significance of the age distribution factor varies from country to country and over time. For example, in the United States and Australia it is very small. In other countries listed in Table III.6 it is situated between eight and ten percentage points. In the five countries for which information is available, the influence of the age distribution factor on women's pay differentials has declined in recent years. This seems to be in line with the changing age pattern of female labour force participation recently observed in the OECD countries. In the extreme age groups (15-19 and 55+), labour force participation has declined due to rising education and early retirement. In the middle age group (25-49), female labour force participation has increased quite rapidly in some countries, though in Australia this is not the case[24]. Hence, the concentration of women workers in the youngest age groups was considerably reduced. The distribution of women workers in prime-age groups has become more even. Hence, the decrease in importance of the age distribution factor for female earnings differentials, as shown by Table 6.

The rise in the average age of women workers has meant a rise in the average length of their working careers. Women tend increasingly to establish their careers in early working life

Table III.6. Changes in relative female earnings by age group

AUSTRALIA
Weekly earnings of all full-time workers

Age group	(Ef/Em) × 100		Percentage rate of change
	1977	1979	1977-1979
15-19	92.5	91.9	−0.6
20-24	91.0	90.2	−0.9
25-29	82.0	87.8	1.3 (est.)
30-34		78.4	
35-39	74.0	70.8	−2.8 (est.)
40-44		73.1	
45-49	72.7	76.3	3.5 (est.)
50-54		74.2	
55-59	76.6	79.0	3.1
60+	73.1	85.7	17.2
Total (weighted average)	76.6	77.3	0.9
Unweighted average	80.3	80.7	0.5
Difference of averages	3.7	3.4	0.4

FRANCE
Net yearly earnings of full-time workers in private and semi-public sectors

Age group		Percentage rate of change
		1975
−18		119.6
18-20		94.6
21-25		84.4
26-30		78.7
31-40		69.9
41-50		65.0
51-60		63.0
61-65		59.4
65+		53.6
Total (weighted average)		68.4
Unweighted average		76.5
Difference of averages		8.1

more firmly than has previously been the case. In all countries, however, women's working career has remained shorter than men's, and this is an important factor in the wage gap between the sexes in certain jobs.

There are several ways to consider "length of experience". In the United States, for example, data based on the length of occupational tenure have recently become available. They refer to the number of years spent in a given occupation, net of any time spent in another

Table III.6 *(Cont.).* **Changes in relative female earnings by age group**

NORWAY

Average monthly earnings of full-time office employees
(Establishments affiliated to the Norwegian Employers' Confederation)

Age group	(Ef/Em) × 100		Percentage rate of change
	1970	1981	1970-1981
18-19	93.0	94.6	1.7
20-24	84.3	88.9	5.5
25-29	76.7	80.9	5.5
30-34	} 64.3	71.9	} 7.5 (est.)
35-39		66.3	
40-49	61.1	63.3	3.6
50-59	64.8	65.9	1.7
60-66	68.6[a]	70.6	2.9
Total (weighted average)	60.4	65.0	7.6
Unweighted average	73.3	75.3	2.7
Difference of averages	12.9	10.3	4.9

a) 66-69.

SWEDEN

Average monthly earnings of full-time employees in industry
(ISIC 2+3)

Age group	(Ef/Em) × 100		Percentage rate of change
	1974	1980	1974-1980
18-19	98.9	99.7	0.8
20-24	83.5	89.4	7.1
25-29	78.9	85.2	8.0
30-34	72.4	80.3	10.9
35-39	67.3	75.0	11.4
40-49	65.0	71.8	10.5
50-59	67.6	72.0	6.5
60-64	70.2	73.1	4.1
Total (weighted average)	63.6	71.4	12.3
Unweighted average	75.5	80.8	7.0
Difference of averages	11.9	9.4	5.3

occupation or out of work[25]. Conclusions drawn from these data indicate that female earnings gain slightly more than those of males with tenure, which means that the male-female earnings gap tends to close somewhat with an increase in the number of years in the same occupation. Since women's average length of tenure is however shorter than men's, this tends to have an adverse affect on the average level of female relative pay. In the United States, 4 per cent of the earnings gap is accounted for by sex differences in the distribution of occupational tenure[26].

Table III.6 *(Cont.)*. **Changes in relative female earnings by age group**

UNITED KINGDOM

Average weekly earnings of all adult full-time workers

Age group	(Ef/Em) × 100		Percentage rate of change
	1974	1980	1974-1980
·—18	86.3	93.0	7.8
18-20	72.5	79.1	9.1
21-24	67.1	75.0	11.8
25-29	63.0	72.8	15.6
30-39	56.4	65.9	16.8
40-49	54.6	62.4	14.3
50-59	59.0	64.9	10.0
60-64	63.5	67.9	6.9
Total (weighted average)	57.2	64.6	12.9
Unweighted average	65.3	72.6	11.2
Difference of averages	8.1	8.0	6.7

UNITED STATES

Average earnings of year-round full-time workers

Age group	(Ef/Em) × 100		Percentage rate of change
	1975	1980	1975-1980
18-24	75.9	75.5	−0.5
25-29	69.4	73.3	5.6
30-34	61.3	65.1	6.2
35-39	52.0	57.0	9.6
40-44	51.8	53.5	3.3
45-49	50.7	50.9	0.4
50-54	54.4	53.2	−2.2
55-59	54.2	52.6	−3.0
60-64	56.2	59.0	5.0
65+	55.9	57.2	2.3
Total (weighted average)	56.5	58.6	3.7
Unweighted average	58.2	59.7	2.6
Difference of averages	1.7	1.1	1.1

Source: National statistics.

In the EEC countries, data exist according to length of service in the same company or organisation, by sector[27]. According to this information, which is now somewhat dated, the effect of job tenure on relative female pay is considerably smaller than the effect of age distribution.

In contrast to the age factor which increases the earnings gap at least in the first half of working life, length of tenure tends to close the gap in most countries and within most sectors. The extent to which the narrowing of the earnings gap is due to a weighting effect, i.e. to the

likelihood for better qualified women to stay on and for the less qualified ones to have a higher turnover, would require further investigation.

In all European countries, the impact of job tenure on relative female earnings is bigger in banking and insurance than in the trade sector. This could be expected, since banking and insurance are likely to offer better prospects of promotion, at least to women with a certain level of qualification, than the retail sales sector.

Other Factors Contributing to Earnings Differentials

The relationship between education and earnings has received more attention than any other, especially in the human capital literature. The argument is made that women have lower earnings because of their limited investment in human capital, i.e., education. Research, in general, indicates that differences in education between women and men do little or only go part of the way to explain the earnings gap, and casts doubt on the assumptions underlying human capital theory[28].

It may be fruitful to consider different types of education and how these translate into different amounts of income. Data on work experience may also offer a more promising explanation of differences in earnings. It should be added, however, that at least in the United States and Canada, returns on experience are generally lower for women than for men. Given this, researchers and policy-makers have turned to an examination of occupational and job segregation using the hypothesis that women are disproportionately concentrated in low-paying jobs as discussed in Chapter II. This in turn has led to an analysis of the institutional features of labour markets (internal labour markets, for example); Chapter I has already touched upon some of these questions[29]. Because of the voluminous literature in this area and its insufficiency to explain earnings gaps, this question will not be further considered in this chapter.

Empirical evidence shows that the level of relative female earnings is closely associated with the size of the public sector in different countries. A recent OECD study has found the size of the public sector to be closely and positively associated with the share of women in its workforce[30]. It also appears that the growth of relative female pay in the last decade was closely related to the size of women's share in public sector employment and the high rise of relative female pay levels[31]. In the public sector, women's pay disadvantage is generally much smaller than in the private sector, and overall gender earnings differentials are therefore smaller. In the United States, a 1976 study reveals that women in the federal service received 33-55 per cent more than women employed in the private sector[32].

The higher level of relative female pay in the public sector may be partly due to differences in occupational structure, according to the above-cited American study. It is also due to a stricter application of the letter and the spirit of equal pay legislation by public authorities.

The relative level of women's pay varies considerably between sectors in all countries for which information is available. As indicated in Table III.7, relative female earnings in six sectors range from the mid-40 per cent point to the mid-80 per cent point. Their lowest earnings in comparison to men's tend to be concentrated in manufacturing and wholesale trade and their highest relative earnings in government service. The reasons why women fare relatively better in some sectors than others seem to be due to factors other than sectoral characteristics, for the ranking of sectors with respect to relative female pay levels differs widely across countries and no sector emerges as having systematically narrower differentials of male and female earnings except the public sector. Nevertheless, it appears from Table 7

that in the four branches of the service sector which are listed, women tend to have higher relative earnings than in manufacturing. In the United States, however, relative female earnings are higher in manufacturing than they are in the service sector, but United States earnings data differ from those of other countries (except Australia) since United States statistics refer to all workers, not just to non-manual workers.

In the countries where sectoral earnings data for non-manual workers are available on a regular basis, relative female pay has increased in recent years in all six sectors listed in Table III.7. A notable exception was "Banking, Insurance and Real Estate" in the United States, a sector which employs many women. Data collected by the OECD indicate that between 1975 and 1980 relative female pay also declined in the sector of "Personal Services", another large employer of women. The decline in these two sectors highlights the virtual stagnation of overall female relative earnings in the last decade. It also leads to the intriguing question of why, once again, the United States differs from Europe in its labour market behaviour. One explanation may be that as more women entered the labour market, these two sectors needed labour, particularly in the low occupational grades. The "crowding" of women into these activities, and the ensuing increased competition, led to a decline in women's relative pay[33]. Furthermore, these sectors, in comparison to the same sectors in Europe, are not highly unionised nor do they offer much job security.

Rather than focusing on changes in the distribution of female labour across sectors, Zabalza and Tzannatos have shown, in their recent study on equal pay in Britain, that the increase of relative female earnings within sectors was a much more important factor contributing to rising relative female pay in the last ten years[34].

In the manufacturing sector, women are predominantly employed in the lower-paying industries. This is the situation in all OECD countries for which information is available, although the importance of the employment distribution factor varies from country to country.

Unlike female employment prospects in the service sector, female manufacturing employment has followed a generally declining trend in recent years in most countries; the more even distribution of the female workforce between branches is likely to reflect widespread job suppression in low-paying industries such as textiles and clothing. Increases in minimum wages also played a role by narrowing male-female pay differentials within branches. The respective importance of these two factors would require further investigation as would the impact of changes in intersectoral pay differentials.

The OECD study of earnings statistics referred to above has concluded that a significant negative correlation exists between the percentage of women in total employment in individual manufacturing industry groups, and the level of branch earnings in relation to the manufacturing average. This general pattern is remarkably similar in different countries, perhaps because the ranking of manufacturing group by level of earnings follows a largely common pattern in all OECD countries. Five branches are almost always at the top of the list: oil processing, the iron and steel industries, the automobile industry, the chemical industry, and printing and publishing. All of these, with the exception of printing and publishing, employ few women. Conversely, the four lowest ranking industry groups with respect to earnings are invariably clothing, footwear, leather and textiles, all of which are characterised by a large concentration of female labour. Hence, in spite of some changes, there seems to be considerable inertia with regard to sex roles in manufacturing and the relative pay levels in different branches.

There are also inter-country differences in the dispersion of earnings in manufacturing industry groups. The dispersion is high, for example, in the United States, while it is relatively low in Sweden.

Table III.7. Earnings of full-time female employees as percentage of male employees' in OECD countries, in six sectors

	Pay period (1)	Year (2)	Manufac- turing (3)	Wholesale trade (4)	Retail trade (5)	Banking (6)	Insurance (7)	Govt. service (8)
Australia	Week	1970	57.4	67.2	68.6	65.0	—	
		1980	71.1	73.7	79.6	70.4	77.7	
Austria	Month	1981		69.5				83.9
Belgium	Month	1974	60.5	65.0	71.1	71.2	68.4	—
Denmark	Month	1974	63.9	71.2	72.6	70.0	63.1	—
		1981	70.8	—	—	—	—	—
Finland	Month	1970	58.3	57.3	70.0	75.7	58.0	72.0
		1980	73.8	68.3	79.3	76.0	64.6	74.0
France	Month	1974	58.0	66.6	66.1	71.8	67.6	—
		1978	61.7	69.7	67.5	74.5	66.1	83.9
Germany	Month	1971	63.5	67.0	60.1	71.6	73.9	—
		1981	66.4	68.3	64.9	77.4	76.5	—
Ireland	Month	1974	—	56.4	58.5	61.7	58.9	—
Italy	Month	1974	61.9	79.0	85.8	79.5	71.1	—
Luxembourg	Month	1974	54.0	58.7	56.3	62.4	54.4	—
Netherlands	Month	1974	51.1	61.1	61.2	56.6	60.4	—
Norway	Month	1970	55.1	61.3	69.9	71.8	59.1	75.5
		1981	65.0	70.3	80.6	76.3	64.5	83.1
Sweden	Month	1970	58.6	60.9	80.3	84.6	82.4	—
		1981	72.1	72.3	92.2	92.5	86.1	88.3
Switzerland	Month	1970	61.8	71.6	63.4	71.7	70.4	—
		1980	66.4	74.7	63.0	78.2	72.6	78.8
United Kingdom	Week	1971	44.3	44.2	47.1	46.0	56.7	
		1980	53.2	54.1	56.1	49.9	60.9	
United States	Year	1970	59.4	51.0	52.5	50.5	64.8	
		1980	61.4	56.1	60.0	45.5	65.4	

NOTES

Australia : All adult workers and employees. Data in columns (6-7) and (8) refer to Finance and Business services, and to Public Administration and Community services, respectively. Data for 1970 exclude managerial staff. October of each year.

Austria : Data in column (4) refer to all private employees and data in column (8) to all civil servants.

Belgium : Data in column (3) refer to Industry in 1972.

Denmark : Column (3): average earnings of salaried employees employed by the Danish Employers' Confederation (largely manufacturing), in 1975 and 1981.

Finland : Column (3): office staff in industrial establishments. Columns (4) and (5): office staff and sales personnel, respectively, in entire trade sector (wholesale and retail).

France : Column (3): Total Industry, in 1972 and 1978. Column (8): "salaires des agents de l'Etat" (annual).

Germany : Column (3): Industry.

Italy : Column (3): Industry, 1972.

Luxembourg : Column (3): Industry, 1972.

Netherlands : Column (3): Industry, 1972.

Norway : Column (3): office employees in manufacturing and mining, in 1972 and 1981. Columns (4) and (5): office employees and shop personnel respectively in the entire trade sector. Columns (6) and (7) refer to Commercial and Savings Banks and to Insurance Companies in 1975 and 1982. Column (8): Central Government Employment, in 1973 and 1981.

Sweden : Columns (4) and (5): clerical employees and shop personnel respectively in the entire trade sector. Column (6): intermediate staff in Savings Banks. Column (7): "staff with responsibilities" in Insurance Companies. Column (8): State employees in 1980.

Switzerland : Average monthly salaries of employees. Column (8): Public Administration.

United Kingdom: Adult non-manual workers. Columns (6-7): Insurance, Banking, Finance and Business services.

United States : Average money earnings of all year-round full-time workers. Column (3): clerical and sales workers in manufacturing. Columns (6-7): Finance, Insurance and Real Estate.

SOURCES

Australia : Australian Bureau of Statistics, *Weekly Earnings of Employees*, Canberra, 1970, 1980.

Austria : Data communicated by the Austrian Delegation to OECD Working Party No. 6 on the Role of Women in the Economy (national statistics).

Benelux, Ireland, Italy	:	Eurostat, *The Structure of Earnings in Industry, 1972; The Structure of Earnings in Distribution, Banking and Insurance, 1974.*
Denmark	:	*Statistical Yearbook* of Denmark.
Finland	:	*Statistical Yearbook* of Finland. *Monthly Statistical Bulletin* of Finland.
France	:	Les Collections de l'INSEE, Nos. 90-91 and 98, 1981, série M; E. Vlassenko, *La Structure des Salaires dans l'Industrie et les Services en 1978;* Dominique Quarre et Alain Minczeles, *Les Salaires des Agents de l'Etat en 1978.*
Germany	:	Statistisches Bundesamt Wiesbaden, *Löhne und Gehälter,* Fachserie 16, Reihe 2.2, *Angestelltenverdienste in Industrie und Handel.*
Norway	:	Norges Offisielle Statistikk, Central Bureau of Statistics, *Wage Statistics,* 1970 and 1981.
Sweden	:	National Central Bureau of Statistics, *Arbetsmarknads-statistisk Arsbok,* various issues; *Löner,* various issues.
Switzerland	:	*Statistical Yearbook* of Switzerland.
United Kingdom:		Department of Employment, *New Earnings Survey,* 1971 and 1980.
United States	:	U.S. Bureau of the Census, Current Population Survey, *Money Income of Households, Families and Persons in the United States,* 1970 and 1980.

Inter-industry pay differentials have, however, experienced a decline in recent years, at least in Europe. As has been pointed out by D. Marsden, some of the high-pay industries which employ mostly men, such as the automobile industry, have been among the casualties of the oil crisis[35]. Another reason why inter-industry pay differentials declined was that in the lowest paid industry groups (clothing, footwear, leather, textiles), the relative earnings level tended to come closer to the industrial average, reflecting, among other factors, the effect of minimum wage legislation.

An exception is printing and publishing where earnings have been among the five highest in most countries, reflecting, among other things, the bargaining power of unions in this industry. Yet, the share of women in employment has been generally well above the manufacturing average, displaying a tendency to rise. Exceptions to this are the United States and Germany where the share of female employment in printing and publishing has been associated with a decline in relative earnings in this industry.

The case of printing and publishing is interesting to note since female employment in this industry is everywhere above the manufacturing average as are total earnings. It reveals that it is beneficial for women to work in industries with "mixed" employment, where earnings are higher than in industries employing mostly women.

The occupational distribution of women workers is a factor that is generally of greater importance for the level of female earnings than is industrial distribution. The majority of working women are employed in low-status jobs – "vertical occupational segregation" – and concentrated in a small number of occupations with a high proportion of female workers – "horizontal occupational segregation". This occupational segregation is discussed at length in Chapter II.

For the EEC countries, it appears that in the wholesale and retail trade sectors, the effect of vertical job segregation is generally less than in banking and insurance. In the last two sectors, women's access to higher occupational grades is likely to be relatively more difficult, and pay dispersion within the sectors is likely to be wider. The effect of vertical occupational segregation on overall relative female pay levels varies from country to country. It is moderate in the Netherlands and much higher in France and the United Kingdom. To what extent the country differences are due to occupational classification factors, or to male-female pay differentials within individual grades, would require further investigation.

In countries that provide information on male and female earnings in a detailed occupational breakdown, it appears that pay differentials within individual occupations may be much smaller than those indicated by national aggregate data. The narrower the definition of occupations, the smaller the earnings gap.

85

For countries such as the United States and the United Kingdom, where studies have been carried out, a positive relationship has been established between the employment share of women in different occupations and relative female pay levels. In occupations where women form a large majority, their earnings gap is generally smaller than in occupations where employment is predominantly male[36]; however, in occupations where women predominate, total average earnings, for both men and women, tend to be low in comparison with occupations performed mostly by men.

The literature which delves into the causes of job segregation has offered several explanations. These can be grouped into three broad categories: first, women are excluded from high-paying jobs for worker-related or job-related reasons; second, women take, for a variety of reasons, jobs which do not pay well; third, the jobs that women hold are mostly underpaid because they are held by women, i.e. the same work would receive a higher wage if performed by men[37].

The question of job segregation, and particularly the first two of these three dimensions of it, have been discussed at length in Chapter II. In the context of the present chapter, the third aspect requires further mention.

The possibility that women's work is underpaid because women do it is one for which there is as yet little direct but much indirect evidence[38]. In addition, women's jobs are generally not carefully assessed and graded according to skill, but paid more or less automatically, at low wages. A major reason for this, according to the authors of a British study, is that women can in practice be recruited at lower wage levels than prime-age males. Hence, the low status of "female" jobs is linked to differences in male and female labour supply and to the intra-family division of labour, these factors being reinforced by women's relative lack of opportunities in the labour market[39].

While the "feminisation" of a job means loss of status and a gradual decline in pay in relation to other sectors, women tend to obtain relatively high pay when they are employed in jobs in which male workers still form a large majority. This is even more likely to happen if they are employed in the same firm because the pattern of sex segregation changes from one establishment to another. However, it appears that women employed in the same jobs as men within the same firm are few. A study of job segregation and related company policy carried out in the United Kingdom in 1979 showed that two-thirds of all jobs were single-sex at the establishment level. It confirmed that all-male jobs tended to be in the higher-paid grades, while all-female jobs were mostly concentrated in the lower grades of both white-collar and blue-collar work[40]. This type of analysis, which is carried out at the company/firm level, is important since it is at this level that work is organised, that tasks are translated into jobs, jobs are graded, and pay differentials are set.

That this segregation of the labour market is to most firms' advantage has been well documented[41]. The segregation of men's and women's jobs provides a category of lower-paid workers which reduces the firm's wage bill. At the same time, it is in most part not against the letter of the existing laws. Men's and women's jobs also tend to be structured differently. Men's jobs are structured in such a way as to encourage productivity (thereby discouraging turnover) and by offering training and experience they become characterised by relatively long promotion ladders. Women's jobs tend to be structured in such a way as to minimise the cost of turnover, although providing fewer advancement possibilities, even with rising seniority and experience. Hence, education, seniority and experience receive different wage rewards in the primary and secondary segments of the labour market[42].

From the evidence examined in this chapter and in Chapter II, it can be concluded that occupational segregation and the system of labour market operation by which women tend to be assigned to lower-level jobs are two primary factors contributing to male-female earnings differentials.

4. CONCLUSIONS AND POLICY DIRECTIONS

The findings outlined in this chapter reveal that in OECD countries women still earn, on average, about 20-40 per cent less than men. Their earnings differentials have narrowed in recent years but they remain substantial. Differentials vary across countries, according to type of employment, industrial sectors and occupations. A major difficulty of making earnings comparisons across countries is that national data tend to use different concepts and that they vary widely in their coverage and periodicity, for example. Hence, precise country differences have been difficult to establish. The chapter presented a factor-by-factor approach which is more easily adaptable to variations in data.

The cross-country survey revealed that in jobs with low earnings and low skills for manual and part-time workers, there exists little difference in remuneration between women and men. But, due to segregation, comparisons in certain sectors are virtually impossible.

An attempt was made to isolate a series of factors – institutional, economic, and compositional and distributional – in order to point to the main causes of male-female earnings differentials and to look at recent changes.

Institutional Factors

Equal pay policies pursued by most countries during the 1970s have had an impact on relative female pay levels and their often fast rise in recent years. However, the effects are limited by segregated labour markets, where women are receiving different pay, relative to men.

Economic Factors

In a few countries, the effects of the recession led to a stagnation or decline of relative female pay, but in most countries relative female earnings continued to grow, especially after the post-1973 period, regardless of cyclical fluctuations. However, the aggregate data make it impossible to analyse the extent to which cyclical effects may have been compensated by other factors.

Compositional and Distributional Factors

Women work much more on a part-time basis, as Chapter I revealed, and even when they work on a full-time basis they work shorter hours than men because of the type of job they are in, and because men work more overtime. Relative female pay is thus reduced. Policies that deal with part-time work will have to examine rates of pay and why a person takes part-time employment if it is to be determined whether part-time workers' lower wages are a reflection of the labour-intensive jobs with a lower rate of productivity or a lack of their bargaining power in the marketplace.

The age structure of the male and female labour force is another important factor. Both women and men have different earnings patterns at various stages of their career. Broadly speaking, pay tends to increase with age, at least initially, but women's pay increases much less than men's pay, and female workers are more concentrated at the young end of the age spectrum where earnings for both sexes are low. Women's working career and average length of experience tend to be shorter than men's, although differences between the average number of years worked by men and women in their lifetime have been declining. They also have less opportunity to be promoted and thus to progress in the salary scale.

87

The distribution of women workers between the public and the private sectors also affects relative female pay levels. The higher the share of the public sector in female employment, the higher their total relative earnings; and the faster the growth in female public sector employment, the faster the rise in total relative female earnings.

The most important distributional aspect of male-female pay differentials was the widely different occupational composition of the female and male labour force. Women's concentration in low-wage occupations is by far the most important factor explaining their low wages. While much emphasis is usually placed on policies designed to alter the effect of occupational distribution on wage differentials, occupational differentiation might be a lesser concern if there were not such large pay differences between occupations. A recent Canadian study in this area supports this focus and adds that "pay rates in occupations reflect not only their demands, responsibilities and required training, but also the relative power of various occupational groups. Furthermore, the rewards for different levels of skill and training are also politically determined"[43]. More specifically, the study concluded that in 1981, women earned an average of $8 700 less than men. This gap could be further reduced to an amount of $2 800 if one abstracts the following factors: education and experience (skill) ($1 600); work on a part-time and full-time basis ($900); public and private sector unionisation ($1 000); branch of activity and occupational grouping ($4 600); responsibilities attached to job ($1 000). The study concludes that policies directed towards the equalisation of pay rates of occupations would not only assist the labour market position of women but also that of disadvantaged minorities in society.

The findings keep pointing to the process whereby women's pay and employment position are determined. A next step would be to look at both the formal and informal payment systems, especially in the small firm sector which may not be covered by equal pay legislation and which may also fall outside of the scope of collective bargaining agreements. In addition, there may not be a written procedure by which workers are paid or graded within small firms. Studies of this nature are few in number[44]. A recent U.K. study of six industries with a substantial number of small firms and establishments has concluded that the jobs in which women are employed tend to be low-paid and of low status whatever the content of the job or the skills and experience of the female employees may be. It found that the main reason why the employment of women has an independent effect in lowering the pay and status of the job is that they can in practice be recruited at lower wage levels than prime-age males. Such differences in labour supply are attributed to the social and family system and limited opportunities in the labour market.

Such studies show the operation of internal labour markets to be an important mechanism contributing to sex and race differentials.

While external labour markets do influence the allocation of labour and the determination of wages (fixing minimum wages for instance), firms in reality have developed their own pay systems, as has been well documented for the United States, Canada and the United Kingdom[45]. Women, however, do not fully participate in wage negotiations and collective bargaining[46].

Agarwal has defined an equitable pay system as one in which jobs are paid for in proportion to their relative value[47]. If a firm wishes to establish such a system, it requires a job evaluation process which measures not only the value of individual jobs but can also make comparisons among values. Using such a measure, one is able to determine the relative positions of jobs within the organisational hierarchy, thereby establishing a reliable base upon which wages can be founded.

Agarwal[48] outlines several steps that are involved in the establishment of a job evaluation system. Initially, detailed information about the jobs needs to be collected. Second, the

compensable factors (job-related contributions recognised and rewarded by the organisation) on which the determination of relative job values is to be based need to be established. Agarwal develops a series of characteristics for compensable factors that will make them a suitable basis for job comparisons. Finally, a hierarchy of jobs must be established based on the compensable factors selected. But job evaluation and classification are rather complex.

The establishment of such a job evaluation scheme may or may not produce an equitable pay structure – this will depend entirely upon how the scheme is developed and administered. On the other hand, pay inequities do seem highly probable in the absence of such a job evaluation scheme within an organisation. Notwithstanding these observations, some countries may wish to focus more of their energies on women's collective bargaining power and the impact this has had on their wage levels. This approach will vary across countries, depending, for example, on the extent of unionisation and types of wage setting systems within a country.

Finally, it must be noted that the goal of equal wages is dependent on the success of all other equal opportunity policies, with measures relating to the desegregation of the labour market being central to this problem.

NOTES AND REFERENCES

1. Harish C. Jain and Peter J. Sloane, *Equal Employment Issues: Race and Sex Discrimination in the United States, Canada and Britain,* Praeger Publishers, New York, 1981, p. 26.

2. UN ECE, *The Economic Role of Women in the ECE Region,* New York, 1980.

3. OECD, *Women and Employment,* Paris, 1980, p. 30.

4. For a survey of policies aimed at reducing differences between men's and women's labour market experiences, see OECD, *Women and Employment op. cit.,* Section 8 and Annex II.

5. A. Zabalza and Z. Tzannatos, *Have Women in Britain Benefited from Equal Pay?* Report to the Equal Opportunities Commission, February 1983.

6. Naresh C. Agarwal, "Pay Discrimination: Evidence, Policies, and Issues", in Jain & Sloane, *op. cit.* in note 1, p. 139.

7. A. Cook, "Equal Pay: Where is it?", *Industrial Relations,* Vol. 14, No. 2, May 1975.

8. N. Agarwal, "Male-Female Pay Inequity and Public Policy in Canada and the United States", *Relations Industrielles,* Université Laval, No. 4, 1982.

9. See, for example, *Journal Officiel des Communautés Européennes,* 26.7 1974, no. C 88.7, Consultation du Comité Economique et Social; or the rulings of the Court of Justice of the European Communities.

10. Commission of European Communities; doc. V/660/80, Brussels, 10 March 1981, *Indirect Discrimination by the Use of Job Classification Systems.*

11. U.S. Department of Labor, Women's Bureau, *Equal Employment Opportunity for Women: U.S. Policies,* report to the OECD Working Party No. 6 on the Role of Women in the Economy, 1982. See also Treiman and Hartmann (in note 17).

12. R.S. Ratner, *Equal Employment Policy for Women,* Temple University Press, Philadelphia, 1980.

13. For a more detailed evaluation of women's labour force participation in recent years, see L. Paukert, *The Employment and Unemployment of Women in OECD Countries*, OECD, Paris, 1984.

14. M.L. Wachter, "Cyclical Variation in the Inter-industry Wage Structure", *American Economic Review*, January 1970. C. Hakim, "Job Segregation: Trends in the 1970s", *Employment Gazette*, U.K. Department of Employment, December 1981.

15. A. Zabalza, *op. cit.* in note 5.

16. See, for example, R.M. Greve and G. Frank, *Women, Work and Society: A Selected Bibliography, 1970-1978*, International Institute for Labour Studies, Geneva, 1980; Naresh Agarwal, *op. cit.* in notes 1 and 6.

17. For a further critical reappraisal of human capital studies see Donald J. Treiman and Heidi J. Hartmann (eds.), *Women, Work, and Wages: Equal Pay for Jobs of Equal Value*, National Research Council, National Academy Press, Washington, D.C., 1981, Chapter 2.

18. *OECD Employment Outlook*, Paris, 1983, p. 34.

19. In 1980, an average male manual worker accrued 5.7 overtime hours per week as compared to the 1.1 overtime hours gained by the average female manual worker. Department of Employment, *New Earnings Survey*, London, 1980.

20. A. McIntosh, "Women at Work: a Survey of Employers", *Department of Employment Gazette*, London, November 1980.

21. See Chapter I for a discussion on part-time work, and *OECD Employment Outlook, op. cit.*, Chapter IV.

22. A. Zabalza, *op. cit.* in note 5.

23. *OECD Employment Outlook, op. cit.*, p. 51

24. Women's Bureau, Department of Employment and Industrial Relations, Canberra, Information Paper No. 1 (1983), Information Paper No. 2 (1984).

25. U.S. Bureau of the Census, *Current Population Surveys, Supplement*, January 1981.

26. N. Rytina, "Tenure as a Factor in the Male-Female Earnings Gap", *Monthly Labor Review*, April 1968.

27. The four sectors are: wholesale trade, retail trade, banking, insurance.

28. Treiman and Hartmann, *op. cit.* in note 17, review studies pertaining to the United States.

29. For further reference, see the following: R.G. Gregory and R.C. Duncan, "Segmented Labour Market, Theories and the Australian Experience of Equal Pay for Women", *Journal of Post-Keynesian Economics*, No. 3, Spring 1981; D.T. Jamison, A. Berry and M.J. Bowman, *Education and Income*, World Bank Staff Working Papers, Washington D.C., 1980; Richard Pohl, Jeanine Soleilhavoup et Joëlle Ben Rezique, *Formation, Mobilité Sociale, Salaires*, Enquête Formation Qualification Professionnelle de 1977, Paris, 1983. Collection INSEE, Série D.

30. OECD, *Employment in the Public Sector*, Paris, 1982.

31. *Ibid*, Table 7.

32. Quoting L. Thurow, "The Indirect Incidence of Government Expenditure", *American Economic Review* (Papers and Proceedings), May 1980.

33. B. Bergmann, "Occupational Segregation, Wages and Profits When Employers Discriminate by Race or Sex", *Eastern Economic Journal*, April-July 1974, pp. 103-110.

34. See A. Zabalza and Z. Tzannatos, *op. cit.* in note 5, Table 2.5.

35. D. Marsden, "Vive la différence – Pay Differentials in Britain, West Germany, France and Italy", *Department of Employment Gazette*, July 1981.

36. N. Rytina, "Occupational Segregation and Earnings Differences by Sex", *Monthly Labor Review*, January 1981; U.K. Department of Employment, *New Earnings Survey*, 1980.

37. D. Treiman and H. Hartmann (eds.), *op. cit.* in note 17, Chapter 3.

38. *Ibid.*

39. A. McIntosh, "Women at Work: A Survey of Employers", *Department of Employment Gazette,* No. 11, November 1980.

40. *Ibid.*

41. For example, P. Doeringer and M. Piore, *Internal Labor Markets and Manpower Analysis,* Lexington, Mass: D.C. Heath, 1971; and R. Edwards, M. Reich, and D.M. Gordon, *Labor Market Segmentation,* Lexington, Mass: D.C. Heath, 1975.

42. D. Treiman and H. Hartmann, (eds.), *op. cit.* in note 17, quoting R. Buchele (1976) and R.W. Rumberger and M. Carnoy (1980).

43. M.D. Orstein, *Equality in the Work Place Accounting for Gender Differentials in Job Income in Canada: Results from a 1981 Survey,* Prepared for the Women's Bureau, Labour Canada, Ottawa, 1983.

44. See Treiman and Hartmann, *op. cit.* in note 17, for a further discussion of existing studies.

45. See P. Sloane, *op. cit.* in note 1; N. Agarwal, *op. cit.* in note 6.

46. See, for instance, D. Gaudart and R.M. Greve, *Women and Industrial Relations,* framework paper and analysis of the discussion of an international symposium, Vienna, September 1978, International Institute for Labour Studies, Research Series No. 54, Geneva, 1980.

47. N. Agarwal, in Jain and Sloane, *op. cit.* in note 1, p. 130.

48. *Ibid.*

Chapter IV

THE SITUATION OF WOMEN MIGRANTS

1. INTRODUCTION

The 1980 OECD High Level Conference on the Employment of Women noted that minority women face a double set of disadvantages within the labour market because of race as well as sex. The Conference declared that Member countries should give priority to the formulation of relevant policies to ensure that the special problems of migrant women were given consideration in relation to all the aims set out in the 1980 Declaration so as to promote equality of opportunity on their behalf[1].

In 1982, the OECD carried out a survey of the special problems faced by migrant women on the labour market in Member countries. The report of the survey summed up the situation of migrant women as one of low incomes and vocational status, long hours, poor working conditions and concentration in a narrow range of occupations. Moreover, migrant women have more dependants but fewer family resources; they have a greater need for gainful employment but run a higher risk of unemployment.

The report distinguished three types of measures relevant to migrant women:

a) to aid the disadvantaged in general;
b) to aid all migrants;
c) to promote equality between the sexes, with measures aimed specifically at migrant women, paying particular attention to policies in the field of family reunification. The Working Party on the Role of Women in the Economy subsequently has reviewed the socio-economic and legal situation of migrant women.

The fact that women migrants often form the least skilled part of the labour force justifies a special appraisal of the discrimination affecting them. What is more, the recession and trends in migration policies in the majority of OECD countries seem to have hit them particularly hard: unemployment is higher than for any other population group; there have been attempts to restrict family reunification; and access to the labour market by the wives of migrants has been made more difficult.

An appraisal of the special position of women migrants is important to an understanding of the situation of women as a whole. While they occupy a relatively minor place in the total female population, their participation rates are very high and so they form a larger proportion of the female labour force (see Table IV.1). During the 1960s, they made a substantial contribution to the general increase in female participation rates: directly through their own participation (in all European OECD countries except Luxembourg and Switzerland the employment of female immigrants increased over the period 1960-70)[2] and indirectly by the specific role they played in the labour market in the period of high mobility of local women workers which characterised many OECD countries between 1960 and 1970. Immigrant

Table IV.1. Working population resident in the host country, by sex

	Total working population				Of which: Immigrant workers				% Immigrants		
	Men	Women	Total	% of women	Men	Women	Total	% of women	Men	Women	Total
Australia[a] 1976		2 070 545		—		510 812		—		24.2	
Austria[a] 1980	1 672 153	1 116 584	2 788 737	40.0	112 048	72 058	184 106	39.1	6.7	6.5	6.6
Canada[b] 1971	5 760 245	3 053 700	8 813 945	34.6	1 158 845	604 925	1 763 770	34.3	20.1	19.8	20.0
Canada[c] 1971					348 020	212 050	560 070	37.9	6.0	6.9	6.4
Belgium[d] 1977	2 562 748	1 254 578	3 817 326	32.9	221 335	85 015	306 350	27.8	8.6	6.8	8.0
France[d] 1975	13 642 675	8 132 185	21 774 860	37.3	1 286 030	298 310	1 584 340	18.8	9.4	3.7	7.3
Germany[d] 1975	16 793 000	10 159 000	26 952 000	37.7	1 453 000	679 000	2 132 000	31.8	8.6	6.7	7.9
Germany[a] 1980		8 098 000		—	1 429 952	641 706	2 071 658	31.0		7.9	
Sweden[d] 1979	2 324 400	1 871 800	4 196 200	44.6	126 400	98 100	224 500	43.7	5.4	5.2	5.3
Sweden[a] 1980					130 000	104 000	234 000	44.4			
Switzerland[a] 1980	1 932 000	1 030 000	2 962 000	34.8	327 000	174 000	501 000	34.7	16.9	16.9	16.9

a) Data supplied by country, 1980.
b) Born in Canada.
c) Immigrated between 1961 and 1971.
d) "Young foreigners and the world of work", OECD, Paris, 1981 (document for general distribution).

93

women entered industry and the services that relieved local women of domestic work on a large scale.

The problem of migrant women has often been somewhat simplistically analysed as being due to low skill levels, low wages, high concentration, poor working conditions and sometimes even low participation rates (a view which persists despite the statistical evidence), but such a view obscures the effects of discrimination. Even less does it grasp changes in a population which has to confront the problems of integration.

The frequent use of these terms gives such a summary view of the immigrant female population as sometimes to be quite erroneous. The dominant idea is one of acute discrimination, seen as comprehensible with regard to a population generally considered to be extremely unskilled, even illiterate, of rural origin and thus confronting the combined difficulties of urbanisation and a foreign language and environment. In the case of women, even more than of men, it is readily forgotten that migration is an extremely heterogeneous process. Because in OECD countries female migration has mainly consisted of married women migrating with, or in order to join, their husbands, the idea of women having been "compelled" to migrate and being less disposed to integration is reinforced; the role of women in the decision to emigrate and the existence of independent female migration have been minimised. In family migration, women do in fact play a part at every stage in the emigration process: the decision to emigrate, preparations for departure and arrangements made in the event of returning home, choosing where to emigrate to (often, apparently, to a place where the woman already has emigrant relatives); on arrival, it is the woman who plays a major part in the adjustment to the new environment and in particular for setting up a circle of friends and relations. A Canadian survey of Portuguese women from the Azores showed that 85 per cent had taken the initiative for emigrating and that, for 66 per cent, the country chosen had been one in which the wife, but not the husband, had relatives[3]. The few programmes so far introduced specifically to help migrant women have suffered from excessively static and insufficiently differentiated assessments. Host countries could usefully strengthen programmes of information and education for the populations of those countries as a means of facilitating the full acceptance of women immigrants.

Efforts have been made in recent years on behalf of this population group, but there have been few studies devoted to a systematic comparison of trends in the male and female immigrant and indigenous populations. The absence of such data increases the problems of analysing discrimination and its causes: problems which include the difficulty of definition; distinguishing between the voluntary behaviour of the people concerned and the more structural role of factors involving "human capital" and labour market; theoretical difficulties due to the interconnection of several specific factors (sex, nationality and possibly race) unsupported by the solid base of a theory of discrimination; and the importance of the time factor in the case of a migrant population. How indeed, over the long term, can the respective importance of factors liable to affect integration (immigration policies with regard to residence and employment, the general situation of the female labour market, rural or urban origin, education and skills of immigrant women) be assessed in the context of a migratory process which is itself heterogeneous and subject to considerable change? A combined comparative analysis of all OECD countries, making no initial distinction between "temporary labour migration" countries and non-European "settlement immigration" countries (Canada, Australia, United States), would give a better idea of the various causal factors at work and would remove some of the difficulties without artificially underlining contrasts that are not hard and fast.

Limiting the analysis to the labour market is necessarily restrictive, but it is justified by the high participation rate of immigrant women. In addition, by so doing, it is easier to assess

the true value of certain preconceived ideas on female migration and its development which underlie policies to promote equal opportunities for immigrant women and in areas less directly connected with entry to the labour market. This labour-market analysis in no way denies the importance of other kinds of discrimination (structural difficulties in obtaining access to education, training, health care, public facilities and information, but also discrimination as regards certain entitlements: family allowances for married women left behind in the home country, restrictions on the right to abortion, the example of the large-family card in France up to 1981), which have been partly researched elsewhere. However, a study of the legal status and entry of young immigrants to the labour market can throw light on other aspects of unequal access to welfare benefits that have not been explored: for example, the large proportion of women in undeclared work and in occupations less well covered by social insurance (domestic service) has direct repercussions on access to retirement, disability and unemployment benefits.

2. A NEW CONTEXT

The pressure of discrimination, particularly on the labour market, varies considerably according to the size and nature of the population concerned. Considerable changes have taken place in the immigrant female population in both respects.

A. A Growing Proportion of Women

It is difficult to make an accurate estimate of the size of the immigrant female population at present resident in OECD countries. The census figures are rather out of date for certain countries[4] and the estimates are often inaccurate. The data are also inconsistent, since in certain countries they cover women born abroad (e.g. Australia), in others they exclude those who have been naturalised, in others they count women with a foreign mother tongue (United States, 1980 census). In the United Kingdom, the different status of Commonwealth subjects also leads to confusion. What is more, existing estimates are very often on the low side, both because of inadequate census coverage of the immigrant population and the wide margin of error due to illegal immigration. In the United States, estimates of the number of illegal immigrants range from 3 to 6 million, 40 per cent of whom might be women according to the various surveys carried out[5]. Lastly, a number of OECD countries which were formerly emigration countries have become immigration countries, and may not have appropriate immigration legislation: there are many illegal women immigrants in Italy, as well as in Spain and Greece; in Italy, action is being taken to regularise their situation.

Consequently, the statistics given must be taken as indicative and approximate. But in any event, immigrant women represent a significant population group in OECD countries. In five major European immigration countries (Belgium, France, Germany, Sweden, Switzerland), their number was put at over 4 million by the end of the 1970s.

During the period 1970-80, the proportion of women among immigrants in the European OECD countries was between 40 and 46 per cent: Belgium (1977) 46.9 per cent, France (1975) 40.1 per cent, Germany (1980) 43.6 per cent, Sweden (1978) 48.3 per cent, Switzerland (1980) 45.9 per cent, Austria (1980) 40 per cent and the Netherlands (1980) 41.7 per cent. In most countries, a steeply upward trend was more or less uniform, from about 30 per cent in the 1960s at the outset of the wave of migration to some 45 per cent in the 1980s. The trend has been observed for all nationalities. This was the combined result of a greater

95

tendency for women to become naturalised and the higher male death rate, which is more marked among immigrant workers (unhealthy and dangerous jobs). In the medium and long term, women may make up the largest part of the population of foreign origin.

A higher proportion of women appears to be a structural factor of migratory flows and is independent of the "form" of the flow, whether immigration is of temporary labour, for settlement, or due to a migration policy of family reunification. Consequently, countries which had applied substantially different migration policies, such as France and Belgium (where family reunification was flexible and even encouraged) or Switzerland and Germany (whose policy was more dissuasive), do not have very different proportions of women in their immigrant populations.

Whether immigration for "settlement" or "temporary labour", legal or illegal, into European or other OECD countries, migratory flows ultimately – though at differing speeds – generate family reunification. This process is not yet over. In the European OECD countries it has continued, and in certain cases has even accelerated with the recession. Moreover, reunification is still continuing, albeit on a substantially smaller scale than in the past, for nationalities that arrived long ago and have already gone through the intensive reunification phase: for instance, about half of the 46 946 Portuguese entering France in family groups between 1976 and 1981 were women[6]. Non-European countries are also affected: in the United States, the growth of legal immigration is partly due to the number of family arrivals (women dominated the entry flows between 1966 and 1979). Women form a high proportion of both legal and illegal immigrants into the United States[7].

The persistence of this rising trend of feminisation is due in part to the fairly lengthy process of family reunification, and to the deterioration of living conditions in home countries. It also owes much to the widening gap between women's aspirations based on the more developed countries and encouraged by expanding education in home countries, and the limited possibilities offered by the female labour market there.

More precise data and studies on the present state of family reunification seem to be called for. A survey carried out in France shows the complexity of this process, which involves the wives of first-generation migrants, wives of "second- or third-generation" migrants and girls joining their parents after being educated in their home country[8].

The phenomenon of specifically female immigration is relatively new to most OECD countries. In the past, while women played an important role in the process of family emigration, independent female immigration was fairly rare – although in the United States, for example, the predominance of women in immigration from Colombia has continued to increase ever since 1960[9]. In Europe, the scale of family reunification conceals the independent female element: Turkish and Yugoslav women have often arrived alone in Germany, either unmarried or ahead of their husbands. A survey carried out in Frankfurt in 1973 showed that 10 per cent of the immigrant married women in that city were there without their husbands[10]. There are also many Spanish women on their own in France and Switzerland, while Finnish women in Sweden form a highly autonomous immigrant population.

Independent female migration is likely to continue, if not increase. In the present context of closed frontiers, this may take the form of illegal immigration. In Australia, women made up 15 per cent of all the people whose situation was legalised in 1980, and in France 17 per cent in 1981. These illegal female immigrants are often very young, and a higher proportion are unmarried than is the case among illegal male immigrants[11].

Finally, the changing balance of the population of immigrant origin in favour of women is due to the intrinsic growth of this population. Immigrants have as many daughters as sons.

Thus, the considerable growth of the immigrant female population over the last few years is still continuing, and so policies will have to be developed in the short term to take account of a trend that cannot yet be fully measured.

B. Demographic Changes

This increase in the proportion of women is accompanied by a significant change in their age profile. Both the highest and lowest age groups are growing. This trend is roughly the same in all OECD countries, regardless of the type of migration. The fall in the average age of women, which is even more marked than in the case of men, is due both to intrinsic growth and to the arrival of younger women through family reunification and, more marginally, illegal immigration.

A study carried out for France in 1981 demonstrates the short- and medium-term implications of the expansion of these age groups[12] assuming that "active" immigration flows do not resume. Even assuming a substantial reduction in immigrant fertility (greater than that used in the study by the *Haut Comité à la Population*), the 17-24 age group, accounting for 16 per cent of total immigrant women in 1980, will climb to 21.5 per cent in 1985, then to 23.7 per cent in 1990, falling subsequently to 18.4 per cent by 1995. This average trend is much more marked in the case of certain nationalities. In the context of a sharp reduction in migratory flows, the increase in the immigrant female population of working age will still amount to between 90 000 and 100 000 in France, 22 per cent of whom will be Algerian and 17 per cent Portuguese.

C. A More Mixed Population

Female migration, like male migration, has always been highly heterogeneous in the OECD countries as a whole. The distinction between "temporary labour migration" countries and "settlement immigration" countries is probably not the most relevant in this context.

The education background of immigrants, in particular, has been diverse. While it is true that there is a certain amount of immigration of highly-educated women into Canada and Australia, and more educated than the local female population, these countries have nevertheless long been accepting (since the late 1950s) quite different and much less skilled immigrants, first from the Mediterranean area (Portugal, Greece) and more recently from Asia. In Australia, in 1980, 37.7 per cent of the women born in another English-speaking country had a relatively high level of education as against 31.8 per cent of those born in Australia and 26 per cent of the women born in other countries[13]. In the United States, immigration from Latin America (Mexico, El Salvador, Colombia, the Caribbean), with a high proportion of women, is scarcely any different in many respects from labour immigration into Western Europe.

In Western Europe, although immigrant women have generally had less school education than their male counterparts, they cannot be regarded as completely illiterate. While the average is four to five years' schooling, a not inconsiderable number have had between five and eight years, not necessarily entirely due to "second-generation" education. Even when migration was at its peak, a significant percentage of women had eight years' schooling. The Representative Survey carried out in Germany in 1972[14], concerned with education in the home country only, showed that ten years ago only 9 per cent of immigrant women were illiterate, a lower level of illiteracy than in the female population of the home country. Over one-third of all immigrant women had between four and five years' schooling and 36 per cent between six and eight years; 12 per cent of the Italian, 5 per cent of the Greek, 39 per cent of

the Spanish, 11 per cent of the Portuguese, 7 per cent of the Turkish and 58 per cent of the Yugoslav women had eight years' education or more.

The survey carried out in Germany in 1980 showed considerable changes in educational levels in the home country compared with the previous survey in 1972. Over this period, while entries of women increased enormously (family reunification), the percentage of women who had never been to school remained substantially the same (9 per cent in 1972, 8.9 per cent in 1980) and dropped quite sharply in the case of Turkish women who account for an increasing proportion of the immigrant female population in Germany and include the highest rate of illiteracy: 18 per cent in 1972, 14.6 per cent in 1980[15].

The fact is that migration does not originate mainly from rural regions but from the most urbanised areas, where education is more advanced. It is generally not the most disadvantaged who migrate, a fact which tends to be forgotten. These regions are also those where family reunification is greatest because of the higher cost of maintaining families in town and because less support is available from traditional structures[16].

The immigrant female population, which has been very diverse ever since migration started, is also changing significantly in ways which must be carefully considered in order to assess the impact of discrimination, evaluate the short- and medium-term problems and make the appropriate adjustments to policies.

The composition and educational level of the immigrant female population reflects the effects of:

- *Its intrinsic growth:* Young women from immigrant families totally or partly educated in the host country, many of whom are currently or potentially nationals of that country, form an educated population;

- *The flattening of the migration wave,* partly under the impact of changes in the home countries, such as increasing urbanisation, longer schooling and lower fertility;

- *The growth of specific independent female immigration.* A survey carried out in the United States in 1980[17] among illegal Mexican women immigrants who had already been in the United States for about five years, showed that although they had less schooling than legal immigrants or indigenous women, some of them had a substantial education (having completed the secondary cycle). These findings are corroborated by other United States studies[18]. A survey carried out among immigrant women in France in 1980[19] showed fairly uniform trends for some of the young women recently arrived either illegally or to join their families, regardless of origin: North Africa, Portugal, Turkey, Mauritius. For all of these young, relatively well educated women, it was the situation in the home country labour market and the impossibility of obtaining a good job in the tertiary sector which had led them to emigrate.

D. Substantial and Growing Labour Force Participation

The substantial participation of all immigrant women in the labour force is a factor common to all OECD countries, regardless of the type of migration (see Table IV.2). Immigrant women are characterised by high participation rates, higher on average than those of local women. These average rates reflect considerable differences between nationalities; for some of whom, often the longest established, they are extremely high: for example, in Sweden in 1980, the participation rates for Finnish, Yugoslav and Greek women were 78 per cent, 84 per cent and 86 per cent, respectively.

These high participation rates are not solely due to the age structure of the immigrant female population, who are on average younger than the corresponding local population.

Table IV.2. **Comparative participation rates of immigrant and local married women in selected OECD countries**

Age group	Australia 1980		Canada 1971		Germany April 1979		Sweden 1980	
	Local women	Immigrant women	Local women	Women immigrating between 1961-71	Total women	Immigrant women	Local women	Immigrant women
15-19	60.7	56.0	36.3	43.9	46.2	43.2		58.4
20-24	71.5	66.1	62.3	63.1	69.2	55.9		74.5
25-34	52.3	55.7	42.7	54.7	58.1	58.8		77.6
35-44	56.9	63.7	41.8	56.1	54	64.5		81.2
45-54	47.1	52.1	42.7	53.2	49.6	59.2		74.1
55-59	26.8	33.6	} 24.3	} 29.4	38.4	54.3	} 53.3	
60-65	14.3	16.2			11.4	–		
16-65	51.9	53.5	39.8[a]	52.1[a]	49.7	57.6	64.6	72.6[b]

a) 15 and over.
b) 16-74.

Sources: Australia: Australian Bureau of Statistics, *The Labour Force,* November 1980.
 Canada : Census of Canada, 1971.
 Germany: Microcensus, 1979.
 Sweden : Statitiska Centralbyran (SCB), *Arbetskraftsundersökningen* (The Labour Force) Stockholm, 1980.

Analysis of participation rates by age group, where such data exist, shows that the greater economic activity of immigrant women is often due to a higher participation rate than for indigenous women for the youngest age group (15-19), as in Sweden, and above all to a generally much higher rate for immigrant married women.

These average rates are in fact underestimates. A substantial proportion of women, and a growing one since the recession and the changes in immigration policies, work "underground", and illegal women immigrants are also characterised by high participation rates. Furthermore, these rates do not generally (with the exception, for example, of Australia) include naturalised women, whose participation rates also are generally high as, for instance, in France.

This high rate of economic activity seems to be a structural feature of migratory flows, whether for temporary labour or permanent settlement, whatever the nationality or level of qualification of the immigrants, and whatever the policies of the host countries. In Australia, for example, it applies equally to highly-qualified and to unskilled immigrants: in 1980, participation rates were 55.8 per cent for women born in the United States, 46.5 per cent for those born in the United Kingdom or Ireland, 62.3 per cent for those from New Zealand, 47.4 per cent for Asian women, 47.5 per cent for those from Greece and 57.3 per cent for women from Yugoslavia.

Some evening-out is taking place. Thus, in Germany, where extremely high participation rates for immigrant women were connected with German immigration policy's preference for labour market immigration, the recent fall in these rates (from 72 per cent in 1970 to 56 per cent in 1980 for the 15-65 age group) is linked with increasing family reunification and the policy of delaying labour market access to women coming to join their families, some of whom work illegally. The same is true of Switzerland, where the trend was already visible in the 1970s. Conversely, in France and Belgium, there was some catching up by nationalities with low female participation rates as the proportion of women grew: thus, Algerian women's participation rates in France increased from 11.8 per cent in 1968 to 15.9 per cent in 1975, whereas the maximum rate in Algeria is 14 per cent (for the 19-24 age group).

As a rule, the average participation rates for immigrant women, which depend in part on the respective numbers of the nationalities represented (a well represented nationality with a very high participation rate puts the rate up, and vice versa), are tending to even out at quite a high level.

This is largely explained by women's independent decisions to emigrate; by the very nature of emigration, connected as it is with plans for the family's social advancement and amassing of savings (possibly with a view to starting their own small business later in their home country); and by aspirations for the same standard of living as the host country (it is well known that the second wage is the biggest factor in raising incomes, made all the more necessary because immigrant men's wages are low and families have to cope with additional difficulties and expenditure when settling in a foreign country).

In the case of immigrant women, having children rarely prevents them from working. The fertility of immigrant women, which is difficult to quantify, is probably very much lower than in their home country[20]. They often come from urban areas where fertility has already declined and where modern contraceptive methods are sometimes used (Turkey, Portugal, Yugoslavia, Spain). Furthermore, some women emigrate at an early stage in their childbearing years with plans linking social advancement to a small family. As compared with the preceding generation, the decline in fertility is probably sudden rather than proportional and is not so much a matter of gradual adjustment to the pattern of the host country as an element in the decision to emigrate. Employment may be fostered by the availability of community child care and educational facilities for young children in host countries and by the support of the extended family, where it is present[21].

Moreover, the relative proximity in time to the traditional community where women play an important role in farming and handicrafts, the changes that have taken place alongside the growth of emigration in home countries (lower fertility, increasing school attendance, higher female participation rates in urban areas) and the development of industries with a specifically female workforce (Tunisia, Morocco, Turkey, the Mexican frontier area with the United States, for example) are also positive factors. Non-participation in the home country is often a temporary state of affairs connected with the rural exodus and unemployment. From this standpoint, emigration serves to reveal the importance of female employment.

The 1960s were already characterised by increasing immigrant female participation, in particular by married women, many of whom were already going out to work[22]. The advent of immigrants' children and the effects of the recession can only increase this participation. The young age groups about to arrive on a female labour market already under strain from the recession will probably have a similar fertility rate to local women and high participation rates.

The current precariousness of employment for immigrant men and the perverse effects of restrictive policies on labour market access by women immigrating to join their families, who under the present insecure conditions have preferred to assert any rights they might have immediately, seem to have speeded up the entry of immigrant women to the labour market.

In Sweden[23], between 1977 and 1980, immigrant women followed exactly the same pattern of rising overall female participation. This is particularly remarkable in the case of women with children under seven years of age. Thus, for example, the participation rates of all women in the 20-24 and 25-34 age groups with a child under seven increased from 66 to 73.1 per cent and from 67.4 to 76.5 per cent respectively between 1977 and 1980, while those of immigrant women rose from 62.5 to 70.3 per cent and from 66 to 74.4 per cent in these age groups.

The issue of discrimination must therefore be considered in relation to a population which has grown fast and can only grow faster and is becoming increasingly diverse in terms of education and behaviour. The picture of a practically illiterate rural immigrant confined to her home does not reflect the reality of female migration in the OECD countries. Policies for the integration of immigrant women in the labour market must reflect the reality, not the myth. In short, the problem is not to encourage isolated and housebound women to enter the labour market, but to permit the high proportion of immigrant women who need to work to do so.

3. INTEGRATION INTO THE PRODUCTIVE SYSTEM

Analysis of discrimination calls for an investment in methods of analysis, statistics and bases of comparison which has not so far been made. Since a rigorous comparison of precisely-defined homogeneous populations and of their integration into equally well-defined labour markets is not possible, the problem might be approached indirectly by comparing the integration of immigrant women into the productive systems of OECD countries with other population groups, in particular immigrant men and local women. The problem of discrimination emerges at once as more complex here than was revealed by the traditional view of heavy concentration in certain sectors, low skill levels and low wages.

The migration of highly-qualified women to Canada, Australia and the United States is a case apart. But in these same countries, the integration of female immigrants of other nationalities – who are far from being a marginal group – shows similar features to female immigration in the European countries of the OECD (disregarding intra-EEC migration).

A. Occupational Segregation

The main feature of women immigrants' employment is their high concentration in certain sectors and, more markedly, in certain jobs, although it is difficult to give homogeneous figures for their concentration in the OECD countries because no homogeneous sector-by-sector classification exists. These rates of concentration are very similar to those of immigrant men, but also to those of local women. In France (1975), the rates of concentration in the first three most representative sectors for each population group[24] are 65.3 per cent for immigrant women, 61.3 per cent for immigrant men, 55.2 per cent for French women and only 36.1 per cent for French men.

In Sweden, where indices for 1975 measure the percentage of people who would have to change jobs in order to obtain a similar distribution to that of the total population, again only the group comprising Swedish men stands out (index = 27); immigrant women, like Swedish women, have a much higher index (index = 44) which is almost the same as for immigrant men (index = 42).

In spite of the differences between the production structures of the countries using immigrant labour, between the participation rates of local women and between legislation concerning reserved occupations, immigrant women work mainly in the industrial and service sectors.

B. The Industrial Sector

Heavy concentration in industry is a salient feature of immigrant women's integration into the productive systems of the OECD countries: 55.9 per cent of the immigrant women in

101

employment in Germany (1980), 30.3 per cent in Sweden (1980), 47 per cent in Switzerland (1980), 46.7 per cent in France (1975) and 45.8 per cent in Austria (1979). This is also the case for the non-European OECD countries.

This distribution clearly contrasts with that of local women throughout the OECD area. While immigrant women are more evenly distributed than immigrant men between the secondary and tertiary sectors, this is essentially because they are far more numerous in industry than local women. These contrasts are as striking in the European as in non-European countries (see Table IV.3).

Within industry, although there are very few immigrant women in building and civil engineering, where male immigrants predominate, they work in large numbers, unlike local women, not only in traditionally "female" industries (textiles, clothing, footwear, leather and food) but also in more male-dominated sectors. For example, in Germany (1980), immigrant women accounted for 14.16 per cent of the total number of women employed in the textile industry, but 23.4 per cent of those in the chemical and plastics industry, 31.8 per cent in metalworking, 35.2 per cent in metal manufacture and processing and 21.7 per cent in the electronics industries. In Sweden (1980), 43.9 per cent of the women working in the rubber and plastics industry were immigrants.

Table IV.3. **Local and immigrant women working in industry in selected OECD countries**

	Local women (%)	Immigrant women (%)	
Sweden, 1980 (mining, manufacturing)	Total female population 14.9		30.3
Germany, 1980 (processing industries)	21.0		56.1
Austria (goods manufacture)	Total female population 31.1		46.3
Australia, 1980	8.5	Born in a non-English-speaking country	12.4
		Born in other countries	Between 30 and 70
United States 1970 1980	18.46	Born in a foreign country	33.37
		Hispanics	28.4
1980	Total female population 13.8		
Canada, 1971	4.2	Women immigrating between 1961 and 1971	15.4

Sources: Sweden : Statistiska Centralbyran (SCB), *Arbetskraftsundersökningen* (Labour Force Surveys), Stockholm, 1980.
Germany : Federal Employment Office, Bonn.
Austria : Labour Market Prospects, 1981. Statistics of the Federal Ministry of Social Affairs, Vienna.
Australia : Australian Bureau of Statistics, *Weekly Earnings of Employees (Distribution)*, 1980.
United States: Census, 1970 and 1980.
Canada : Census, 1971.

Table IV.4. **Service or equivalent personnel as a percentage of female immigrant workers**

France	(1975)	27.7	Canada	(1961-71)	25.2[a]
Sweden	(1980)	11.8	United States	(1970)	30.6
Germany	(1980)	10.6			

a) Based on women who migrated 1961-71.
Sources: France : Census, 1975.
Sweden : Statistiska Centralbyran (SCB),
Arbetskraftsundersökningen (Labour Force Surveys),
Stockholm, 1980.
Germany : Federal Employment Office.
Canada : Census, 1971.
United States: Census, 1970.

C. The Tertiary Sector

The service sector in certain countries employs a very high proportion of immigrant women: 51.8 per cent in Austria in 1979, 46.9 per cent in Sweden in 1980. The distribution of female immigrants between industry and services depends partly on the structure of production. In Germany, immigrant women are numerous in industry, whereas in Austria (where tourism is highly developed) they are employed more in services.

The jobs they take in this sector are mainly cleaning and the like (private domestic service, office cleaning, hotels and catering) and subordinate tasks in the health sector in those countries where these are not civil service jobs reserved for their own nationals, as in France and Belgium.

This distribution is very different from that of local women, who are concentrated in office jobs. In Germany (1980), 29.5 per cent of the total female population worked in government and office jobs, 12.7 per cent in commerce, 8.3 per cent in public health and hygiene services and 6.8 per cent in cleaning and the like. The corresponding percentages for immigrant women were 8.2, 4.1, 5.2 and 10.6.

Here again, the degree of segregation by sex is often not so high for immigrants as it is for the indigenous population: for instance, there are also more male immigrants in cleaning and maintenance jobs than there are male nationals in office jobs, which are usually taken by women.

However, it would surely be misleading to interpret in wholly positive terms this seeming breakdown of occupational segregation between immigrant women and men. It is rather a sign of the segregation of immigrants into unskilled and low-paid jobs, irrespective of their sex. This should prompt caution in analysing occupational desegregation of women generally, in case women are entering unskilled, low-paid and declining "male" occupations which are being deserted by men.

D. The Underground Economy

The employment of immigrant women is a typical feature of the so-called underground economy, where they are either illegal immigrants with no residence or work permit or have such permits but work undeclared. However, it is not possible to say how far this could modify the relationship between the different sectors, nor to what extent their undeclared employment is greater than that of other population groups. Immigrant women are mainly employed in this way in the clothing trade and domestic service and, to a smaller extent, in catering and commerce. The major consequence as regards equality of treatment comes out in

103

social insurance coverage. They share with many others in marginal jobs, for example "out-workers", low pay, lack of union protection, and risk of disease and injury. Being outside the law makes them even more vulnerable to exploitation. Undeclared work enables them to avoid taxation.

E. The Skill Range

Immigrant women are mainly concentrated in the least skilled jobs. There is less of a gap between the skill levels of male and female immigrants than between male and female nationals, which in fact reflects the weak position of male immigrants. For example, in France in 1975, 21.6 per cent of French women workers were categorised as "manual workers", compared with 46.7 per cent of immigrant women workers. Within this grouping, the least skilled categories ("semi-skilled" and "unskilled") accounted for 84.5 per cent of immigrant women, 75.8 per cent of French women, 65.9 per cent of immigrant men and 47.4 per cent of French men. But it appears that in the manual worker categories, where immigrant women predominate, they are not always worse off than local women.

F. Wages

On the whole, all OECD countries observe the general principle of outlawing wage discrimination on grounds of sex or nationality. Discrimination usually arises, first, because of differences in skill levels and, second, through segregation in employment.

On average, immigrant women earn less than local women. However, few accurate and comparable figures on wages are available, particularly on average hourly wages. The available data (Australia 1980, Canada 1971, Sweden 1980) show that immigrant women's average weekly and monthly wages are in every instance at the lowest levels and that the wage differential with local women is much narrower than with immigrant men.

But the situation is in fact probably more complex. Appreciable variations emerge between male and female wage ratios and immigrant and native female wage ratios, notably according to age (Canada 1971), skill and sector (Germany 1980, Australia 1980), and it is not possible with the data to draw any conclusions and especially to situate the immigrant women/immigrant men differential exactly as compared with local women/local men differentials. On the other hand, it may be said that, in terms of average monthly wages, differences in the number of hours worked (which are sometimes longer for immigrant women) probably narrow the gap between the wages earned by immigrant and local women to the advantage of the former.

G. Hours and Conditions

Working hours of immigrant women are frequently abnormally long or abnormally short and irregular, and are frequently outside the normal working day. In Sweden in 1980 the average working week was 33 hours for immigrant women and 31 hours for Swedish women. This situation arose because of the big difference in the proportion of women in part-time work in the two population groups: 46 per cent of the total female population worked part-time and 35 per cent of immigrant women. In that country in 1975, not only were Yugoslav women working longer hours than Swedish and immigrant Finnish women, but their working hours were also as long as those of Yugoslav men and longer than those of Swedish or Finnish men. The same survey showed that the greatest difference in the case of arduous and inconvenient hours (night work and shift work) was again between Yugoslav and Swedish women[25]. The journey from home to place of work took the immigrant women twice as long. A survey carried

out in France in October 1978 on the working conditions of immigrant wage-earners[26] yielded identical findings: 18.7 per cent of immigrant women worked less than six hours per day, 16.2 per cent of them between 6 and 8 hours; for French women, the corresponding percentages were 11.2 and 14.2 respectively; 11.6 and 9.6 per cent of immigrant women worked ten and eleven hours, against 9.9 and 6.6 per cent of French women. More French than immigrant women had normal working hours (57.8 per cent against 43.9 per cent). The main reason for this difference lies in the hours worked by domestic servants, which may be either very short or very long. This is not something that affects male immigrants. The difference between the working hours of immigrant and local women appears to be even more striking in the case of married women with young children. This was revealed by a study carried out in the United Kingdom in 1975: there, too, it was found that longer days were worked by immigrant women[27]. As regards night work, protective legislation (where it exists) applies to all women, whether immigrants or nationals. Exceptions are made, however, when necessary, such as for night work in hospitals, but also in the canning industries. It seems here that proportionally more immigrant women are affected (except in countries where the jobs concerned are state jobs reserved for nationals, e.g. hospital jobs in France where only 1 per cent of immigrant women are on night work as against 5 per cent of French women).

Few precise data exist that can be used to compare the working conditions of immigrant women with those of other reference groups. OECD countries' general legislation on work by women, prohibiting certain heavy work, applies to both immigrant and native women without distinction. Differences in working conditions are due mainly to the industries in which immigrant women are employed. In manufacturing, for instance, they often work in industries where the pace of work is very strenuous; generally speaking, more immigrant than native women work on assembly lines. Another disadvantage from which female immigrants suffer to a much greater extent than either immigrant men or local women operates through the isolated working conditions associated with domestic service.

Thus, the integration of immigrant women as compared with male immigrants seems to be characterised mainly by differences in skills and wages and, as compared with local women, by differences in concentration, sector of employment, and working hours and conditions.

4. LIMITS OF INTEGRATION

The picture that has emerged reflects the integration of a number of fairly dissimilar waves of migration that have extended over a lengthy period. How far do the various component categories of the immigrant female population, who differ in origin, education and training as well as length of residence and legal status, depart from this general pattern in their integration into the labour market? More broadly, have changes in that market been in line with changes in the composition of the immigrant female population? Looking at these questions is another approach to equal opportunities. Very little work has been done in this connection. The points mentioned here are only brief illustrations and are confined to a few strata of the immigrant female population.

A. Illegal Female Immigrants

The situation here is very uneven, but the problem exists in all OECD countries. Illegal immigration is on a massive scale into the United States and is also on the increase in European countries following the restrictions introduced under the new immigration policies. It is now also beginning to occur in former emigration countries such as Italy, Greece and

Spain. But in the past, too, many women were illegal immigrants and swelled the ranks of domestic servants. Illegal immigrant women differ more by the fact that they are outside the law than by any departure from the composition of legal immigration. Their integration into the labour market, on the other hand, does depart from that general pattern in three respects:

- *Lower wages,* but not usually below the statutory minimum[28];
- *Greater concentration* in a few jobs: domestic service, made-up clothing and, to a smaller extent, catering and commerce, at the expense of jobs in industry (except in the United States, where the legislation and administrative practice combine to create a special situation which explains the presence of illegal immigrant women in industry and even in the public sector);
- *Longer working hours.* In France and Germany, very long working hours in the clothing trade (14 hours a day) combine with work distributed very unevenly over the year, piecework rates and poor working conditions that are made worse by the fact that when these women work at home they often do so through their husbands or fathers to whom the wages are paid direct; men working in the clothing trade are usually employed in workshops and bring work home for their wives and daughters, so that the latter often have no direct contact at all with the employer[29].

B. Successive Waves of Migration

Are women belonging to the older waves of migration better or differently integrated into the labour market than recently arrived women? Are the effects of this "seniority", as well as age, significant?

On the whole, just as immigrant women have taken the place of native women, each successive wave of female immigrants has to some extent taken the place of the preceding one. This can be seen clearly in the case of domestic service. In France, there was a substantial shift between 1968 and 1975: in 1968, 66.2 per cent of the immigrant women employed in service jobs were Spanish; by 1975, this proportion had fallen to 39 per cent in favour of Portuguese and Moroccan women. But the mobility of the earliest waves of immigrants, which has been little studied in the case of women, seems limited. The shift is mainly from cleaning jobs for private persons to office cleaning and thence to jobs in industry. But shifts from industry to cleaning and the like are also frequent[30]. On the other hand, integration into the tertiary sectors (new shopping patterns, industrial-scale catering) would appear to depend not so much on the slow advance of the early waves of immigration as on the promotion of children of immigrants, as well as on the different way in which more recent waves have fitted in. Generally speaking, rather fewer of the women who have immigrated recently have taken jobs in industry; this is due partly to the fact that they have different kinds of skills, but also to a difference in the labour market situation, with the decline of the industrial sector and the growth of tertiary activities.

However, the picture is still very incomplete given that there have been no comparative studies which also include a definition of the legal framework and therefore which take account of the fact that the different nationalities and migratory flows have not always enjoyed the same freedom of access and movement on the labour market.

C. Naturalisation

Naturalised women are variously covered by the statistics on the immigrant female population and have a relatively specific profile owing to their age, which is often

106

comparatively high, their status (complete freedom on the labour market and possibly access to jobs reserved for nationals in some European OECD countries where other immigrants are not equally privileged) and because being naturalised allows them to be selective to some extent. Few details are available on this subject. Some examples, however, bear out the assumption that women in the manual worker category and with lower skills are less likely to become naturalised (France, 1975; United States, 1970).

Nevertheless, the gains made by naturalised women seem to be inferior to those of their male counterparts. For instance, in France (1975), there was a 23-point difference between naturalised and foreign women in the semi-skilled and unskilled worker category and a 7-point difference with French-born women. In the case of naturalised men, the corresponding differences were 29 points compared with foreign men and 3 points compared with French-born men.

To put pressure on women migrants to renounce their nationality of origin in order to accede to more stable or better paid employment – especially in the case of the second generation – will probably have consequences for their links with their country of origin.

D. New Generations

Young women born of foreign parents are, like their male counterparts, classified as "second-generation migrants", and the OECD country statistics concerning them are usually unreliable and not comparable. These statistics generally only include young women who have not automatically acquired the nationality of the host country. They differ a great deal in education and aspirations. While, as a rule, the proportion of young men who become manual workers is even higher than in the preceding generation[31], this does not always apply in the case of young women, who are clearly entering the tertiary sector, especially the more highly prized jobs in shops, offices and banks.

This trend would be even more marked if the statistics took account of young women born of foreign parents but who are nationals of the host country, given that their nationality makes it easier for them to find jobs in the tertiary sector (in France and Belgium, it also enables them to take state jobs).

Table IV.5. **Socio-economic categories of immigrant women according to age group**

	Proportion of manual workers (%)	Proportion of non-manual workers (%)
Belgium (1970)		
Under 25	58.1	37.5
Over 25	49.6	31.1
France (1975)		
Under 25	72.2	22.6
Over 25	74.2	10.4
Germany (1978)		
Under 25	74.2	22.6
Over 25	75.6	19.0

Sources: Belgium : Census.
France : Census, 1975.
Germany: Federal Employment Office, Bonn.

Yet young immigrant women still far outnumber young local women in the manual worker category (see Table IV.5). The same trends are apparent in the OECD's non-European Member countries (Australia, 1976).

E. Highly Qualified Female Immigrants

The qualified contingent of the women who emigrate to "settlement" countries obtain better jobs than native women, usually because of their higher qualifications. They seem, however, to do less well than their male counterparts with similar qualifications. Thus, data for Canada show that although 26.2 per cent of male immigrants and 16.2 per cent of female immigrants are university graduates, the jobs found by these two groups, for example in teaching, reflect a wider gap. As a rule, the de-skilling suffered as a result of emigration (which does not prejudge earnings) is greater for qualified women than for qualified men. Furthermore, in Australia a small fraction of these qualified immigrants do seem to take jobs in industry, at least temporarily: 12.4 per cent of the women born in English-speaking countries, which provide the most highly qualified immigrants, are to be found in the manual worker category, against 8.5 per cent of Australian-born women (1980).

In OECD immigration countries as a whole, the arrival of rather better qualified female immigrants from countries where qualification levels used to be low has resulted in a marked de-skilling which, given current labour market conditions, seems likely to last: 38.8 per cent of the Hispanic women without papers working in the clothing trade in the United States used to have jobs as technicians or in public service, shops or offices in their home country[32].

Studies on immigrant women usually leave out refugees, who account for an increasing proportion of the female immigrants to all OECD countries. The female refugee population, like refugees as a whole, at first consisted of quite well-qualified people, sometimes with a little capital of their own; now, however, an increasing proportion of these refugees have few qualifications. Migration for economic reasons and political migration seem, too, to be increasingly interconnected. On the whole, women refugees have a better chance of becoming integrated (higher educational level, greater freedom of access to and freer movement on the labour market in countries where there are restrictions on immigrants, support from associations). Like women immigrants in general, their participation rate is high[33]. They find work more often in the tertiary sector, although a significant number also work in industry, at least temporarily. It would be interesting to be able to compare their integration with that of women migrating for other reasons.

F. Unemployment

Data on unemployment must be treated cautiously since male and female unemployment did not increase at the same time. Unemployment among immigrant women reflects both their rising numbers and redundancies (a large proportion of immigrant women are concentrated in industries which were very hard hit by the recession). Average rates of unemployment among immigrant women are higher than for other population groups. In particular, the young female immigrants entering the labour market are very prone to unemployment in all OECD countries. These developments are shown by figures for 1977-82 in France. The sharp rise appears most of all to have affected women in the 25-49 age group. Unemployment among immigrant women under 25 and over 50 years of age has increased less rapidly than for the corresponding male immigrant age groups, but much more rapidly than for French women[34]. Unemployment is rising in a context which seems to reflect a gradual deterioration in the overall integration of immigrant women into the labour market.

Spells of unemployment are also fairly long, but it also seems that the particular situation of immigrant women obliges them to accept less skilled, lower-paid jobs to a greater extent than local women. The 1980 figures for Germany, for example, show that while immigrant women were slightly in the majority as regards fairly long spells of unemployment (21.7 per cent of them were unemployed for between six months and one year, against 17.8 per cent of immigrant men and 20.2 per cent of German women), they accounted for a smaller proportion of very long-term unemployment (3.7 per cent, against 3.9 per cent of male immigrants and 6.2 per cent of German women) and a higher proportion of short-term unemployment (21.7 per cent, against 24 per cent of male immigrants and 16.3 per cent of the total female working population).

G. Occupations: Change, Not Progress

The productive system has been permeated by all categories of the immigrant population in all OECD countries. As regards women, the process has apparently been the result of a gradual shift from domestic service to office services (coinciding with the development of industrial cleaning firms and the subcontracting of maintenance) and then to manufacturing and the more highly regarded jobs in the tertiary sector. Little is known about this shift because of the high incidence of undeclared working in certain areas (private domestic service and clothing trade). Such trends are a continuation of those observed during the preceding period, for which the more homogeneous data available can be used to make a fairly accurate assessment. In the 1960s, the industrial sector grew and prospered everywhere. The proportion of immigrant women employed as manual workers in industry rose from 28 to 36 per cent in Belgium, from 37 to 47 per cent in France, from 6 to 27 per cent in Luxembourg, from 31 to 35 per cent in Sweden and from 20 to 21 per cent in the United Kingdom. Alongside this, however, there was already a marked increase in the proportion of immigrant women taking up certain jobs in the tertiary sector, which had a higher status than the ones they traditionally occupied (domestic service): from 24 to 29 per cent for office and shop jobs in Belgium, and from 16 to 18 per cent for non-manual workers in industry, shops and offices in France. In Sweden, the proportion remained constant (22 per cent), but in the United Kingdom it increased slightly (from 25 to 26 per cent).

But the reality is not necessarily one of a slow shift reflecting the advance of the oldest established strata of the immigrant female population. It looks, rather, as though this apparent movement is due, first, to the arrival of the "second generation" on the labour market and, second, because fewer new arrivals have taken jobs in the declining industrial sector[35]. We are beginning to see a movement straight from domestic service to the new service activities and sometimes even direct entry into the latter. This new movement reflects both the higher educational level of the latest immigrants and the deskilling of jobs in certain parts of the tertiary sector.

The position of immigrant women could serve here as an indication of structural changes in the labour market affecting all women, by which a move into new occupations is accompanied by a worsening of their position in some respects.

In a number of countries (France, the United Kingdom, the United States, Germany), there has been an increase in particular forms of employment (undeclared work, subcontracting to evade labour regulations) in which immigrant women play an important role. Traditionally, a proportion of female immigrants have always worked undeclared as domestic servants, which often served as a springboard for entry into the labour market. The rigidities introduced by immigration policies have in all countries made for the expansion of this kind of work. The restrictions on access to employment imposed on women who immigrate to join

their families have not prevented them from entering the labour market, but have simply obliged them to work undeclared in those jobs where it is easier to do so (France during the period 1974-81 and Germany)[36]. But it is not only in this area that underground employment is on the increase. Certain traditional forms of undeclared employment occupying large numbers of immigrant women appear increasingly to be related to modern, not declining, sectors of the productive system linked with exports (fashion industry), the development of "downstream" services (cleaning, fast food) generated by the tertiary sector in the large urban centres[37]. While certain traditional kinds of undeclared domestic service appear to be on the decline, other kinds are stimulated by demand from an increasing number of local women who are going out to work. These forms of employment are fuelled by the restrictions on immigration, since these help to boost the supply of women whose papers are not in order.

Immigrant women are becoming more involved in other forms of employment which enable them increasingly to circumvent the labour regulations. As subcontracting becomes more and more common, there is growing demand for immigrant labour: the majority of the women who work for the industrial cleaning firms are immigrants. In countries such as France and Belgium, where foreigners are not allowed to work in certain state jobs, this is evaded to an ever increasing extent by subcontracting de-skilled jobs (cleaning, laundry, catering). But immigrant women receive no social benefits from the firm whose work they are helping to do.

This has been found to be the case in two countries, France and Germany, where the rate of immigration is high. In France, between 1968 and 1975, the proportion of semi-skilled manual workers increased in the case of immigrant women from 27 to 39.5 per cent. While male immigrant supervisors and skilled workers increased by 5.5 points and male semi-skilled workers by 2.4 points, immigrant women in the corresponding categories increased by 2.1 and 10.3 points, respectively. The gap has considerably widened, by 7.4 points. This deterioration appears to be much more severe than that suffered by French women between 1962 and 1968, another period during which more and more women were going out to work and when the gap between French male and female unskilled workers (the equivalent category at that time) widened by 2 points[38]. The same trend can be seen in Germany throughout the period: for skilled workers, the gap between immigrant men and women increased from 18.2 points in 1968 to 20.16 points in 1972 and 25.6 points in 1980[39].

The recession, the growing number of young immigrant women arriving on the labour market and the direction taken by immigration policies have certainly been key factors here. Many female immigrants, much better educated than their predecessors, have been obliged to accept and remain in jobs well below their qualifications, which may not be recognised.

Immigrant women therefore join the labour market on inferior terms, even though important changes are taking place both in their education and in their aspirations. There is thus no doubt that discrimination exists.

5. FACTORS AND TRENDS

This summing up gives a clearer idea of the importance of certain parameters such as language and cultural difficulties, education and vocational training, and the legal problems raised by immigration policy. Some of these are changing rapidly. What is to be attributed to structural factors on the one hand, and strictly discriminatory behaviour and regulations on the other?

A. "Human Capital"

The labour market inequalities of immigrant women are usually attributed to their inferior education and vocational training and to language and cultural barriers.

Cultural differences in themselves do not seem to play a major role. Often posited as a cause of the participation rates of immigrant women (even though their rate may well be higher than that of local women), they play hardly any part at all, as witnessed by the wide variations in the participation rates of women of the same nationality in different countries. During the 1970s, for example, Turkish women participated at very different rates in the labour forces of Germany (57.6 per cent in 1970), Austria (52.6 per cent in 1971) and Australia (over 70 per cent), as against countries like France (10.6 per cent in 1975) and Belgium (9.5 per cent). The labour market plays a far more important role.

The language barrier is harder to assess. It is generally accepted that immigrant women are on the whole less familiar than men with the host country's language. In 1980, for example, 25.6 per cent of the immigrant women in Germany knew no German, as against only 7.8 per cent of the men. This is partly because women participate less in the labour market (the language being learnt mainly at work), partly because women coming to join their husbands have not been in the country as long and partly also because the role of keeping up traditions devolves upon the immigrant woman. Unfamiliarity with the language impedes the acquisition of skills and, in particular, access to vocational training, just as it does for a man. But for a woman with family responsibilities, it is also a severe handicap in running the home and coping with administrative problems, while, as regards employment, it is an insurmountable obstacle to access to the most highly prized jobs in the tertiary sector. Nevertheless, level of education stands out as the most important factor; language is not an obstacle for the most highly qualified women immigrants (e.g. refugees).

The role of education in the integration of immigrant women becomes obvious from a comparison of highly-qualified immigrants (to Australia and Canada) with those who have less schooling. Here, the differences are very marked, in the short as well as the medium term. However, for immigrant women with an average (i.e. secondary) education, like some recent arrivals in European countries, the differences are much less obvious in the short term and the jobs taken are often identical. There are not enough data at present to assess medium-term trends. If immigrant women overall have a lower level of schooling than immigrant men, it seems that – as is the case for the female population as a whole – even when levels of schooling are the same for women and men, the former are still at a disadvantage in the labour market[40].

Literacy training, however necessary a basic provision, cannot therefore be expected to solve the problem of finding jobs for an immigrant female population for whom illiteracy is a marginal problem and whose average educational level is rising rapidly. It is more a question of the level of schooling necessary for access to vocational training, from which immigrant women are practically absent, and of the type of education received, as with the rest of the female population. Second-generation immigrant girls, some of whom are theoretically better educated than boys (because they have been more successful at school and enter the labour market later), are at an especial disadvantage here. However, in some countries, more immigrant than local girls take traditionally male vocational training courses[41].

B. Regulations

In the OECD countries generally, most women's rights legislation does not discriminate in any way against female immigrants. But, like all foreigners, immigrant women in several countries encounter legal barriers on their access to and mobility within the labour market

built into immigration policies. This has been widely studied. Countries fall into two distinct groups: those such as Australia, where immigrants have the same freedom of employment as nationals, and those such as the countries of Western Europe that impose severe restrictions on labour market access and mobility (except within the EEC for nationals of an EEC country, who are in principle entitled to freedom of movement of employment, as in Scandinavia, where freedom of employment exists for the citizens of the Nordic countries).

There is generally a preliminary period of one to three years in which employment is confined to one job or one industry, and often one region, followed by a second period in which the immigrant has more freedom but has to obtain and/or extend a work permit. Only dependent employment is permitted in many cases, special permission being required for self-employed craftsmen, traders, etc.

For women, labour market access and mobility restrictions are generally more severe than for men, and some have increased in recent years. These restrictions are more stringent partly because the great majority of immigrant women enter a country on a family reunification basis, even though they may intend to look for work at once. Any rights they may have are acquired indirectly. Many of the "labour immigration" countries, in contrast to "settlement" countries, restrict the right of a newly arriving spouse to work (making it depend on how long her husband has spent in the country, granting a work permit in the light of the employment situation). A large number of countries have restricted this right still further since 1974. France tried to limit family reunification, and then only to allow it subject to exclusion of the wife from the labour market (1974). This could not be enforced, but up to 1981 it was standard administrative practice to refuse a work permit to any woman who could be legally turned down, and to limit the issue of more privileged residence and work permits. Only in 1981 were labour market restrictions lifted for all women entering the country for family reunification (previously, only women of certain nationalities could enter freely under the improved terms of bilateral agreements). In Germany, following a period in which wives entering after 1974 were wholly barred from the labour market, a waiting period was introduced as from 1979: although newly-arrived wives or husbands could, as mentioned above in the case of France, be refused access on account of the employment situation, they were granted a permit after a waiting period of two to four years, depending on their nationality and the industry concerned. Access was restricted to industries that were particularly short of manpower. By 1982, 77.6 per cent of immigrants needing a work permit were in possession of one generally giving unrestricted access.

The permit for the wife usually depends in the first place on her husband's residence and work permits. There are very substantial differences in one and the same country concerning both a woman's access to and her mobility within the labour market, depending on her nationality. The status of wives depends very largely on bilateral agreements (between France and Portugal, and between Germany and Greece, Spain and Turkey).

But the unequal treatment of women also stems very largely from the indirect impact of the regulations. How many women have been entitled to enter a country as workers in the same way as men and thus with rights of their own rather than of a family reunification basis? To what extent have their possibilities of direct immigration been reduced by conditions concerning employment sector or level of skill, giving the benefit to industries in which few women are employed? Is entry granted as easily to a wife migrating on her own, to a woman with dependent children or to a single woman as it is to a man in the same situation? In fact, immigration for employment is mainly confined to men in every OECD country, while most immigrant working women enter the country via family reunification.

A further question is whether a woman has the same chance as a man of obtaining the status that will give her more mobility on the labour market. The detailed statistics available

for Switzerland[42] do not reveal any great imbalance. However, no male/female breakdowns are available in other countries for the different kinds of permit. Yet women might be indirectly discriminated against here: conditions such as having worked continuously, never having been unemployed, holding certain qualifications for the job held or having completed a certain period of residence are all disadvantageous to a woman (due to childbearing, work in domestic service, often undeclared, higher unemployment rates, more frequent returns to their own country to attend funerals or to look after sick relatives, higher proportion of employment in less qualified jobs and in declining industries).

But identical provisions for both sexes can also militate against women because particular regulations may matter more to them because of their special impact on female employment, as when access to the civil service or to self-employed occupations is reserved for nationals (teaching, health, commerce, hairdressing, etc.).

Lastly, the relative dependence of most married women on their husbands (the employment and mobility of the husband taking priority), bears even more strongly on immigrant women when there are restrictions on access to the labour market. The labour markets for immigrant men and women are not necessarily the same. Yet the male employment situation is the reference where the regulations allow women to be refused a work permit.

Finally, there is the problem of the dependence of a woman's residence or work permit on her husband's in the event of divorce or separation. In most cases, it is customary to grant the woman a work permit or to extend it. But that is only a matter of practice, more entrenched in common law countries with their concept of acquired rights. This is a major source of anxiety for women at a time when the rates of divorce, separation and even desertion (also affecting immigrant women from the Maghreb) are rising. Problems of access to social insurance benefits can also arise for married women whose entitlements depend on their husbands' residence and work permits. This reinforces the unequal treatment of men and women in social security systems studied in Chapter VI. The problem is particularly serious in the case of women migrants arriving for family reunification, whose only rights are likely to be those derived from their husbands.

These discriminatory effects are considerable but have been little studied: mobility to higher-grade jobs, which is already inhibited by the educational factor, is still further limited by restrictions associated with the different kinds of work permit, for example permits confined to one industry. However, these restrictions and the tighter rules introduced as a result of changes in immigration policy aimed primarily at barring immigrant women's access to the labour market have run up against the general trend of female labour market participation: like other women, immigrant women have not withdrawn from the labour market since the recession set in; their participation has been just as rigid as revealed both by the rise in participation rates and the heavy flow into unemployment.

To sum up: in one way or another, women have continued to enter the labour market. Tightening the restrictions (as in France and Germany) probably even accelerated entry to the labour market perversely by fuelling uncertainty about the future and persuading immigrant women that having a job, with or without a work permit, would be a guarantee of preserving or obtaining their rights. These regulations therefore had the effect of boosting domestic service and increasing undeclared employment. They have been one of the contributory factors to the expansion of the underground economy.

C. Discrimination

In some cases, an immigrant woman may suffer direct discrimination because of her nationality or sex, irrespective of her educational level, skills, legal status or availability to

work. Whereas in less attractive sectors, especially industry, immigrant women in some countries are making their way into traditionally "male" jobs and training courses, a young immigrant woman can encounter racist and sexist obstacles in the more attractive parts of the tertiary sector regardless of her qualifications. In countries like France and Belgium, young women from the Maghreb countries are particular targets. Sex discrimination therefore varies appreciably according to sector of activity in the case of immigrant women.

6. CONCLUSIONS AND POLICY DIRECTIONS

The salient points in the situation of immigrant women appear to be:

- A high concentration in all occupations which relieve local women of housework and child-care duties, and in industries deserted by them;
- Heavy concentration in the underground economy either illegally (without papers) or in undeclared employment. Here, too, they have often replaced local women in out-work and like them are not covered by the regulations or protected against exploitation;
- A specific type of work organisation, both in the pace of work and in working hours (unsocial, long and/or irregular), made all the more arduous since housework and child care often involve special problems (poor housing conditions, and inadequate familiarisation with local conditions and the administrative system – something largely left to women);
- Lack of mobility, since discrimination is apparently worsening in the long term and some of the progress ostensibly made does not concern the oldest established women immigrants but is due rather to the different situation of more recent arrivals and "second-generation" women, accompanied by the de-skilling of jobs in newly penetrated sectors.

Policies for immigrant women should be concerned above all with the growing heterogeneity of the immigrant female population in all OECD Member countries, with the likely continuation of female immigration due to family reunification and the growing tendency for women to emigrate independently and even illegally, and with the increasing participation of immigrant women in the labour force. It would be a mistake to think that in future immigrant women, and particularly young women of foreign origin, will have less need to participate in the labour market than men.

As things are, the various forms of inequality, already considerable in the past, can only become worse. This is because immigrant women seem to be the prime target for changes in immigration policy, which was already discriminatory. A major trend appears to be emerging in favour of greater limitation of access by wives to the labour market. Immigrant women, it appears to be thought, are more flexible than the rest of the population as regards employment, and could help to reduce unemployment by remaining outside the labour market. This might simply mean that more immigrant women join the underground economy, while the integration of earlier immigrants into the labour force is hampered.

Returning home poses special problems: returning migrants have high female participation rates[43]. Re-entry into the labour market and loss of independence for those who invest capital in their own business, shop, etc., are problems that have received little attention. But, as for immigrants in general (and probably even more so for women, since returning home means confronting a more traditional society), only a minority of immigrant women can be expected to return to their home countries and no anti-discriminatory policy on their behalf

ought to be based on that eventuality. For women who do return, rights to social security benefits earned abroad should be maintained.

Much progress could be made by removing legal obstacles (labour market access and mobility, problems concerning indirectly-acquired rights) which entail discrimination as compared with male immigrants, local women and immigrant women from other countries. The fact that the immigrant female population is becoming increasingly heterogeneous means that policies must be diversified, especially to address the problems of vocational training, in which immigrant women are very much under-represented. Differing needs for literacy training, secondary education and vocational training must not be confused.

Generally speaking, no policy to promote equal opportunities for women can work if progress by some women means worse conditions for others, particularly if domestic work, although no longer performed free of charge, is simply transferred to other women.

The situation of migrant women in the OECD countries is different depending on whether countries admit their immigrants on a permanent basis, with the rights of full citizens, or not. Temporary immigration (although migrant workers are tending increasingly to stay on in the host country) is found in most European countries, while permanent immigration mainly concerns the United States, Australia, Canada and New Zealand. Generally speaking, a review of the different policies, measures and programmes adopted by the immigration countries to help foreign workers and their families should, in principle, distinguish between the various kinds and degrees of assistance required for the different categories of immigrant women – single, married, refugees – and also for women of different cultural backgrounds. In consultation with the group concerned and in compliance with the rules and principles of the host country, care should be taken to maintain links with their former culture and language while providing sufficient help for successful settlement; their cultural identity should be preserved if they so desire.

Whatever measures are implemented with a view to temporary or permanent settlement, they must take account of the unique problems of women immigrants. Most of them – though by no means all – join their husbands under family reunification policies; some are isolated because of child-rearing responsibilities and, unlike male immigrants, may not at first have sufficient contacts with the people of the host country to be able quickly to pick up its language, customs, standards and laws and to grasp the arrangements concerning the welfare and medical services. They often cannot read newspapers, official notices and the instructions on household products. They do not speak the host country language well enough, besides often lacking the necessary education and skills to enter the labour market. Very often, their isolation is due to the fact that they work both day and night (in their own homes and in jobs with long working hours), and it is also quite frequent for husbands to forbid their wives any recreation outside the home without their permission. The adjustment process for migrant women should therefore also include a programme of briefings for husbands to explain the needs and problems of their spouses in the new cultural environment.

The information and statistics available in most countries are too sparse properly to identify the special problems confronting the various groups of women immigrants. Data on these women ought to distinguish between their very different categories. The following information is required to gauge the problems and find appropriate solutions for the different groups of immigrant women and would also be useful in the case of men:

- Level of education and last occupation before entering the host country; entry status; proportion of emigrants intending to enter the host country's labour force; industries and occupations migrants would like to go into as compared with their present job; and participation rates of male and female immigrants compared with the working population of the host country.

Improving migration statistics is already included in the programme of the Working Party on Migration. Basic data on age, marital status, number and age of children, educational attainment and the employment status of the spouse should be collected systematically.

A. Equality of Treatment

The legal status of "migrants" differs according to country (e.g. freedom of movement for EEC countries and between Nordic countries, under bilateral agreements, or permanent or temporary immigration). Moreover, the criteria for granting residence and work permits vary from one country to another and depend to a large extent on the host country's economic situation. The first work permit is generally for a fixed term and limited to one employer or one specific job. Temporary immigrants cannot usually choose or change their area or kind of work without permission.

Immigrant women workers, if this should not be the case, ought to be entitled in the same way as nationals to coverage by the labour and industrial standards legislation and hence by the existing measures prohibiting discrimination in employment, recruitment, training, promotion and working conditions, and establishing equal pay for equal work, and by all the other provisions of the host country's industrial relations legislation.

Single immigrant women are in the minority and normally have the same legal status as immigrant men, but when they marry they should not lose their acquired rights. The employment status of women immigrating to join their husbands seems to suffer greater discrimination in certain countries. Their residence status in the host country legally derives from that of their spouse and main family support, and women, more frequently than men, can lose their right of residence because of illness, lack of money, unemployment, poor housing, divorce, etc. Member country authorities may wish to consider whether the legal status of immigrant women should not be more adequately protected against unforeseen changes in their material and family circumstances.

The legal status of immigrant women should not be solely dependent on their marital status, and when that changes, they should be awarded residence and work permits subject to the same conditions as immigrant men. Female immigrants should have the same status as men if they are able to meet the residence and work permit requirements laid down by the host country's immigration policy with respect to employment, financial resources and housing.

B. Measures of Assistance

When immigration is permanent, the purpose of policies to assist immigrant women is to enable them to play a full part in the society and economy of the host country. Permanent immigration countries are usually well equipped with information and initiation programmes, and generally treat immigrant men and women on an equal footing with their own male and female citizens. In the countries with predominantly temporary immigration, the process of integration starts where necessary by learning the language, followed by a gradual induction into the host country's culture and institutions. Such initiation programmes and the education of children should be accompanied by measures to safeguard the cultural and traditional values of the immigrants and their children so as to facilitate their voluntary return to their home countries.

Indeed, the situation becomes more complicated when immigration is intentionally temporary; the motivation for complete adjustment and integration is reduced when immigrants arrive already intending to return home to their own country.

Mothers who have emigrated for a fixed period may have little opportunity or pressing need to learn the host country's language and consequently are often unable to acquire a basic education or to go on a training course to improve their skills, even though, soon after joining their husbands, they take a job to help support their families and save often with a view to cutting short their period of immigration. But even then, the return may often be postponed (for children to complete their schooling, for example) and, in the meantime, the immigrant woman experiences adjustment problems which compound her disadvantages. Indeed, such women are ill-prepared even for badly-paid temporary jobs which offer no opportunity for promotion and demand very long weekly hours. Moreover, the incidence of unemployment is more frequent among women immigrants than among men because their educational and training levels are not high enough to help them retrain for another job. At the same time, they often have large families and this extra burden is too heavy to allow them free time outside working hours for training or social participation. Equal employment opportunities, therefore, do not really exist for these immigrant women, who usually manage only to get low-grade unskilled jobs. In fact, they often fail to take full advantage of those rights they do have because of lack of information, lack of training, and lack of time and motivation.

Because immigrant women are not granted the same facilities as men, the European host countries in particular should put more emphasis on initiation programmes to help them participate in the labour market and community life and, above all, set up vocational training programmes for the different categories of women to improve their employment prospects.

Not only is government assistance required, but it is also incumbent on employers and the trade unions to inform these new workers of industrial and social rights and give them more training facilities. This assistance will also enable temporary migrants to return home to their own countries more highly skilled and better equipped. The programmes and measures listed below should, as far as possible, be introduced and co-ordinated with the emigration country so that they do indeed correspond to the cultural characteristics and educational levels of migrant women.

To sum up, the programmes and measures which might be introduced or strengthened in host countries by national authorities, employers and trade unions include:

a) Teaching the host country's language;

b) Providing more information about the social environment and the social services available (child care, medical care);

c) Particularly for women from rural backgrounds, providing information on the conditions of urban life;

d) Introducing immigrant women workers to the occupational environment, including industrial rights and obligations, education and training facilities, work habits and new skills;

e) Action by trade unions to encourage immigrant women to join and take part in their decision-making activities, inserting provisions in collective agreements to promote and protect the interests of immigrant women;

f) The provision of multilingual support services in case of industrial illness or accident;

g) Measures to safeguard cultural values with a view to a possible return home, together with information on the transfer of social security benefits, investment of savings and on employment prospects in their own country in the fields in which they have been trained in the host country. This, of course, implies no pressure to naturalise. Measures to aid reintegration on return should be shared by the host countries and the countries of origin.

These programmes and measures should be developed in close co-operation with immigrant women and their organisations.

C. Women Immigrants and Unemployment

Immigrant women are often concentrated in industries which are hard hit by the economic recession and are more frequently unemployed and for longer periods than immigrant men. The measures and programmes designed to help nationals of the host country to secure similar employment and the training entailed should also be available to unemployed immigrant workers, including women. However, other special measures, such as more advanced training in the host country's language, information and vocational training, initiation to trade unions and progressive desegregation of the labour market, will help women immigrants to obtain more skilled and better-paid jobs. Not only will these measures improve immigrant women's employment prospects, but they will also equip them to be self-sufficient in the event of widowhood, divorce or desertion.

NOTES AND REFERENCES

1. OECD, *Women and Employment: Policies for Equal Opportunities,* Paris, 1980, pp. 153-154.
2. United Nations, *Labour Supply and Migration in Europe: Demographic dimensions, 1950-1975, and Prospects,* 1979.
3. M. Estellie Smith, "The Portuguese Female Immigrant: The Marginal Man", *International Migration Review,* Vol. 15, No. 1, 1977.
4. In France, where the results of the 1982 census are not yet available, the latest figures on immigrants date from 1975.
5. Douglas S. Massey, "Background and Characteristics of Undocumented Hispanic Migrants to the U.S.", *Migration Today,* Vol. XI, No. 1, 1983.
6. OECD, SOPEMI Report 1982, Paris, 1983, p. 13 (document for general distribution).
7. For a detailed discussion of this, see Marion F. Houstoun, "Aliens in irregular status in the United States: a review of their numbers, characteristics, and role in the U.S. labor market", *Intergovernmental Committee for Migration: Sixth Seminar on Adaptation and Integration of Immigrants.* Geneva, 11-15 April 1983. Information Document No. 35.
8. Yann Moulier, Roxane Silberman, "La montée de l'activité féminine, une tendance qui va s'accentuant", *Travail et Emploi,* ministère du Travail, Paris, No. 12.
9. Douglas T. Gurak and Mary M. Kritz, "Dominican and Colombian Women in New York City. Household Structure and Employment Patterns", *Migration Today,* Vol. X, No. 3/4, 1982.
10. Maria Borris, *Ausländische Arbeiter in einer Grossstadt,* Europäische Verlaganstalt, Frankfurt/Main, 1973.
11. Claude V. Marie, "L'immigration clandestine en France", *Travail et Emploi,* No. 17, 1983, pp. 28-30.
12. Roxane Silberman, Yann Moulier, Souad Harchaoui, Hafedh Chekir, *Les femmes immigrées et l'emploi, Nouvelles tendances,* Ministry of Labour, France, 1981.
13. Australian Bureau of Statistics. *The Labour Force, Educational Attainment,* Canberra, 1980.
14. Bundesministerium für Arbeit und Sozialordnung, *Repräsentativuntersuchung,* Bonn, 1972.

15. Hofmann, R., *et al.*: "Situation der ausländischen Arbeitnehmer und ihrer Familienangehörigen in der Bundesrepublik Deutschland" – *Repräsentativuntersuchung*, 1980, Forschungsbericht des Forschungsinstituts der Friedrich-Ebert-Stiftung im Auftrag des Bundesministers für Arbeit und Sozialordnung, Bonn, 1980.

16. W.F. Heinemeijer *et al.*, *Partir pour rester, incidence de l'émigration ouvrière à la campagne marocaine*, REMPLOD Project, Socio-Geographical Institute, University of Amsterdam, (Pub. No. 2), The Hague, 1977.

17. Margo Corona De Ley and Rita J. Simon, *Female Immigration and Illegal Work: findings of survey among Mexican women working without papers in the Los Angeles region*, University of Illinois and Urbana-Champaign, Urbana-Illinois (forthcoming).

18. Sheldon L. Maram, with S. Long and D. Berg, *Hispanic Workers in the Garment and Restaurant Industries in Los Angeles County*, University of California, San Diego, Working Papers in U.S. Mexican Studies 12, 1982.

19. Moulier, Silberman, *op. cit.* in note 8.

20. Silberman, Moulier, Marchaoui, Chekir, *op. cit.* in note 12.

21. No data are available on this point: the 1972 *Repräsentativuntersuchung* in Germany does not indicate less use of public facilities as compared with German women. In the United Kingdom, on the other hand, a 1975 survey revealed greater use by the family: *A study of working mothers and childminding in ethnic minority communities*, Communities Relations Commission, July 1975, London, p. 23. The survey carried out in France in 1981 showed that a large number of Turkish women working in eastern France left their children at home in Turkey with their mothers, see Silberman *et al., ibid.*

22. United Nations, *op. cit.* in note 2.

23. Statistiska Centralbyrån (SCB), *Arbetskraftsundersökningen* (labour force surveys) Stockholm, 1977, 1980.

24. Roxane Silberman, "Femmes immigrées, une discrimination supplémentaire sur le marché du travail?", *Revue du Greco* 13, Centre National de Recherche Scientifique (CNRS), Recherches sur les migrations internationales, No. 4/5, 1982.

25. Haavio-Mannila E., "Level of Living of Migrants in Sweden", mimeograph, EIFO, 1979.

26. Claude Marie, "L'immigration clandestine en France", *Travail et Emploi*, No. 17, 1983, pp. 27-40.

27. Community Relations Commission, *A study of working mothers*, *op. cit.* in note 21.

28. Maram, *op. cit.* in note 18; De Ley, *op. cit.* in note 17.

29. M. Morokvàsic, *Yugoslav Women in France, Germany and Sweden*, CNRS Research Report, Paris, 1980; Silberman, Moulier, Harchaoui, Chekir, *op. cit.* in note 12.

30. Moulier, Silberman, *op. cit.* in note 8; I.T. Leonetti, F. Levi, *Femmes et immigrées. L'insertion des femmes immigrées en France*, Documentation française, Paris, 1979.

31. A. Lebon, *Migrants' Children and Employment – The European Experience*, OECD, Paris, 1983.

32. Maram, *op. cit.* in note 18.

33. 1975 Census, France.

34. Silberman, *op. cit.* in note 24.

35. Moulier, Silberman, *op. cit.* in note 8.

36. *Ibid.*

37. Saskia Sassen-Koob, *Exporting Capital and Importing Labour: The Role of Caribbean Migration to New York City*, Center for Labor and Caribbean Studies, New York, 1981.

38. Silberman, *op. cit.* in note 24.

39. This calculation is based on data from the 1972 and 1980 *Repräsentativuntersuchung*, both quoted above. Although the figures are not entirely homogeneous, the trend shows up sufficiently strongly to be taken into account.

40. This is the case in Canada.

41. Lebon, *op. cit.* in note 31.

42. 1981, 1982 and 1983 SOPEMI Reports, OECD, Paris (documents for general distribution).

43. Michel Poinard, *Travail féminin et projet de retour*, Université du Mirail, Toulouse (forthcoming).

Chapter V

THE POSITION OF GIRLS AND WOMEN
IN EDUCATION SYSTEMS OF OECD COUNTRIES

1. INTRODUCTION

The objective of equality between the sexes in education and training was embodied in the declarations of the Ministers of Education in OECD in October 1978 and of the High Level Conference on the Employment of Women in April 1980[1]. The Ministers of Education gave priority to the adoption of "educational measures which contribute to the achievement of equality between girls and boys, women and men". The High Level Conference agreed on the aim of developing education "to provide a full range of educational choices for young women and young men, both for further education and skill qualifications for employment". The European Ministers of Education, at their Eleventh Session of the Standing Conference in 1979, were even more explicit about the need to see educational equality between the sexes extend beyond a concern for more equal formal *opportunities* in order to embrace equal educational *outcomes:*

"In order to promote real equality of opportunity, educational policy should aim not only to provide equal access in formal terms, for boys and girls, or men and women, to all stages and sectors of the education system, but also, without doubt, to achieve practical equality of access to equally valuable educational provision."

It is thus critical to focus upon instances and areas where inequalities between the sexes in education and training remain outstanding and upon the barriers and impediments that frustrate more equal chances. Many studies have demonstrated the enduring nature of female educational disadvantage. Despite progress in overall participation levels, significant differences remain and a continuing division between the sexes is still clear in terms of subjects studied, particularly in vocational education and training. The removal of formal barriers of access to girls and women is by no means tantamount to realising actual equality of educational opportunity and results.

This chapter examines the position of girls and women in education systems of OECD countries based largely upon the evidence of nationally representative statistics[2]. There is thus much more extensive treatment of education rather than training where comprehensive data are extremely difficult to collect and few statistics exist (except from smaller-scale and local studies). For this reason, it excludes discussion of in-firm training and management training, areas that are critical ones for women. The chapter seeks to describe the patterns of inequality between the sexes in education rather than analyse and explain them, which would require much more extensive treatment and would have to take account of differences in national systems. The main patterns of sex inequalities in education are outlined, inequalities that are fundamental to the labour market and employment inequalities described in Chapters I and II.

121

2. HIGHER FEMALE PARTICIPATION

A. Compulsory Schooling

In compulsory schools, where enrolment levels are near 100 per cent almost everywhere, the main visible inequalities between the sexes are in the choices and attainments in the different school subjects, as will be discussed below. Where there is institutional separation at the lower secondary level, into selective and non-selective schools or into general and vocational branches, the question is examined of girls' participation in these different institutional settings. Are girls under-represented in selective secondary schools, in countries where these are found?

Germany is one of the countries that has selective lower secondary schools. Here, the proportion of girls in the prestigious *Gymnasien* has increased noticeably over the last fifteen years. From under-representation in 1965/66 at 42.2 per cent, by 1981/82 girls made up just over 50 per cent of the lower secondary *Gymnasien* rolls, which is higher than their numbers in the relevant age group. In the intermediate schools, or *Realschulen,* girls also outnumber boys, the corresponding figures being 51.5 per cent for 1965/66 and 53.6 per cent for 1981/82. About half the selective, secondary school population is female in Switzerland too. The United Kingdom has retained a minority of selective secondary schools alongside the comprehensive system. Girls comprised over half the compulsory grammar school pupils both in 1965 (50.6 per cent for England) and in 1979 (51.9 per cent for England and Wales).

The problem, therefore, is not the extent of participation, but the relevance of girls' education for employment. Where there are separate general and vocational institutions or branches, there is a pattern that is similar across a number of these countries. Girls tend to be evenly or over-represented in the general institutions or branches and under-represented in the vocational ones. In Austria, for example, 48.1 per cent of general compulsory pupils were girls in 1981/82 but they were only 33.0 per cent of students in vocational schooling, both proportions having altered little throughout the 1970s. A similar pattern is seen in the Netherlands and Belgium.

This important difference becomes more striking still in the subsequent stages of education and training. In short, it seems that vocational preparation at the compulsory school level is regrettably weak: girls who are early school leavers tend to be particularly ill-prepared for the labour market, while girls who stay at school seem in many cases to be responding to lack of job opportunity, although their extra length of schooling does not necessarily provide further preparation for employment.

B. Post-secondary Education

In upper secondary schools, and post-compulsory education generally, the trend once again is of higher levels of female involvement compared with ten to fifteen years ago. Much depends upon the branch of education pursued. In the general, long-cycle lines of study, the numbers of young women now equal or exceed those of young men. In the more directly vocational lines or sectors, however, women still tend to be in the minority, sometimes markedly so, especially in training such as apprenticeships. Striking disparities persist in access and choice of subjects.

A summary of the main patterns of girls' enrolment in post-compulsory secondary education for some countries is contained in Table V.1. In most countries young women make up about half or more of the students and trainees. Aggregating the different forms of upper

secondary schooling and vocational education, of the eleven countries covered by Table V.1, Australia, Canada, Finland, France, Japan, Spain and Sweden all show proportions at, or near, 50 per cent. Levels of female post-compulsory secondary enrolments in Italy and the Netherlands are only slightly below their proportion in the total 15-19-year-old population. This leaves, from the countries covered in Table V.1, only Germany at 46.6 per cent and Austria, with a 41.5 per cent share.

Looking beyond the countries covered in Table V.1, and at establishments mainly within educational administrations, several other countries also show that young women now participate at the upper secondary level in equal or greater numbers than young men. This is apparent in Belgium, Ireland, Luxembourg, New Zealand, Norway, Portugal, the United Kingdom, and the United States. Indeed in some, women make up well over half of the upper secondary student body. In addition to Finland (see Table V.1), the figure for Belgium in 1979/80 is 56.2 per cent, while in Ireland it stood at 57.4 per cent in 1980. The rate of growth of participation of young women at this level has varied. In some countries, the growth has been steady throughout the last decade or more. Others, on the other hand, have witnessed change of particular rapidity. In only fifteen years in Spain, the proportion of young women in upper secondary education grew from little more than a quarter of post-compulsory students to a half by 1980 (Table V.1). In Australia, a clear over-representation of males staying on in the last three years of secondary schooling at the end of the 1960s was reversed by the middle of the 1970s, and now significantly more young women remain in upper secondary school.

The pattern of a female advantage of numbers in general education, and a male advantage in vocational education and training is seen too in Denmark, France, Greece, Ireland, Norway, Portugal, Spain and Finland, where over 60 per cent of general students are women. In a number of other countries, the picture is only slightly different in that young women and men are approximately evenly balanced in the general courses. The last fifteen years in Germany, for example, have seen a rapid growth in female participation in the *Gymnasien* after the end of compulsory schooling, their share rising from only 37.8 per cent in 1965/66 to approximate equality with men (49.7 per cent) by 1981/82. Since general upper secondary education prepares students for entry to higher education, this progress should once again not be underestimated, but it has to be qualified by the reservations considered below concerning the value of female lines of study for entry to the labour market.

Moreover, there is some evidence to suggest that the qualifications obtained in general post-compulsory education are rewarded differently for young men and young women in the labour market and that there is greater incentive for young women to stay on in order to achieve them. For instance, in the case of the United Kingdom, Raffe[3] found that boys who stayed on at school considerably reduced their chances of getting jobs, whilst there was an improvement for girls.

Because of the increase in female participation in the general upper secondary branches almost everywhere, it is not surprising that young women now study mathematics and science in greater numbers, even if the increase can often be described as little more than modest. Two examples from Scandinavian countries show that progress can be more rapid. About half of the young women in the upper secondary *Gymnasien* in Denmark, for example, now pursue the mathematics line, compared with only 34 per cent in 1970, and in Norway the evolution has been equally noticeable. While in 1966 only about a fifth of science "Artium" candidates were girls, the proportion had approximately doubled by 1980 (41.4 per cent). These examples are not, however, indicative of a significant trend towards breaking down of the traditional choices of school subjects by sex. Not only has progress in this regard been less marked in a number of other countries, but very few girls study technical and applied sciences, while their

Table V.1. **Percentage of girls in different types of secondary education and in the total of post-compulsory secondary education: 1965-80**

	School year beginning in:			
	1965	1970	1975	1980
Australia				
Secondary 2nd cycle	45.3	46.3	48.7	50.9 (1981)
Austria				
Upper-primary	—	51.2	50.3	49.0 (1979)
Secondary 1st cycle	—	43.5	45.3	47.4 (1979)
Secondary 2nd cycle	—	47.7	51.8	52.4 (1979)
Pre-vocational year	—	42.9	39.4	38.0 (1979)
Comprehensive schools	—	—	—	48.4 (1979)
Technical: short	—	73.1	55.5	48.5 (1979)
Technical: long	—	30.7	34.6	41.9 (1979)
Professional: part-time	—	33.1	31.4	32.3 (1979)
Total secondary post-compulsory	—	42.8	41.4	41.5 (1979)
Canada				
10th year and beyond	48.2	48.7	49.1	49.1 (1981)
Finland				
General-Gymnasium	56.1	57.5	59.3	61.0
Vocational	—	—	46.7	47.1
Apprenticeship	—	—	37.2	46.0
Total secondary post-compulsory	—	—	53.1	54.1
France				
2nd cycle general	50.9	53.8	55.7[a]	57.0 (1978)[a]
Vocational short	54.7	49.4	47.5	46.8 (1978)
Technical	35.6	47.8		
Apprenticeship	—	21.2	21.4	23.1 (1978)
Total secondary post-compulsory	—	47.7	49.5	49.7 (1978)
Germany				
Comprehensive school	—	—	48.3	48.4 (1979)
Middle "real" school	—	—	52.5	53.7 (1979)
Gymnasium 1st cycle	51.5	52.9	52.5	53.7 (1979)
Gymnasium 2nd cycle	42.2	44.7	48.4	50.1 (1979)
Technical/Vocational full-time	37.8	41.4	46.4	48.9 (1979)
Technical/Vocational part-time	63.3	51.6	55.2	55.4 (1979)
Total secondary post-compulsory	44.1	41.9	40.0	40.3 (1979)
	44.3	43.6	45.6	46.6 (1979)
Italy				
2nd cycle general	38.6	43.2	47.2	50.1 (1979)
Vocational	37.0	41.4	45.2	45.7 (1979)
Technical and artistic	23.8	25.9	32.8	37.9 (1979)
Teacher training	86.7	89.2	92.3	93.7 (1979)
Total secondary post-compulsory	39.4	41.6	44.3	47.8 (1979)
Japan				
2nd cycle general	52.2	52.9	51.5	51.3 (1981)
Vocational training	40.3	43.0	45.4	45.1 (1981)
Total secondary post-compulsory	40.8	48.8	49.2	49.9 (1981)

	1965	1970	1975	1980
		School year beginning in:		
Netherlands				
1st cycle general full-time	—	49.1	51.0	52.9
1st cycle vocational full-time	—	40.6	43.8	40.6
1st cycle general part-time	—	30.3	48.7	70.6
1st cycle vocational part-time	—	43.8	48.7	26.2
2nd cycle general full-time	—	41.7	45.4	49.5
2nd cycle technical/vocational full-time	—	46.4	41.0	43.6
2nd cycle general part-time	—	23.0	41.3	65.0
2nd cycle technical/vocational part-time	—	32.0	49.5	52.0
Apprenticeship	—	6.2	15.8	21.1
Training of young workers	—	56.6	54.8	58.1
Total secondary post-compulsory	—	37.6	41.5	48.0
Spain				
2nd cycle general/teacher training	40.3	43.2	48.8	53.5
Technical and other	29.5	33.5	60.3	64.0
Vocational training	3.3	5.1	28.9	37.9
Total secondary post-compulsory	27.3	37.5	46.4	49.8
Sweden				
3/4-year courses	—	42.3[c]	41.4	45.6
2-year courses	—	47.4[c]	51.8	51.4
Special courses[b]	—	46.8[c]	58.3	62.0
Total secondary post-compulsory	—	45.0[c]	48.9	50.7

a) Including technical education.
b) Courses of varying length: several weeks to a year or more, as preparation for a specific trade.
c) 1971.
Source: *Educational Trends in the 1970s: A Quantitative Analysis,* OECD, Paris, 1984, Table 24.

predominance in languages, arts and humanities has often become more, not less, clear over recent years.

C. Further and Higher Education

Changes in higher education are more difficult to summarise, not least because, taking OECD countries together, the non-university sector is comprised of such a wide range of courses and establishments serving an equally wide range of purposes. The proportion of women students in non-university education varies considerably from one institution to the next, and also from one country to another. The relatively low female share in non-university higher education in Greece (36.2 per cent in 1979/80), for example, can be contrasted with their three-quarter share in New Zealand (74.4 per cent in 1981).

In universities and their equivalent institutions, however, the trend of enrolments is a clear one towards greater equality, as Table 2 shows, even if women are still the minority of university students in most OECD countries.

As can be seen from Table V.2, some countries are much closer to attaining an equal balance than others; indeed, in one or two, women have begun to outnumber men. For new

Table V.2. **Percentage of women among the new entrants to higher education: university level (U) and non-university level (NU)**

				Academic year beginning in:				
	1965	1970	1976	1977	1978	1979	1980	1981
Australia[a]								
Universities		38.7[b]	41.4	42.2	43.4	44.5	46.1	46.7
CAE (degree level)[c]		24.7[d]	31.0	36.6	38.7	43.0	43.2	44.4
CAE (diploma)			59.6	61.3	63.2	63.7	61.5	57.4
Austria								
U		37.8[e]			47.0	46.2		
Belgium								
Total						38.8	41.5	42.3
Canada								
U				47.2	47.3	47.9	48.4	
NU						50.4	50.9	51.4
Denmark								
U	28.5[f]	31.5	39.4	38.8	39.4	40.5	40.7	
NU			58.4	49.8[g]	49.0[g]	47.1[g]	55.0	
Finland								
U	50.8	47.1	51.6	51.5	51.1	50.8	52.3	
NU	56.3	62.0	65.8[h]					
Germany								
U	32.4	37.8	38.5	42.8	42.9	41.6	43.4	45.2
NU		15.0	24.5	28.1	30.8	32.2	31.8	32.4
Italy								
U		36.5	41.5	42.7	44.3	44.6	44.8	45.4
Netherlands								
U	19.0	21.6	31.2	32.1	33.3	34.4	35.4	
Spain								
U	24.2	28.1	39.0	39.9	38.5	42.7	46.5	
NU			38.6	40.1	42.8	46.5	47.5	
Sweden								
U		41.4	47.9					
Total higher education after the reform					57.0	59.0	59.0	
United Kingdom								
Universities	29.8[c]	31.9	36.2	37.7	39.5	39.5		
United States								
U	44.0[f]	45.9	49.6	50.5	50.8	51.2	51.4	
NU	40.7[f]	42.2	50.8	52.9	53.7	54.5	54.4	
Yugoslavia								
U		35.9	38.5[i]	39.0	38.4	38.4		
NU		35.6	42.5[j]	37.7	37.4	38.7		

a) Full-time and part-time.
b) 1973.
c) CAE: Colleges of Advanced Education.
d) 1971.
e) 1972.
f) 1966.

g) Not including training of pre-primary teachers.
h) 1975.
i) 1968.
j) 1969.

Source: *Educational Trends in the 1970s, op. cit.*, Table 26.

entrants in university-level courses, both Finland and the United States have now surpassed the 50 per cent mark. While women have long enjoyed relatively equal access in the former, the female share of university entrants in the United States has grown steadily over the last fifteen years from 44 per cent in 1966 to 51.4 per cent in 1980. The Canadian figure is also high (it stood at 48.4 per cent in 1981) as is that for Sweden. Admittedly, the female majority in the latter – nearly 60 per cent in 1979 – covers both university and non-university types of education. Nevertheless, the figure is a high one and in 1976, the last year for which specific university data were available, women students made up only a little less than 48 per cent of the new university student body.

The clear division between the sexes in the subjects they follow, which already exists in upper secondary schools and colleges, continues in the courses women and men study in universities. With the overall increase in the share of female enrolments, rather more women now follow all courses – including scientific subjects: in medicine, the proportion of women is much the same as their average for university enrolments as a whole. Examples from other faculties, however, do not always show the same trend as will be seen below.

3. CONTINUING FEMALE DISADVANTAGES

A. School Subjects

During the later years of compulsory schooling, differences that appeared minimal at the primary school in gender choices and attainments in school subjects emerge clearly. By the time upper secondary schooling is reached, these patterns are clearly apparent.

Far fewer girls study mathematics and the physical sciences than boys and fewer still study technical subjects even though in most countries there has been some growth in female students in these areas. Consequently, the general increase of female participation has meant that the concentration of girls in subjects in which they were already over-represented has often become even stronger. This is a matter of concern, for such over-subscribed subjects may lose their value both in educational and in labour market terms.

Some examples show this very clearly. Young women now comprise nearly 60 per cent of total *baccalauréat* graduates in France. If the specific types of *baccalauréat* are examined, in less than the ten years between 1972 and 1981, the percentage of girls studying philosophy and letters (*baccalauréat* type A) had risen from 72.4 to 79.6 and within economics and social studies (type B) the corresponding rise was from 55.8 to 65.0 per cent. In contrast, they are still under-represented in the prestigious type-C *baccalauréat* (mathematics and physical sciences), though the proportion of girls has grown from 32.7 to 39.5 per cent during this time, and they are largely absent from the mathematics and technical sciences, type E *baccalauréat* making up a mere 4 per cent of successful students in 1981.

The proportion of girls studying the humanities and social sciences in the three- and four-year lines of upper secondary schooling in Sweden is equally striking. In 1980, no fewer than 85.6 per cent of these humanities students were girls as well as 72.1 per cent of social science and 60.3 per cent of economics students. In all three, these are higher than the corresponding proportions in 1975. In contrast, girls made up only 11.8 per cent of "technical students with special courses" and little more than a quarter of other science/technical students in three- and four-year lines in 1980[4]. Charting the same pattern in another Scandinavian country, in less than fifteen years in Norway, the proportion of female "Artium" candidates in languages has grown rapidly from an already high 64.8 per cent in 1966 to a predominant 84.5 per cent by 1980. The general pattern is reinforced further by examination

of GCE "A" level students in the United Kingdom. The female majority among students of the arts and humanities has continued to grow over the last fifteen years. Having stood at 56.5 per cent in 1965, the proportion of young women had reached 65 per cent by 1979.

Simultaneously there has been a drop in the number of boys who pursue these disciplines. The distribution between the sexes in the two main lines of the *Gymnasien* in Denmark – mathematics and languages – shows a male exodus from languages counterbalancing the trend towards greater evenness among young women between these two lines. Whereas a quarter of male upper secondary *Gymnasien* students were in the languages line in 1970 – already a clear minority – by 1981, this had fallen still further to 16 per cent. Nearly 85 per cent of young men at this level, in other words, pursued the mathematics lines.

The balance of the sexes in social science subjects is an interesting source of comparison between the different OECD countries. In some countries, the proportion of female students is rising, but not in all. In Norway, for example, the proportion of young women among social science "Artium" candidates fell significantly between 1976 and 1980, coincidentally as students of economics (where well under half the students were female in 1976) ceased to be separately classified. It could be that the balance of the sexes in the social sciences depends upon the emphasis of the courses. Where they are more theoretical, and oriented to economics, the more likely they are to attract male students. The more they are courses in commerce and administration and the general study of society, the more they may attract female students.

Despite the general modest trend towards greater female participation in mathematics and physical sciences, there are some countries where the levels remain low and where the traditional patterns of choice are eroding, if at all, only very slowly. Thus, while in the United Kingdom, GCE "A" level female scientists are on the increase, only 27.1 per cent of mathematics and science students were girls in 1979, even if this had grown from 21.7 per cent in 1965. The C *baccalauréat* in France and Switzerland – mathematics and physical sciences – have fewer female than male students: the French figure of 39.5 per cent in 1981 is relatively high compared with the Swiss female proportion of "C" *maturité* students – 20.7 per cent in 1982/83.

This persistent segregation is clearly important. To take a concrete example, mathematics, and the C *baccalauréat* in particular, have become increasingly sought-after in France for the additional competitive advantage that they have acquired in terms of future educational and job careers[5]. The languages and letters *baccalauréats* are devalued comparatively. The fact that the most valued courses and qualifications, as they change over time, remain male domains and that female growth in them is often slow, may well mean that this is only enough to ensure that the position of young women has not actually become worse. Educational advantage can therefore be characterised as a "moving target" and the fact that it does change renders the establishment of more equal chances especially problematic. It cannot be assumed that the changes described above are the consequences of deliberate policy to increase female participation: also important in increasing length of schooling are limited job opportunities for school leavers. Moreover, the concentration of girls and young women into certain fields of study helps to perpetuate labour market segregation, with all its consequences.

B. Vocational Education

In most OECD countries, girls and women remain at a disadvantage in vocational education. This is already apparent at the compulsory school level, as seen above. By the time students progress to post-compulsory education, the patterns become marked and in many courses and in many countries, young women are seriously under-represented. Sex differences

in apprenticeships are striking as are the rigid divisions into "male" and "female" branches along traditional lines. These divisions are breaking down, if at all, only very slowly.

In several countries, the female share of vocational establishments and branches at the upper secondary level is about 40 per cent of the students and trainees. In some cases, higher proportions are found. Thus in France, while young women comprise about two-fifths of the graduates of the CAP *(certificat d'aptitude professionnelle)*, they are more than half of the more advanced BEP *(brevet d'études professionnelles)*. In others, the female share is lower than the general average. In Denmark and Spain, the corresponding figures are between 35 and 40 per cent, while only a third of middle-level vocational students in Austria were women in 1981.

The rigid divisions by sex of the subjects pursued is more striking than the overall female under-representation. A simple way to demonstrate the extent of segregation is by taking cases where students and trainees have the choice of a number of vocational branches and then to identify those that display a relatively even balance between the sexes. Here the 40-60 per cent range for the distribution between males and females is adopted as a reasonable, if somewhat arbitrary, indication of a relatively even balance. A stark example of segregation by sex using this indicator is that of the students obtaining the CAP in France. In the twenty-two branches with more than a thousand successful students in 1980 (i.e. covering altogether nearly 230 000 students), none at all come within the 40-60 per cent range. Indeed, only two of the twenty-two branches fall within the 25-75 per cent range. The extremity of the division by sex in these courses is shown by the fact that of these twenty-two most popular branches, young women are less than 5 per cent of the successful candidates in over half of them. The example illustrates not only marked segregation but it also shows how young women tend to be more highly concentrated into a very limited number of branches – commerce, secretarial studies, paramedical, catering, clothing. In several of these subjects in the CAP, the degree of female concentration actually increased during the 1970s.

Similar comparisons can be made for upper secondary vocational students in countries as diverse as Japan and Norway. Again using the 40-60 per cent range indicator (and excluding the graduates from the "general" line), only the relatively small, residual branch "other" had an even balance of the sexes among the graduates from this level in Japan in 1981 (44.3/55.7 females to males). In the two most popular of these vocational upper secondary lines of study – industry and business (with about 150 000 graduates or more in each) – there were only 4 per cent women students in the former while almost 70 per cent in the latter. The same can be seen in Norway. Excluding general students in upper secondary education in 1979, none of the other seven lines of study had a balance of the sexes that came within the 40-60 range. Only 14.5 per cent of more than 35 000 students in the "Manual and Industrial" line were female, while making up two-thirds of the 20 812 students in commercial and clerical subjects. In only three of the sixteen two-year vocational upper secondary lines in Sweden did the male-female distribution come within the 40-60 range in 1980 and these were relatively small branches. Otherwise, the picture is the same: a marked separation of the sexes in each line of study with a particular concentration of young women into a small number of branches.

Extending the perspective to include apprenticeships introduces a sector of training where the general picture is one of clear male predominance. In some countries this has altered little. In others there has been somewhat more progress over recent years though women are still well outnumbered. A number of examples serve to illustrate the degree of female under-representation. Over 135 000 apprentices were in training in Australia in 1980, but of these a mere 6.7 per cent were women, the same proportion as in 1975, and this figure would fall to less than 2 per cent if apprentice hairdressers were excluded. The figure for New

Zealand is very similar. The United Kingdom, in manufacturing industries, is little different – a 3.2 per cent female proportion of apprentices and trainees in 1982 is even below that for 1965.

Such overwhelming male dominance in apprenticeships is not found everywhere, however. While still heavily under-represented, women made up some 20 per cent of apprentices in France and in the Netherlands in the mid-1970s and about a third in Switzerland in 1980. In the case of the Netherlands, the 1970s saw a sharp rise in the proportion of women apprentices: only 6.2 per cent in 1970, it had risen to 21.1 per cent by 1980 (Table 1). Germany, with its widely developed apprenticeship system, enjoys a more even balance between the sexes – and throughout recent years the female proportion of apprentices has stood between 35 and 40 per cent. The Finnish figure is higher still, and the overall balance between women and men is practically equal (46.0 per cent women apprentices in 1980).

One main reason why women are barely represented in this kind of training is because the apprenticeship system operates mainly in industrial and craft occupations, which are overwhelmingly male. Even in Germany, with its more broadly-based apprenticeship system, inspection of the situation in specific occupational fields reveals a familiar pattern of concentration and division by sex. Taking the 10 occupations with the most male trainees, on the one hand, and the most female trainees, on the other, the concentration of women into a small number of fields is again apparent. This cut-off point of the ten most popular training fields takes in only 40 per cent of the male trainees but the significantly higher proportion of about 60 per cent of the females. Of the ten most popular male training fields – which included over 400 000 young men in 1981 – in nine out of ten of them, women were less than a tenth of the trainees and, indeed, less than 1 per cent in half of them.

In oversimplified terms, there appears to be an approximate division between the English-speaking and the European countries. In the former, apprenticeships remain in traditional fields with very few women. In the latter, the apprenticeship system is more broadly based with correspondingly more female apprentices. It must be emphasized that apprenticeship systems themselves differ greatly from one country to another and comparisons are therefore to be made with caution. Variations in the female levels between countries may be more a reflection of differences between these systems – for example, in terms of occupations covered, the overall numbers of apprentices, the length of training – than of their degree of openness to women.

C. Higher Education

Attention was given above to the fact that female enrolments in higher education have grown in many countries, while in a small number women are as numerous among new university entrants as men. At the same time, however, it should be emphasized that women remain in a minority of two-fifths among university students in many countries. In several, the proportion is lower still. In Austria, Germany and Greece, they make up between 35 and 40 per cent of the university student body. The female share is below 35 per cent in Switzerland, the Netherlands and Japan. Among post-graduate students, men are in the clear majority. In several countries the proportion of women post-graduate students is between a quarter and a third and, not surprisingly, lower than this among doctoral students. Even in countries where women are generally well represented in universities, their share of doctorates scarcely rises above a quarter. They were 19.7 per cent of successful doctorate candidates in Germany in 1980, and 23 per cent in Canada in the same year, while they were 24.3 per cent of doctorates awarded in Finland (1981/82) and 28.1 per cent in the United States in 1979[6].

It was also noted above that non-university higher education is a sector so various and differentiated that summary statistics are extremely hard to interpret. Nevertheless, it is the sector where much of the specialist, advanced technical education takes place in which women are often absent, while they dominate the more general, liberal arts institutions and those that provide preparation for occupations such as nursing or primary school teaching. Technical subjects, such as engineering, still admit few women.

Yet, apart from the question of the balance of the sexes in the different programmes and institutions of higher education, it is also necessary to examine their changing status and position. If present trends continue, the subjects pursued by a high and rising proportion of women are those that most risk devaluation, in both educational and labour market terms, while the subjects in which they are under-represented are more likely to have higher employment value and less vulnerable academic standing. This concern has been spelled out in detail in a recent OECD report:

"Of particular interest in the present discussion is the situation of those university programmes which have traditionally had a high academic ranking and prestige but which, under the combined effects of massive expansion, the declining employment value of their degrees, and consequent changes in student choices, risk becoming increasingly unattractive options. The situation of such university programmes – more often found in the field of humanities, social science and pure science – becomes even more critical when in addition to the problems created by lack of employment outlets, they constitute the main or only open access sector of higher education and are thus perceived both as "high risk" options and as "safety valves" for the overall system ... In addition, the trend among senior academic staff members to neglect or abandon undergraduate programmes coupled with the increasing difficulty of teaching a highly heterogeneous student body – in terms of motivation, ability, socio-demographic characteristics – render the task of maintaining high academic standards increasingly difficult ... [The danger is] that once certain disciplines or university programmes are deemed to have low employment value they risk being further downgraded by a diminution of their academic standing."[7]

The relevance of this warning to the question of the creation of more equal opportunities between the sexes is evident. Precisely those courses or programmes in which women are concentrated are those singled out above as risking greatest relative devaluation and downgrading. Greater female enrolment in them may be contributing to the further diminution in educational and labour market terms.

A number of examples illustrate these patterns and trends. The following list of proportions of women studying engineering[8], through repetition of a basically similar story, gives a clear idea of the lack of female participation: Belgium 7.3 per cent (university level, 1981/82); Canada 9.7 per cent (full-time university level, 1980/81); Germany 10 per cent (higher education students, 1981); Ireland 8.3 per cent (higher education undergraduates, 1981); Luxembourg 4.3 per cent (higher education students 1980/81); Japan 1.3 per cent (university graduates 1979/80); New Zealand 2.7 per cent (level 5, AAVA New Zealand certificate students, 1981); Switzerland 10.3 per cent (university level students, 1982/83); United Kingdom 5.5 per cent (undergraduate university students, 1978); United States 8.3 per cent (Bachelor degrees, 1979). In several countries, such as Finland, Greece, Portugal and Yugoslavia, the figures are slightly higher. The general picture, however, is one of very marked male predominance in engineering and related fields. In new fields such as bio-engineering, however, women are better represented.

An attempt to demonstrate statistically that certain disciplines that already admit a majority of women are continuing to do so increasingly, encounters the problem that the definitions of subject areas vary. Some examples are nonetheless illustrative. At the beginning

of the 1970s, women were in a slight majority among full-time undergraduate education students in Canada (55.4 per cent). A decade later (1981), the female proportion stood at 68.6 per cent of education students. Among full-time undergraduates in health and health-related courses, the decade of the 1970s saw a greater entrenchment of women students – their share of 72.7 per cent in 1972 had attained 82.8 per cent by the beginning of the 1980s. In Finland in 1980, women made up nearly three-quarters of the humanities student body, while in Japan they were nearly 65 per cent of humanities graduates. In both Switzerland and the United Kingdom, the share of women in the languages and letters faculties grew over the 1970s. In the former, in only eight years since 1975, their proportion had risen from 53.9 to 60 per cent, while for the United Kingdom, it had grown from 57.2 per cent to 65 per cent of languages and literature university undergraduates between 1970 and 1978. These examples suggest that despite the fact that women are a minority among university students, they form a growing majority in certain disciplines, which are often those that suffer most from educational and labour market devaluation. It is important to note that in higher education the advances that have been realised have been largely concentrated among those from more privileged social strata. The factors of gender and social class interact and therefore to be female and of working-class origin means that a dual educational handicap has to be overcome. A Norwegian study summarises this dual handicap:

> "Both during transition from compulsory school and schools for secondary education as well as between matriculation exam and further education, girls are taking less advantage of their educational opportunities than boys. This tendency is much more significant in the lowest socio-economic groups."[9]

In contrast to women in higher social groups, reports a Swedish study, "the daughters of working-class parents have been almost totally unable to achieve a place in the male-dominated, high prestige programmes"[10]. The difference in the gap between men and women from different social backgrounds who have attended university in Australia confirms the same picture. About 30 per cent of sons of professionals study at university compared with about a quarter of daughters of comparable social milieu. The sons of semi- and unskilled workers are well behind their more privileged fellows – only some 5 per cent have studied at this level, a sixth of the rate for professional sons. But for girls, the contrast of rates of university attendance is doubled since only 2 per cent of the daughters of semi- and unskilled workers had managed to reach this level in the education system[11]. It is thus necessary to investigate the position of women in different social groups – from lower social strata and ethnic and cultural minorities – if their position in education is to be properly understood.

D. Adult Women

Representative, reliable data on the education of adults are extremely difficult to compile and interpret, especially on a comparative basis across countries. Even so, the general picture appears to be that the same patterns evident for young people are continued into adult life. That is, women are more numerous among those pursuing general courses, frequently with little direct application in the labour market, while men are at a clear advantage in education and training of a more vocational kind, including training organised through the workplace.

In Norway and Sweden, for example, women are in the majority in adult education courses. They were 58 per cent of adult education students in Norway in 1979 (as in 1975) and in Sweden the pattern is clearer still: 60.6 per cent of new adult students under the age of thirty in municipally-organised courses were women in 1978, and their popularity with women is more marked among older students – they comprised some 67 per cent of students aged

thirty and over in the same year. A similar picture emerges in the United Kingdom. Among students over the age of twenty-five in post-compulsory education, most are found in part-time courses and, of these, the large majority are in evening courses of non-advanced further education. Women made up three-quarters of these, more than a million students in 1978/79, and were 70.1 per cent of all part-time students aged twenty-five and above.

Evidence from the United States adds support to this view of the different educational experiences of men and women. Drawing on the recent "Participation in Adult Education" survey, it has been reported:

"The panel data also indicate adult females participated in all forms of higher and further education programs in greater numbers than adult males. For those 35 years old and over, 207 000 females, compared with 136 000 males, enrolled full-time. In part-time degree programs, females out-number males by over 200 000 (454 000 versus 208 000). And, three of every five older participants in non-credit courses are female. This appears to be a reassuring finding, since adult females have received less prior education than their male counterparts. However, other data indicate than adult males tend to participate in programs offered by providers other than colleges and universities (employers and professional associations, for example), and so maintain the existing differences in education and training."[12]

4. CONCLUSIONS AND POLICY DIRECTIONS

The factors that lie behind these patterns of inequality are manifold and complex. Several studies place emphasis upon the potential of the school, and teachers in particular, to change attitudes held by girls and boys towards school subjects and attainment with the aim of encouraging girls into a broader range of fields. But it is clear that any changes in attitudes and aspirations that schools might foster could only have an impact as part of a coherent set of policies to widen labour market opportunities for women, as discussed throughout this report, and particularly in Chapter II.

Education does, however, have a significant responsibility and role to play and there are many features of policy and the organisation of learning that do affect the patterns of segregation described in Chapter II. Recognition of this has led several countries to establish special commissions with responsibility for reducing sex inequalities in education and, in certain cases, to adopt general legislation prohibiting discrimination by sex in educational practices. It is commonly recognised, however, that most of the problems reside in informal practices, organisational structures and widespread influences rather than formal discriminatory arrangements. A number of the more important areas through which educational change can contribute to greater equality between the sexes can be identified here.

Specialisation

One major area is the organisation of education itself, particularly the nature and timing of specialisation into branches and tracks with a preponderance of one sex. The timing and nature of specialisation is of great importance to the educational careers of girls and boys. In countries where specialisation begins early in the school career, the patterns which are apparent later in education and training prove difficult to change, having been institutionalised at an early juncture. Timetabling practices can also narrow the options open to girls because certain school subjects are sometimes only available when taken in combination with

others with which they are conventionally associated. Whether they leave school early or continue to pursue their studies at a more advanced level, girls who have specialised early in over-subscribed subjects may in fact find themselves caught up in an educational process which in many cases leads to unemployment.

The Curriculum

The issues raised by the question of the curriculum are many. It has been argued that the very existence of school options and diverse branches in secondary schools hampers progress towards reducing sex segregation. It is possible that the fact of a school subject being obligatory can change attitudes towards it: this may well explain why girls are generally more successful in mathematics than physics, for example. The curriculum can also reinforce stereotypes, as substantial research has shown. This has resulted in extensive efforts in several countries to scrutinise the curriculum, and school textbooks in particular, so that such stereotypes be reduced or eliminated.

Single-sex and Co-education

For many, co-education is a prerequisite of more equal opportunities in education between the sexes. To support this view, it is argued that girls often suffer from a lack of curricular opportunities when taught separately from boys. More generally, there is the viewpoint that both sexes suffer, in many respects other than the purely scholastic, when they are schooled apart. Despite the force of both arguments, the issue has other facets which are not so straightforwardly favourable to mixed schooling.

First, there is evidence from several countries that for several reasons girls have higher rates of achievement in single-sex schools[13]. Second, the image of certain school subjects as "masculine" and others as "feminine" may be easier to break down in single sex settings because of the models provided by teachers, and the lack of pressure from peers. Third, the evidence that teachers respond differently to girls and boys when they are taught together, giving preferential treatment to boys, and that pupils are more likely to behave according to typical "masculine" and "feminine" roles when always in the same classroom, suggests that co-education may have unintended consequences.

However, there is not necessarily a simple choice between the one sort of school and the other but, rather, a number of avenues which could be explored. For instance, there is growing interest in certain courses being taught to boys and girls separately, especially in mathematics and sciences. The role models provided by male teachers in "male" subjects and female teachers in "female" subjects could be modified to some degree through staff recruitment and training policies that took this into account.

Teachers

The role of teachers is of course a vital one in helping pupils to make informal decisions concerning school subjects and training fields. This is true both generally, throughout education, and more specifically in the guidance and counselling that is offered (or, perhaps equally pertinently, not offered). It is a factor that should receive much more attention in the initial training of teachers and in in-service training – particularly because the processes whereby sex-typed images and learning are reinforced are so implicit and hidden, yet pervasive.

Teachers and staff themselves provide very concrete models along sex-typed lines. Relatively few school or college directors are female. Male science and female arts teachers

and, to an even greater extent, female primary and pre-primary staff are the norm. Staff recruitment and teacher training policies could take account of this more explicitly. Some countries have already introduced measures with the aim of encouraging more men into pre-primary and primary teacher training. At the same time, efforts should be made to allow women to enter non-traditional teaching fields and positions of authority. These considerations apply to all levels of education and training, general or vocational, and not just to mainstream primary and secondary schooling.

Vocational Education

Young women at the end of their schooling face a serious lack of opportunity, with a severely limited range of training options open to them: limited in terms of occupational fields and in terms of places on extensive training courses. This problem is raised, if anything, even more sharply for older women. Training that would enable promotion or a realignment of careers, organised by or through the workplace, is generally much more restricted for women than men. There is also a pressing need for suitable learning places for those who wish to re-enter the paid labour market after a number of years' absence – a problem that has not been treated in this chapter, which has confined itself to school education.

The data presented in this chapter lead to the general conclusion that, at school level, the problem is no longer one of female under-participation in post-compulsory education, as measured in years of schooling, although under-participation persists at the level of higher education in many countries. Rather, the problem concerns the type of education that girls receive. They are leaving school with a limited range of employment options, increasingly confined to areas in which competition for available jobs is increasing.

NOTES AND REFERENCES

1. *Women and Employment: Policies for Equal Opportunities,* OECD, Paris, 1980, pp. 153-155.
2. As presented in *Educational Opportunities for Girls and Women,* OECD, Paris (forthcoming).
3. D. Raffe, "Staying on at School and Probability of Employment" in J.A. Gray, A. McPherson and D. Raffe, *Reconstructions of Secondary Education: Theory, Myth and Practice Since the War,* Routledge and Kegan Paul, London, 1982.
4. These patterns are, if anything, clearer still in the two-year theoretical lines.
5. For an extensive discussion of these changes, see M. Cherkaoui, *Les changements du système educatif en France 1950-1980,* PUF, Paris, 1982.
6. In both these countries, this represents a significant increase over the last ten to fifteen years. The 1966/67 Finnish figure stood at 7.8 per cent, while that for the United States in 1971 was well down at 14.3 per cent.
7. *Policies for Higher Education in the 1980s,* OECD, Paris, 1983, pp. 84-85.
8. Countries differ in terms of their exact definition and coverage of engineering and so very precise comparison is difficult.
9. P.O. Aamodt, *Education and Social Background,* Samfunnsokonomiske Studies 51, Central Bureau of Statistics, Norway, 1982, p. 167.
10. A. Svenson, "On Equality and University Education in Sweden", *Scandinavian Journal of Educational Research,* Vol. 24, 1980, p. 84.

11. D.S. Anderson and A.E. Vervoorn, *Access to Privilege: Patterns of Participation in Australian Post-Secondary Education,* A.N.U. Press, Canberra, 1983, p. 147.

12. A. Wagner, " Participation of Adults in Higher Education: Survey of the Situation in the United States", in Schutze and Wagner, *Adult Students in the Anglo-Saxon Countries,* 1984.

13. J. D. Finn, L. Dulberg and J. Reis, "Sex Differences in Educational Attainment: A Cross National Perspective", *Harvard Education Review,* Vol. 49, No. 4, November 1979, pp. 494-496.

Chapter VI

THE TREATMENT OF WOMEN IN SOCIAL SECURITY AND TAXATION

1. INTRODUCTION

The treatment of women in matters of social security and income taxation has been an issue of growing concern in industrialised countries in recent years. In the context of the general movement towards equality between the sexes, attention has come to be focused on the fact that social security and taxation systems contain elements which discriminate against women or, when neutral in principle, disadvantage them in various ways. The promotion of equality between men and women in this sphere is seen as important both because income transfer and taxation measures play a large part in determining the income which individuals receive during certain periods of their lives and because such measures may exert a strong influence on behaviour in other areas. The major concerns are with ensuring adequate protection for women, placing them on an equal footing with men in social security and taxation structures, and eliminating practices that hinder progress towards a more even sharing between the sexes of roles in family and economic life.

This chapter provides a preliminary review of the situation of women in the social security and income taxation systems of Member countries. It examines ways in which existing structures are disadvantageous for women and considers recent reforms and innovations aimed at providing more equitable treatment. Given the wide range of institutional variations displayed by the systems in the various countries, the report is not intended as a comphrehensive review of the policies of individual countries. The objective is to highlight the main types of problems and issues facing countries in this area and to provide an indication of the sorts of reforms which are being adopted or considered. As such, any references to individual countries are included purely for the purpose of illustrating general points and should not be taken to indicate that the problem or policy refers only to the country mentioned.

The discussion here is limited to public social security programmes. Although it is recognized that occupational, or so-called complementary, employment-based programmes are of considerable importance in some countries, it has not been possible to include them in the report. The term "social security" is used here in a broad sense to include social insurance systems, universal programmes funded from general revenues, means-tested programmes and supplementary welfare benefits. Although services may constitute an integral part of some systems, the present discussion deals only with cash-transfer programmes. Two aspects of taxation will be considered: these are the unit of taxation and so-called tax expenditures on relevant allowances, such as allowances for dependants and for child-care expenses.

Section 2 gives a brief exposition of the general sources of the problems facing women in social security and taxation. Section 3 discusses interpretations of the principle of sex equality.

The remaining sections of the report are devoted to an examination of issues and reforms in specific areas of social security and in taxation.

2. GENERAL SOURCES OF INEQUALITY

Public social security systems combine a variety of objectives which may be pursued through a range of different structures. A central aim of all systems is maintenance of a minimum income for the needy. Most Member countries also have insurance programmes, the primary aim of which is to replace a proportion of earnings in respect of specified contingencies. Both income maintenance and social insurance programmes are important instruments of income redistribution. The fundamental purpose of taxation is, of course, to raise revenue in order to meet government outlays. However, the tax system also affects the distribution of income, albeit to a lesser extent than public expenditure programmes.

The design of both social security and taxation systems reflects certain value judgements as to what constitutes fair or equitable treatment for various groups. These systems also attempt, as far as possible, to avoid any unintentional distortion of individual economic behaviour. However, since the objectives of distributional equity and neutrality towards economic behaviour are frequently incompatible, it is necessary to establish a balance between them. In the context of the present discussion it will be argued that the priorities of social security and taxation systems have frequently been defined in ways which are disadvantageous to women and which have impeded their progress towards equality with men in the labour market and in broader social terms.

The main features of the taxation and social security systems of Member countries were determined at a time when the social and economic circumstances affecting women were quite different to those prevailing at the present time: female labour force participation rates were low and a high proportion of women did not work in paid employment after marriage. Consequently, the notion of what may be called the "breadwinner family", in which the husband is responsible for the economic well-being of the wife and children, while the wife devotes herself primarily to care of the home and the children, has exerted a strong influence on the development of these systems. Many aspects of social security and taxation policy have been based on the assumption that married women are economically dependent on their husbands and have little or no attachment to the labour market.

Policies based on this notion of sex differentiation regard the family as the basic administrative and economic unit. Income disparities are measured on a family rather than an individual basis and so the main concern is with equity between family units rather than between individuals. It is considered equitable to assign certain benefits to married men on the assumption that they are the sole or primary source of economic support for the family. Conversely, it is considered appropriate to compensate wives for loss of the support of a husband in case of death, incapacity or marital breakdown and to protect them through rights derived from the husband's entitlements. It also follows that married women's claims on the social security system are circumscribed in various ways on the grounds of assumed dependence on a husband. And in the case of taxation systems, establishing parity between family units takes precedence over considerations of any possible disincentives which this may carry for married women to take paid employment.

Such policies are rendered increasingly inappropriate by changes in both female employment patterns and family relationships. Labour force participation rates of women,

138

particularly married women, have risen significantly in recent decades. Patterns of family organisation have diversified considerably. These trends have been accompanied by changes in the view of women's role in society. It has come to be generally recognized that married women as well as men have the right to work in paid employment and that marriage is a partnership in which both parties should have equal rights and choices.

Of course, taxation and social security policies at the present time are only partially based on assumptions deriving from the notion of the "breadwinner family". In response to the changes just described and to demands for more equitable treatment for women, systems have in recent years been moving towards treating people on an individual basis, regardless of marital status, and towards eliminating sex inequality. The rate of progress has varied considerably from country to country, however; important elements of policy in many systems continue to be oriented towards the nuclear family as a social and economic unit of support and to assume a dependent position for women within the family. At present, therefore, social security and taxation systems are in a transitional phase: some policies are based on the notion of equal roles for men and women while others, by reinforcing the notion of female dependency, tend to retard the process of social and economic change which is taking place.

But the problem of reforming these systems is complicated by the fact that women have not yet achieved equality in the labour market and still bear a disproportionate share of the responsibility for child care and other domestic functions. Consequently, the majority of women attempt to combine a variety of roles. Some women remain in the labour force all their lives, others drop out or work part-time while they have young children, some return to work following divorce or widowhood.

As such, the needs and concerns of women themselves are diverse in this transitional stage and changes aimed at achieving more equitable treatment have to take cognisance of the situations of various groups of women as well as of the overall objectives of taxation and social security systems. Policies aimed at achieving sex equality need to be supplemented for a transitional period by measures designed to ensure that women and men who may have already lived a substantial proportion of their lives according to a pattern of sex role differentiation do not suffer as a result of changes in criteria.

The general problems on which this chapter focuses include:

i) Formal inequality under social security and taxation legislation;
ii) Indirect inequality arising from women's disadvantaged position in the labour market;
iii) Gaps and inconsistencies in the protection of women under existing structures;
iv) Equity for single workers and two-earner couples relative to one-earner couples.

With regard to formal inequality, explicit sex discrimination has become increasingly unacceptable. Over the past several years provisions which treat the sexes differently have progressively been eliminated from the systems of Member countries. However, there are still critical areas where the rules applying to men and women are different: unequal pension ages still apply in a number of countries and survivors' benefits and dependants' benefits are not accorded on the same basis to men and women in many systems.

The elimination of formal inequality cannot, however, solve some of the most difficult problems concerning the treatment of women. A major issue is the indirect inequality which arises when disadvantages which women encounter in the labour market are reflected in, and may even be amplified by, the social security system. As such, even where legal entitlements are similar for both sexes, the actual benefits received by women in general may be inferior to

those received by men in general. This form of inequality is particularly pronounced in social insurance systems, which base entitlements on earnings and/or employment records and it arises from three sorts of factor: *i)* a sizeable proportion of women in many Member countries interrupt employment in order to care for young children; *ii)* women are more generally confined to low-earning occupations than men; *iii)* women form a large segment of the part-time labour force.

In social insurance systems where benefit entitlement is built up on the basis of contributions related to earnings, interruptions in employment pose serious problems for women by diminishing their entitlements to pensions and sickness/disability benefits, or, in cases where they have trouble re-entering the labour force, to unemployment benefits. The fact that women tend to be confined to low-paid employment also leads to lower entitlements under earnings-related social insurance systems. Of course, this problem relates equally to low-paid men. Women also form a high proportion of the part-time workforce. Such employment is usually covered only inadequately, or not at all, by social insurance with the result that part-time workers build up inadequate pension entitlements and may also experience severe problems in claiming unemployment and sickness benefits.

Under income-tested systems also, apparently neutral rules of entitlement tend to put women at a particular disadvantage since many provisions are based on marital status. For instance, in cases where both partners of a couple are eligible for a benefit it is quite common for the benefit to be paid to the principal breadwinner only, usually the husband. Moreover, many schemes take the couple rather than the individual as the income unit for means-testing. Given that the labour supply of married women is more elastic than that of men, joint means-testing might be expected to exercise a stronger work disincentive for wives than for husbands.

Much of the concern about the treatment of women in social security systems has stemmed from the fact that existing structures often fail to guarantee adequate security. Benefits accruing on the basis of individual rights are frequently inadequate because of the types of problem just outlined above. Social security systems have generally sought to guarantee the security of married women by assigning them derived rights based on the husband's social security record. However, such derived rights are generally inferior to autonomous rights in both scope and level of benefits. Moreover, such systems become particularly problematic in cases where the husband dies before retirement or where marital breakdown occurs.

The basic equity issues concern the treatment of married women compared with other adults and the treatment of two-earner couples and single workers compared with one-earner couples. Taxation and social security structures which take the family as the basic economic unit have generally tended to operate more favourably for one-earner couples and to assume a dependent position for married women within the family[1].

Attention has been drawn in many Member countries to the increasing vulnerability of women to poverty in the context of the current economic recession. As such, the necessity of ensuring equal and adequate access to the social security system for women has become a matter of particular urgency. It is also essential that at a time of high unemployment, social security and taxation structures should not place additional obstacles in the way of women's employment. A number of Member countries have reported that reforms of importance to women, such as a more individually-based social security system and increased family allowances, are hindered by current concern with limiting the growth of public expenditure and that some cost-saving changes in social security schemes have been of particular disadvantage to women. Many countries are now in the process of examining options for fundamental reform of their social security and taxation systems. An essential element of any

such reform should be to eliminate all forms of discrimination and to incorporate firmly the principle of sex equality.

3. PRINCIPLES OF SEX EQUALITY

The general principle of sex equality adopted here is that social security and taxation systems should contain no discrimination based on sex either directly or indirectly, in particular by reference to marital or family status.

On the basis of this principle, the two sexes must be accorded the same legal rights to social security benefits and the same treatment with regard to social security contributions and personal taxation. Eligibility for benefits and liability for taxes should be determined on an individual basis rather than on the basis of marital or family status and there should be no assumption of dependency except in the case of children and incapacitated adults.

Furthermore, elimination of indirect inequality implies that policies should aim at securing more equal benefits for men and women. Where criteria determining entitlements are such that, due to disadvantages affecting them in the labour market or because they continue to bear a disproportionate share of the burden of child-rearing women tend to receive inferior benefits, policies should be implemented which would improve benefits received by those only marginally attached to the labour force and which would reduce the impact of unequal earnings on benefits paid to men and women.

Systems should be structured so as to facilitate more equal roles for the sexes. Taxation and social security provisions should carry the same incentives for both sexes with regard to the division of time between paid employment, domestic duties and leisure. Positive measures aimed at removing indirect inequality should apply equally to both sexes, so as to avoid encouraging role differentiation.

Childbirth should be recognised as a socially necessary function and women should not be economically or socially disadvantaged for bearing children. Care of children should be recognised as the joint responsibility of parents and society. Relevant policies should treat both parents equally except in the case of provisions related to the physical well-being of the mother during maternity.

Dependent children should be provided for in their own right through child benefit schemes regardless of the parents' economic status. The benefit should normally be assigned on an equal basis to both parents. However, where one parent is predominantly responsible for child care the benefit should be paid to that parent.

Care of elderly or disabled adults should be viewed as essentially a societal responsibility. Allowances paid to the elderly and disabled should be sufficient to enable them to pay for necessary care. Where relatives of either sex choose to provide care they should be eligible to act as paid care-givers.

In social security and taxation systems which are based on the principle of individual treatment, it should not be possible to recognise dependency related to past or present marital status. This would imply removal of benefits linked to marital status. However, such a reform would need to be accompanied by changes designed to provide alternative income support to various groups who would be disadvantaged by alterations in eligibility criteria, most notably sole parents as well as older widows and wives who have had little or no attachment to the labour force. The phasing out of benefits linked to marital status would also have to be accompanied by vigorous affirmative action programmes designed to overcome structural disadvantages which limit women's chances of attaining economic independence.

4. OLD-AGE AND SURVIVOR PENSIONS

A high proportion of the elderly population in all industrialised countries are women. Among Member countries in 1981, women outnumbered men in the population over age 65 by between 1.2:1 and 1.8:1. Given that the female life span is on average several years longer than that of men, the probability of women finding themselves alone in old age is high. It is in the area of pension provisions that women experience some of the most serious problems within existing social security structures, and poverty among elderly women has given cause for concern in many countries. Because of this and also since many of the general issues are clearly illustrated by the case of pension programmes, these programmes are discussed in more detail than other policy areas.

In a majority of Member countries pension schemes are linked with employment and benefits are calculated on the basis of years of contribution and lifetime earnings. Such schemes have typically provided primary benefits for insured workers and derived benefits for wives of workers on the assumption that married women would be unlikely to have worked sufficiently long to have acquired independent entitlements. Rising female labour force participation rates have meant that an increasing proportion of women are gaining autonomous pension rights. At the same time, changing family patterns and new perceptions of women's role have created dissatisfaction with derived rights, although there will still for some time to come be a significant proportion of women who have worked for only short periods during marriage for whom derived rights constitute an important source of protection. So at the present time, the problem is how to adapt pension systems to the changing circumstances of women without disadvantaging those who may be dependent on existing structures of protection.

A. Direct Pension Rights for Women

The principle of equal and independent social security rights requires that women should have their own rights to pensions and not be treated as dependants of their husbands. The main cause for concern with regard to direct pension provision for women is that the unequal division of labour within the family contributes to labour market behaviour for women that is one cause of their receiving relatively low retirement benefits. In the majority of Member countries whose pension schemes are linked to employment, and benefits depend on earnings and on length of insurance coverage, women's position as low-paid and part-time workers, with periods of employment interrupted by domestic duties, severely diminishes the benefits received on retirement. These problems due to career and earning patterns are further compounded in some systems by the existence of a minimum insurance requirement so that people who have contributed for less than a minimum number of years cannot qualify for any pension.

One way of securing more adequate pension rights for women would be to give pension credits for specified periods of child-rearing in much the same way that periods of registered unemployment are credited under existing arrangements in many Member countries. This would be in accordance with the principle that parents should not be disadvantaged with respect to pension rights for time spent out of the workforce caring for children. Any reform in this direction should apply equally to both men and women so as to encourage more even sharing of child care between the two sexes. In order to represent a viable choice, however, this type of provision would need to be accompanied by replacement of income through a system of earnings-related parental allowances, available to either parent, and by protection of employment and of seniority.

142

So far, only a few Member countries have actually enacted reforms in this area although others are considering changes. In those countries which have made reforms the general pattern has been to allow a specified number of years to be credited to the pension contribution record in respect of each child reared. The actual period credited varies quite widely, as illustrated by the following examples: in Canada, under the Canada Pension Plan, credits are allowed for people caring for children up to age seven; in Sweden, credits are allowed for children up to age three; in France, two years are credited for each child reared. It should be noted that the period credited in a particular country may depend on other provisions for families with children, such as availability of crèche facilities.

Crediting periods of child care has not generally been accompanied by provision of earnings-related parental allowances. One exception to this pattern is Sweden where such allowances are available for a period of 270 days, followed by provision of a flat-rate allowance for a further 90 days. The more usual solution has been to allow flexibility as to the earnings on which the pension is calculated. Some countries disregard the years of zero-earnings during which parents were out of the labour force, others allow the best years of earning to be used to make up the required period. However, while such arrangements improve pension entitlements for women, they are unlikely to encourage men to assume more responsibility for child-rearing since, in the absence of parental allowances, the cost in income foregone would be substantial.

The issues raised by interruption of employment to care for an elderly or infirm relative are rather different. At the present time, women bear a disproportionate share of the burden of such care, foregoing both employment and the associated social security protection. In accordance with the principles set out in Section 3 of this chapter, allowances to the elderly and disabled should be sufficient to enable them to purchase care and relatives should be eligible to act as paid care-givers. Under such a system, the caring relative would be able to maintain social security coverage for pensions and other benefits in the same way as any other employed person.

In some Member countries consideration has been given to the idea of providing benefits for full-time homemakers by accounting for non-market work. This would involve assigning a notional value to domestic duties and allowing full-time homemakers to become members of social security schemes in their own right. It is important to note that the implications of this idea are quite different from those involved in crediting pension rights for a limited period of time spent in caring for young children. Crediting pension rights for child care assumes a temporary interruption in employment. Beyond a limited period, the cost in earnings and social security credits foregone by remaining voluntarily out of the labour force would fall entirely on the individual or couple involved. By contrast, the idea of assigning independent social insurance coverage to full-time homemakers implies acceptance of the notion that one partner of a couple should be enabled to remain outside the labour force even in the absence of young children. Since most full-time homemakers are women, to extend social insurance coverage to them in this capacity would simply serve to reinforce differences in economic status between the sexes.

There would also be problems of implementation and equality. The suggested methods of financing such a system include compulsory or voluntary contributions by the working spouse, or financing out of payroll taxes. The objection to levying an extra contribution on one-earner couples has been that this would impose an undue financial burden. The objection to financing from payroll taxes has been that this would add to already high payroll taxes. Providing pension credits for non-working spouses would also create serious inequities since couples in which both partners work, couples where one partner works part-time and single people also have to undertake domestic duties or pay to have them done.

A different version of the idea of accounting in some way for performance of domestic duties involves sharing earned pension credits equally between spouses so that the partner who has spent time out of the labour force is not penalised. The principle underlying this notion is that employment and domestic work constitute different but equally necessary contributions to the household. Pension-splitting proposals have received serious consideration in several countries but so far the procedure has been introduced in only a few cases. For instance, both Canada and Germany now allow the option of dividing pension credits accumulated during marriage equally between divorcing couples. However, the number of couples taking advantage of this option has been unexpectedly small. It has been suggested that divorcing women may be relinquishing their right to a half-share in the pension credits in return for more favourable alimony settlements. In Canada there has been a proposal in the recent budget to make pension-splitting automatic when the younger spouse reaches age 65. It has also been proposed in the budget that employers' pension plans under federal jurisdiction be split on divorce and that pensions be paid in the form of a joint and survivor annuity.

There has recently been a trend towards improving pension provisions and social insurance coverage generally for part-time workers. Although such improvements may not be aimed at women specifically, they are nevertheless beneficial to the large number of female part-time workers. Some reforms in this area have, however, had the intention of improving pension coverage for people who work part-time in order to care for young children. For instance, in Belgium, women who transfer from full-time to part-time employment for this motive are permitted to top up their social insurance contributions to the full-time level and so to retain full insurance coverage[2].

The problems posed by low earnings for pension entitlements are not, of course, confined to women. However, the widespread problem of poverty among older women is certainly due in part to the generally low level of female earnings. To the extent that earnings-related pension systems are based on the principle of providing benefits which replace a fixed proportion of earnings, then low-paid workers will inevitably receive low benefits. Many systems attempt to offset the disadvantage by weighting the benefit formula in favour of the lower paid. Others provide a basic universal pension and perhaps also a means-tested supplement in order to ensure an adequate income for pensioners.

Many of the problems associated with women's pension entitlements under employment-related systems may be avoided by universal and income-tested pension systems. A number of Member countries, including New Zealand, Canada and the Scandinavian countries, extend benefits to all elderly residents. In Australia there is an income-tested pension financed from general revenues. The advantage of such systems is that earnings and career profiles do not affect entitlement to benefits and some of the countries which do not at present provide these types of pensions have considered this option as a solution to the problems facing women.

However, while uniform payment systems, either non-means-tested or means-tested on the basis of individual income, represent a viable method of providing independent pension entitlements for women, they are not entirely free of problems. Such systems normally aim at providing a minimum income for pensioners and so the pensions are relatively low and are intended to be supplemented by other benefits. For instance, in Canada and the Scandinavian countries the universal pension is simply the first tier of the system and there are also employment-based public schemes and non-public occupational arrangements. In Australia the income-tested pension and in New Zealand the universal pension are the only general public pensions, but occupational schemes provide an important additional benefit for many workers. The possible disadvantages which particularly affect women under occupational schemes are illustrated by the Australian case: present deficiencies include lack of portability between schemes, lack of vesting and preservation rights and lack of coverage for women

generally, but particularly for those in part-time employment[3]. So even though everyone may have access to the same minimum pension in all of the countries mentioned, women remain at a disadvantage in so far as the employment-based parts of the pension systems are concerned. Some of the countries mentioned attempt to improve the situation of persons with inadequate employment-related pensions by providing a means-tested supplement to the universal pension.

One other issue which has been raised in relation to universal and income-tested pension schemes concerns the income unit on which pension rates are usually based. Although such schemes are based on the principle of individual entitlement, the actual benefit received is often affected by marital status. Several countries pay universal pensions at a lower rate for married couples than for two single people sharing living accommodation. The rationale behind this practice is that married couples benefit from economies of scale. However, since single people can also benefit from economies of scale in a shared household, it has been argued that married couples are treated inequitably in this respect. In some countries, for instance the Netherlands, the criterion of marital status has been replaced by that of a shared household as the basic income unit for all income tax and transfer programmes which take into account economies of scale. Means-tested pensions are often based on the joint income of a married couple rather than on each partner's individual means. In cases where one partner reaches pensionable age while the other is in employment, this can diminish the pension. In at least one country, considerations of this sort have led to the gradual phasing out of rules which treat couples as a joint income unit.

B. Unequal Pension Age

Apart from the issues just discussed, one other important area of discrimination in individual pension rights is pensionable age. In many Member countries, women may claim their pensions up to five years earlier than men and this has become a controversial issue. The original justification for this provision appears to have been to avoid the situation of husbands having to support wives on a single pension since wives were on average younger. However, many schemes currently incorporate both different pension ages and a dependant's addition for a younger wife. Unequal pension age is increasingly regarded as an unjustifiable discrimination between the sexes.

It is argued that women are treated unfairly by being expected to retire earlier than men and that in employment-based pension systems this practice makes it difficult for women to build up a long enough contribution record. It has also been pointed out that different retirement ages are unfair on an actuarial basis since women draw pensions for a longer period than men on the basis of similar contributions. One solution being considered by countries which have different retirement ages is equalisation of the ages at an interim point between the present ages. This might be more acceptable in political terms than raising present retirement ages for women by as much as five years. At the same time it would not be as costly as reducing male retirement age to the present female level. Another suggestion has been to raise female retirement ages gradually over a fairly extended period until they are the same as those presently applying for men. This would avoid any perceived unfairness to those now nearing retirement. A third answer to the problem would be to introduce flexible retirement ages for both sexes since some countries already have limited provision for this.

C. Derived Pension Rights

All Member countries provide pensions to surviving spouses although the conditions of eligibility vary widely between countries. Under earnings-related insurance systems these

usually take the form of a proportion of the deceased worker's pension. Under universal or income-tested arrangements survivors are entitled to old age pensions in their own right so entitlements derived from marital status mainly affect persons under normal pensionable age.

Many countries also provide pension supplements for the spouse of a pensioner and these are frequently payable in respect of a spouse who has not reached pensionable age. Again, in universal or income-tested systems each partner gains entitlement in his or her own right on reaching the normal pensionable age. In earnings-related systems it is quite common for a spouse's addition to be made to the worker's pension.

With the growth of female employment and the rise in divorce rates the continued provision of derived rights has raised two major sets of problems for social security systems:

- Gaps and inadequacies in derived pension arrangements;
- Inequities arising from the continued provision of derived benefits in a context where an increasing proportion of women are earning entitlement to individual rights through participation in paid employment; from the fact that derived rights are in many cases not fully reversible between men and women; and from the conditions under which persons under normal pensionable age are eligible for support.

Gaps and Inadequacies

In countries where pension entitlements are linked to employment, the usual solution to providing for the non-working wife on the death of the husband has been to allocate her a proportion of the husband's pension. High poverty rates amongst widows have given rise to increasing criticism of the level of widows' pensions, which in many countries amount to considerably less than the husband would have received. Serious problems have also been posed by rising divorce rates. Under current regulations the right to a widow's pension may be greatly diminished or even lost in the case of divorce, regardless of how long the marriage lasted. And where the husband is still living, the divorced wife may not even be paid the spouse's supplement which is attached to the husband's pension.

Another concern in some countries has been with the position of older widows who have not reached normal pensionable age. In most countries pensions are payable to widows under a certain age only if they have dependent children. The qualifying age for widows without dependent children may be as high as fifty or fifty-five years. For women with little employment experience, the gap between the time when the children cease to be dependent and the re-qualifying age for the pension may entail considerable hardship.

Inequities

The continued provision of derived rights in the context of high labour market participation rates for women has raised issues of equity concerning the treatment of working women compared with non-working women. Serious anomalies arise when, as happens under some systems, the pension received by an employed woman is less, or not substantially higher, than the derived pension which she would have received if she had never worked. An associated inequity is that the combined pensions of couples in which both partners have worked may be less than the pensions paid to a couple with similar earnings where only one partner has worked[4]. The broader issue here is whether it is fair to other contributors to pension schemes to provide derived benefits for non-working spouses on the basis of a single contribution by the working partner. There is growing acceptance for the point of view that the

only equitable basis on which to provide preferential treatment for one-earner couples is that the non-employed partner is caring for young children.

Another issue is the lack of reversibility of derived pension rights. Under contributory schemes, it is relatively common for women to be denied the right to pass on derived benefits to husbands in the same way that men are entitled to such benefits for their wives. Again, this anomaly arises from the fact that derived rights were introduced with the family model of a working husband and a non-working wife in mind. This situation is clearly inequitable in the sense that married women pay the same contributions to pension funds as other contributors but receive a more restricted range of benefits.

The issue of equal dependants' benefits for men and women is slightly different under universal and income-tested schemes. Under these schemes widows' pensions and pensions for a wife under pensionable age have generally been paid on much more favourable terms to women than to men. The assumption underlying such practices is that wives are dependent on husbands in all cases but husbands are dependent on wives only in exceptional circumstances. In terms of the principle of sex equality, it is inequitable to apply different eligibility criteria to men and women.

The final major equity issue which has arisen in relation to rights derived from marital status is concerned with the payment of benefits to persons under the normal pensionable age. It is usual for younger widows to obtain pensions only if they have children, and an income test may also be applied, although a small minority of countries impose neither of these conditions. For women without dependent children, there is usually a higher qualifying age and in some cases also an income test. The inequities arise from the fact that widows with children may be treated more generously than other single-parent families, and widows without children may be treated more generously than other single persons. Widows' benefits are more generous than benefits paid to unmarried, separated and divorced mothers in many countries. Systems which provide a separate pension or benefit for sole parents irrespective of their marital status are the exception. Two examples of this type of system are Australia and Ireland where all sole parents are treated equally in terms of social security benefits.

Policy Responses

A number of countries have taken steps to improve survivors' benefits so as to provide higher incomes for widows in old age. In some cases the derived pension for widows is now the same as what the husband would have received. Other reforms in this context have included easing the qualification requirements for older widows in recognition of the fact that they may have problems in re-entering the labour market; allowing widows over a certain age to retain their pensions upon re-marriage; indexing deferred survivor benefits by wage growth between the worker's death and the time benefits begin to be paid; and lowering the surviving spouse's eligibility age.

Reforms have also been introduced to improve the situation of divorced women with regard to derived pension rights. In cases where the husband is still living, some countries allow the divorced wife to claim the portion of his pension which would have been paid for her if they had remained married, while others now treat women who are elderly at the time of divorce as if they were widows. In many cases divorced women can now receive widows' pensions on the death of the ex-husband, although in some countries a widow's pension is paid only if the ex-wife was in receipt of alimony payments at the time of the husband's death. Where there is more than one surviving wife, a number of countries divide the widow's pensions according to the duration of each marriage. Despite such reforms, however, derived pension rights still pose serious problems in case of divorce in many countries.

The issue of reversibility of derived pension rights has also been under review. A few countries now have full reversibility of derived rights in the pension schemes, which means that insured women can obtain benefits for spouses and survivors under the same conditions as men. Recently, courts in several other countries have ruled that discrimination against insured women in respect of derived rights is unconstitutional and the countries in question are examining possible solutions. For instance, the Spanish Constitutional Tribunal recently ruled that legal discrimination between men and women with regard to survivors' pensions is unconstitutional. However, reversibility of derived rights is by no means generalised in Member countries.

While the sorts of reform just discussed address the problems of adequacy and sex equality in a limited way, they do not represent a solution to the wider problems posed by pension entitlements based on marital status. Many of the issues discussed here call into question the basic principle of providing protection through derived rights and highlight the anomalies arising from the continued existence of such rights at a time of changing patterns of social and economic behaviour on the part of women. The retention of derived rights perpetuates the notion of financial dependency in marriage and is clearly incompatible with the principle of moving social security systems towards entitlements based purely on individual status. Moreover, the inequities arising from the coexistence of individual and derived rights are likely to increase as more women gain economic independence. At the same time, any abrupt changes in eligibility criteria for pensions may impose hardships on older women for whom derived rights may be the sole or major source of protection.

Policy-makers are therefore faced with the dilemma of whether to improve derived rights and make them the same for both sexes or to remove them altogether. So far, few countries appear to have adopted any clear direction on the issue. As noted earlier, several countries have taken steps to improve the independent pension rights of women by introducing more flexible qualifying conditions. However, the same countries have in many cases also improved derived benefits. Other countries have concentrated mainly on improvement of derived rights. Although the question of phasing out derived rights has been raised in many countries, particularly by groups concerned with improving the status of women, few countries have adopted this as a policy goal or moved consistently in this direction. It may be viewed as an easier political exercise in the short term to improve derived rights, or even to make them reciprocal, than to address the more fundamental problem of improving the position of women as independent members of pension schemes. In the long run, however, equal treatment will only be achieved by a transition away from rights based on dependence and towards a system of individual rights. In this context changes in pension systems will have to go hand in hand with measures in other policy areas to improve women's position in the labour market.

5. FAMILY RESPONSIBILITIES

The way in which social security systems treat different members of family units and the assistance given for performance of family responsibilities have serious repercussions on the position of women. Certain conceptions regarding the role of women are reflected in the way in which protection is given – whether through derived or autonomous rights, in the hierarchy of dependency which is assumed and in the methods by which allowance is made for fulfilment of family obligations. A recurring theme in the discussion so far has been the way in which many social security arrangements are ill-adapted to providing for people who drop out of the labour force to care for children.

Family policy, in the sense of programmes intended specifically to do things for the family or to achieve certain goals regarding the family, is potentially of major significance in promoting greater equality for women[5]. Income support for families with children, maternity benefits, and child care are usually central to family policy and the way in which provision is made in these areas may either facilitate more equal sharing of family responsibilities between parents or may reinforce traditional sex role differentiation.

All Member countries provide income support of some sort for families with dependent children. With regard to the status of women, an important question is whether such support is provided in such a way as to encourage the mother to devote herself full-time to child care rather than taking up employment. The extent of the incentive for the mother to remain out of the labour force would depend partly on the size of the allowance relative to the additional contribution which a second earner could make to the family income. In general, however, a system of child benefits or family allowances paid irrespective of parents' income does not distort work decisions, whereas any benefits or allowances that are means-tested or only paid to mothers at home would tend to distort choice.

Most countries provide some form of child allowance regardless of family income and as the level of such benefits is generally rather low, it is unlikely these affect work incentives markedly. Many countries also provide additional assistance to low-income families. Although one-earner families are more likely to qualify for assistance, low-income two-earner families also benefit. In at least one country the income ceiling for the family allowance is higher for two-earner families. Nowhere do allowances appear to be contingent on a family having only one wage earner. Up to 1978, France had what was known as the "single-wage allowance" which was paid only to one-earner families, but this has been replaced by an allowance related to family income which can be claimed whether the mother works outside the home or not.

In all, child allowance systems do not appear to offer any particular encouragement for one parent to abstain from paid employment. However, family benefits are also provided through the tax system in many countries in the form of tax relief for children and dependent spouses. Dependent spouse rebates are usually contingent on a single income or on low earnings by one spouse and, as such, constitute a disincentive for the wife to work. This issue is discussed in detail in the section on taxation below. There appears to be a trend among Member countries towards allowing the value of family allowances to fall in real terms. As such, quite apart from considerations of equality of roles, the addition of a second income may become very important for people with children.

With the growth in employment of married women, the question of compensation for income loss and protection of employment in connection with childbirth has become increasingly important. The right to a period of paid maternity leave with protection of employment exists in all of the European Member countries[6]. In Canada maternity benefit is paid through the unemployment insurance system. New Zealand has had a statutory period of six months' unpaid leave since 1981. There is no maternity cash benefit, although unsupported pregnant women and mothers can receive cash benefits. The United States and Australia do not have any general scheme for maternity leave and so the practices vary between states. Neither do these two countries have any general scheme of maternity benefits: in Australia paid leave is available to some, mainly government employees, while in the United States benefits are available in some states only[7]. An important development in recent years has been the extension of maternity leave and benefit provisions to the self-employed and to family workers in several countries where they were not previously covered.

Many Member countries have extended the period of maternity leave beyond the International Labour Organisation standard of twelve weeks which is related directly to the

need for physical recovery of the mother. However, there are wide variations in the normal duration of compensated leave; in most countries the duration ranges from twelve to eighteen weeks, but in Finland the maximum duration is 258 working days while in Sweden it is 360 days. In countries where normal leave lasts for shorter periods of time there has been a trend towards allowing for an extended period of leave to enable the mother to remain at home to care for the child beyond the normal period of maternity leave. For instance, in Austria, since 1961, cash benefits are paid to mothers up to one year after confinement. Various other Member countries allow extended leave for periods varying from six months to three years. Such extended leave usually carries the right to reinstatement in employment and counts towards retirement benefits but it is not always compensated by cash benefits.

An important innovation in some countries has been the introduction of extended leave which may be taken by either parent. This represents a move away from segregation of roles and a recognition that fathers should participate in caring for children too. So far, parental leave has been introduced in only a few countries. The system is most highly developed in Sweden where parental insurance gives entitlement to a cash allowance equivalent to 90 per cent of the parent's pay for 270 days and SKR 37 per day for a further 90 days, regardless of income. From the total of 360 days, 180 days may be used until the child reaches age eight. Leave may be taken in the form of whole days, half-days or quarter-days. In addition, parents of either sex are entitled to up to 60 days of paid leave per year per child in order to look after sick children under age twelve. The father also gets ten days of paid leave in connection with childbirth. Periods of paid parental leave are credited towards the earnings-related pension in the same way as periods of employment. Since 1978, Norway has allowed parents to take up to ten days leave per year to care for sick children, while in Germany parents who are employed and liable to social insurance may be granted exemption from work up to five working days per year per child in order to nurse a sick child.

Some other countries allow either parent to take unpaid leave on expiry of normal maternity leave: in Finland and Norway this leave lasts one year; in Spain the father has, since 1980, been entitled to up to three years' unpaid leave to look after a child; in France a two-year leave was introduced in 1977. In the Netherlands the trade unions have called for the introduction of statutory rights to unpaid parental leave which could be taken by either parent. In Belgium, the introduction of unpaid parental leave has recently been advocated as a means of creating work for the unemployed. The suggestion is that the person on leave would be temporarily replaced by an unemployed person. The question of parental leave is under discussion in Austria. The United Kingdom believes that parental leave is a matter for negotiation between the social partners rather than for government intervention. Proposals for a Community-level Directive to entitle workers to parental leave and leave for family reasons under harmonized conditions in member States of the European Community have been adopted in principle by the European Commission and should shortly be submitted to the EEC Council of Ministers for further consideration.

Despite the improvements just outlined, there are still wide variations in the terms of maternity protection and parental leave from country to country. And while the 1970s saw steady improvement in this field, there are signs that progress has begun to slacken in the 1980s. As noted in a recent review by the International Social Security Association, gains in this area have been relatively modest during the past year or two, since most countries are unwilling to make changes which might entail additional expenditures[8]. Indeed, at least one country has recently reduced both the duration of paid maternity leave and the level of benefit. This slowing of progress is to be regretted since the development of systems of parental leave and the introduction of more flexible working arrangements for parents are vital elements in the attainment of equality for married women. Finally, although this report does not cover

services, it should be noted in passing that the development of day care facilities for children is also essential in order to allow parents, particularly mothers, to participate in the labour market.

6. UNEMPLOYMENT

The main area of formal discrimination which remains with regard to unemployment compensation concerns dependants' benefits although in a few countries married women are still not eligible for unemployment benefits in their own right. In a number of countries married women who claim benefits are not granted any addition in respect of dependent children whereas married men automatically receive this addition. However, this is one of the areas affected by the European Communities Directive on equal treatment in matters of social security[9]. By the end of 1984, all Community members must allow additions for dependants to be added to unemployment and sickness benefits on the same terms for either spouse.

However, the rules of unemployment compensation systems often disadvantage married women in indirect ways. Some countries link benefit levels of eligibility for certain unemployment benefits to a "breadwinner" test, defined by level of income, in the case of married people. In several cases benefit additions for dependants are only granted if the claimant earns more than 50 per cent of the family income and in other cases a married woman's benefit is cut off sooner than that of other recipients unless she is the primary earner of the couple. Another practice followed in some countries is to differentiate benefit levels according to family status and to provide higher benefits for "heads of household". All of these practices have the practical result of diminishing benefits for married women since they are rarely the primary earners of couples.

In countries without an earnings-related insurance scheme, such as Australia and New Zealand, and where eligibility for unemployment benefit depends on joint spouse income, married women are more likely to be disadvantaged than married men. Where both spouses are unemployed, benefit is usually paid to the principal earner, normally the husband. An unemployed woman may not receive any benefit if her husband's income exceeds the income-test limit. Moreover, such systems may discourage a woman from continuing to earn once her husband becomes unemployed. For instance, in the case of Australia, it has been pointed out that under existing regulations the effective tax rate on the benefit for a married couple in which the husband is unemployed and receiving educational allowances is very high for a considerable range of income of the wife. The implication of this situation is that wives of unemployed men are likely to be discouraged from continuing to work. In fact Australian data for 1980 showed that wives of unemployed men were six times as likely to be unemployed as wives with employed husbands[10].

Another area of concern is the treatment of part-time workers and low earners. In many countries these categories are comparatively badly covered by unemployment insurance and other social benefits. This may be particularly disadvantageous for women, given the high rate of female part-time employment and the generally low level of female earnings. Mothers of young children who become unemployed may also be disadvantaged by administrative procedures: in some countries attention has been drawn to the fact that such women are often asked to provide details of their child-care arrangements by the authorities responsible for deciding eligibility for unemployment assistance. It is difficult to know how widespread this practice is since much depends on the attitudes of those who administer the system.

151

A final problem is that women who drop out of the labour force in order to care for children usually lose their eligibility for unemployment compensation. At the same time many women experience difficulty in re-entering employment after a period devoted to child-rearing or after divorce or separation and little provision is made in most Member countries for retraining older women.

Recent reforms to unemployment compensation provisions have had mixed results for women: while a number of discriminatory elements have been removed, other changes have created additional disadvantages. Most countries still have no provision whereby people who leave their jobs to look after children can retain their coverage under unemployment insurance, but a few countries do permit this. For instance, in Sweden periods of paid parental leave are counted in determining eligibility for unemployment benefits. In Belgium rights to unemployment benefits remain valid for up to three years from the date of birth of a child in the case of women leaving their jobs to look after children. Belgium has also recently made it possible for mothers who switch from full-time to part-time work in order to care for children to retain full social security coverage for sickness and unemployment benefits by paying an extra contribution in addition to the reduced contribution normally paid by part-time workers.

Efforts to economise in the area of social security have resulted in the introduction of more stringent qualification requirements for unemployment compensation in a number of countries. For instance, in several cases the qualifying period for benefits has been extended, requiring applicants to have worked for a longer minimum period in order to establish eligibility. Such changes are likely to have serious repercussions for women with young children who may have difficulty in reaching the required qualifying limit. Another change, made in several countries, has been to reduce the period for which unemployment insurance benefits are payable, particularly in the case of workers who have been in employment for shorter periods of time. These changes may also affect women more severely than men, given that their careers are more likely to be interrupted and that a larger proportion of women than men remain unemployed for long periods (see Chapter I, Section 6).

7. SICKNESS AND DISABILITY

The following discussion refers only to cash benefits and does not include consideration of health services. Schemes providing cash benefits in respect of sickness and disability may be divided into the following categories: those providing benefits during temporary unfitness for work due to illness; those providing benefits in respect of long-term disablement; and those providing benefits in respect of occupational injury or disease.

Working women do not normally experience problems under schemes providing cash benefits in respect of short-term unfitness for work due to illness. In most Member countries this risk is covered by statutory insurance schemes for employees, under which women and men receive equal treatment. An important discriminatory element, whereby women are not allowed to claim increases in benefit for dependants, has been or soon will be removed from most systems. In a minority of Member countries where sickness benefits are means-tested it has sometimes been difficult for married women to receive benefits: for instance, in Australia prior to 1977 a married woman was disqualified from obtaining sickness benefit if it was reasonably possible for her husband to maintain her. This practice has since been discontinued. In New Zealand, the practice of paying an income-tested sickness benefit to a married person for thirteen weeks regardless of their spouse's income was established in 1975

but was discontinued in 1983. All benefits, except old age, are now income-tested on family income, with the result that one partner of a couple may be precluded from obtaining benefit on the basis of the other partner's income.

With regard to benefits in respect of long-term illness or disability, many of the issues are similar to those relating to old age pensions so it is not necessary to discuss them in detail. The main problem is that in most systems invalidity or disability benefits are provided under insurance schemes for workers, and those who are not covered by social insurance, particularly housewives, generally have little or no entitlement to benefits. A few countries have recently made provision for parents who interrupt employment to care for young children to retain the right to insurance coverage for disability or invalidity benefits for a limited period. Some countries provide non-contributory, income-tested benefits for those with insufficient or no entitlement under insurance-based schemes. In a small number of countries where the social security system is not insurance-based, all long-term invalidity or disability benefits are income-tested and are not contingent on the claimant's employment history. However, income-tested benefits are generally less generous than those provided under social insurance schemes. Moreover, where benefits are contingent on family income, entitlements for disabled partners are reduced on the basis of income earned by employed partners.

Those who are disabled as a result of injury or disease sustained at work are generally entitled to a relatively high level of cash compensation. Schemes providing such compensation do not normally discriminate either directly or indirectly between men and women.

8. TAXATION

The trend towards increased participation by married women in the labour force has led to a re-examination of the way in which income-tax systems treat the income of spouses. Many countries have improved the status of married women under fiscal legislation so that in formal terms they are, like all other taxpayers, treated as individuals. The more contentious question has been whether or not the earned income of spouses should be aggregated for tax purposes. The main issues involved here concern work disincentives for married women and the appropriate tax differentials between one- and two-earner families. Both of these issues have been examined in some detail by the Committee on Fiscal Affairs of the OECD and the quantitative data presented in reports by this Committee is of considerable assistance in clarifying the position of married women taxpayers[11]. Much of the discussion which follows is based on these reports. It should be noted that this discussion refers only to earned income[12].

To set this discussion in a broader context, it should be noted that taxation may not be the predominant factor influencing work decisions. In fact it is unclear what the influence of taxation may be, as compared with other factors such as the availability of child-care facilities and access to suitable employment. However, empirical evidence suggests that the labour supply of married women is more elastic than that of married men and, as such, it might be expected that the work decisions of the former would be more sensitive to income taxation[13]. The main aspects of taxation arrangements which could have a particular effect on the work decisions of married women are whether or not the earned incomes of spouses are aggregated, the progressivity of the tax schedule and the distribution of allowances between husband and wife and how these change when the wife enters the labour market.

The change in the tax position of two earners on marriage may have an impact on the work decisions of the spouses. If marriage increases the tax burden of such couples, then the

wife (who will usually be the lower earner) may be discouraged from working. In most countries, however, marriage does not appear to affect the tax paid by two single earners[14], though in some joint taxation countries, there is a slight increase in the joint tax burden. In many joint taxation systems marriage does not affect the overall tax position of the couple because a reduction in the husband's tax, due to marriage allowances, offsets the increase in the couple's tax due to the progressivity of the system. In such cases, however, it has been argued that the wife's tax burden is heavier after marriage while that of the husband is lighter, though conceptually it is difficult to isolate the wife's tax position.

In principle, a one-earner married couple could increase their income either by the wife entering the labour market or by the husband earning more, though in practice the husband may have little control over increasing his earnings and the wife may be unable or unwilling to work outside the home. Assuming that work decisions by spouses are taken in the context of the effect on the economic position of the family as a whole, the incentive for a married woman to enter the labour force may be affected by the tax cost of additional income earned in this way relative to the tax cost of the husband increasing his work effort. The additional tax cost to the couple is generally less when the wife enters the labour market than when the husband increases his earnings. Under joint taxation the additional allowances gained by the wife entering the labour market ensures that the proportion of the additional income which is subject to tax is much lower when it is earned by the wife rather than by the husband, and this offsets the effects of aggregation, at least at low- to medium-income levels. Under individual taxation the wife normally receives the same basic tax allowance as the husband, but the husband usually loses the marriage allowance[15].

Where, however, tax minimisation is not a major aim of a couple or is not feasible (the lack of child-care facilities may, for example, rule out the possibility of the wife entering the labour force) the considerations set out in the preceding paragraph may be irrelevant to the wife's work decisions. Also, as noted in the 1980 OECD report, insofar as tax considerations do influence wives' work decisions, it will be rather by the way that women perceive their tax situation than what it actually is. In that context individual taxation may be preferable to joint taxation since the tax effects on the wife are more transparent.

However, the overall tax burden of the couple may be less important in the context of the wife's work decision than her tax burden relative to other taxpayers. Comparing the relative tax positions of single and married women, the 1977 OECD report found that in countries using individual taxation the married woman was either in the same or in a better position than the single woman, whereas in joint taxation systems married women tended to have a relatively higher level of tax[16]. In some countries with joint systems, however, it was found that the operation of quotient or income-splitting systems or the interaction of the rate schedule and allowance structure resulted in similar treatment of single and married women or even more favourable treatment of married women at the average production worker's income level.

The analysis outlined above suggests that the tax unit is not necessarily a decisive feature of tax systems in influencing the work decisions of married women, although at higher income levels it may exercise an important influence on these decisions. In practice, the tax burden on married women is the outcome of the interaction between the tax unit, the tax relief and the rate structure. The influence of the tax unit on work decisions is likely to depend to some extent on whether these decisions are taken in the context of the effect on the economic position of the family as a whole or on the basis of the wife's tax burden relative to other taxpayers at similar income levels.

There has been a trend in OECD countries in recent years away from compulsory joint taxation to individual taxation for married couples, although just under half of Member

countries continue to use joint taxation. In reviewing the motives for changing to individual taxation, the 1977 OECD report notes that a wish to encourage married women to participate in the labour force was a major objective[17]. Changes in the tax unit are under discussion at the present time in several countries. Among the options being considered are a change from income-splitting between husband and wife to a family-quotient system in Germany[18], and the modification of the individual taxation system in the Netherlands in order to reduce the tax burden of one-earner couples relative to two-earner couples.

If the willingness of married women to go out to work is influenced by the size and the marginal impact of the tax thus incurred[19], and if this additional tax is considered too high, some categories of women may be deterred from taking up employment. It has been noted in OECD studies and elsewhere that the non-taxation of the imputed value of work performed in the home by the wife may encourage women to stay at home, although this problem is part of the broader issue of the influence of taxation on the allocation of time between paid work, unpaid work and leisure. The marginal impact of the tax incurred by going out to work may be further increased by the cost of paying someone to do the housework and care for children. The problem of assigning a value to work performed in the home makes it virtually impossible to include such work in taxable income. A few countries have recognised the necessity of compensating for the extra expenses incurred in families where both parents work by providing tax relief for child-care expenses. However, insofar as these reliefs take the form of tax allowances, under a progressive income tax system, they are of little or no benefit to those not paying tax or those on very low taxable incomes (such as women in part-time employment). Moreover, in the context of budgetary pressures resources might be better directed to expanding child-care facilities.

Tax relief for child-care expenses up to a certain maximum have been available to working mothers for some time in Canada and, under certain circumstances, in the United States. The amounts deductible were increased in both countries in the early 1980s in response to criticism that the tax systems were unfair to two-earner couples. New Zealand has allowed a rebate on a proportion of child-care costs to either spouse since 1969. Norway provides a deduction up to a certain limit in respect of documented child-care expenses, claimable by the spouse with the larger income. Sweden provides an additional deduction when both spouses are employed and they have children under sixteen years of age. The deduction is claimable by the spouse with the lower income. It should be noted that where the child-care relief is restricted to working mothers, as opposed to mothers who are students or who have health problems or as opposed to the father, the notion that child care is the mother's responsibility is perpetuated. It should also be noted that some countries, such as Sweden for instance, provide additional assistance for working parents in the form of low-cost, public child-care facilities.

The question as to what would constitute equitable treatment for two-earner couples vis-à vis one-earner couples has been widely debated in recent years. The use of joint taxation has usually been justified on the grounds of producing more similar tax burdens for equal-income couples regardless of how their joint income is earned. In practice, it appears only income-splitting or quotient systems succeed in equalising tax bills, although other joint systems may mitigate the differential between one- and two-earner couples[20].

The question of tax relief in respect of dependants also raises equity issues. All Member countries give tax reliefs of some sort. There is certainly a case to be made for supporting a non-working spouse where there are children or other dependants to be cared for or where the spouse is incapacitated or involuntarily unemployed. However, provision of tax relief, or any other form of support, for non-working spouses generally has come in for criticism. It is argued that this practice is inequitable vis-à-vis families where both spouses work since, in

conjunction with the non-taxation of domestic labour, it provides a double tax exemption for single-earner families. The rationale for such relief is usually stated in terms of adjustments to taxable capacity, under the ability to pay approach to taxation. However, this comes back to the question of whether there is a case for regarding non-working wives only as a charge on the taxable capacity under the ability to pay approach to taxation of the household. It could be argued that a wife's domestic labour is a factor that increases taxable capacity[21].

Apart from the equity issue, tax relief for dependent spouses has also been criticised on the grounds that it may be more important to concentrate income support on children than on non-working spouses. In some countries, the value of dependent spouse reliefs has risen more quickly over time than reliefs for children. It has been suggested that reliefs should be concentrated on children rather than dependent spouses. A more far-reaching suggestion has been that such reliefs should be removed altogether and replaced by direct transfers to families with children and to persons caring for incapacitated adults. This last solution would be consistent with moving tax and transfer systems towards an individual basis since it would remove the concept of the dependent spouse.

The issue of tax relief for dependent spouses has, for the reasons just outlined, been under discussion recently in a number of countries. In Australia, there has been extensive debate on this issue, particularly since tax relief for a dependent spouse has approximately retained its real value in recent years while the value of family allowances has declined. In 1982, the dependent spouse rebate was increased only for single-income married couples with children. In Canada, critics of the dependent-spouse tax exemption have argued that it should be abolished and that, instead, more funds should be allocated to day-care services and child-care support for working parents through the tax system, and that this support should take the form of tax credits rather than tax deductions as is currently the case. So far, however, this point of view has received little support in official circles. In Sweden, the policy is to eliminate all dependency reliefs and to support families with children, single parents, and couples where only one partner can find work, through direct transfer payments. In the United Kingdom, there has been extensive discussion on whether to abolish the marriage allowance, although the debate has not so far resulted in any changes. New Zealand abolished the dependent spouse rebate in 1982 and at the same time increased the rebate for dependent children. Despite criticism, however, most countries continue to provide marriage allowances via the tax system. A major barrier to change is the transitional problem, particularly for single-income couples on low incomes where the wife has never worked since marriage or the commencement of child-bearing. Many such women lack educational training for paid employment, cannot find suitable avenues for employment and have no access to unemployment benefits. The withdrawal of a dependent spouse allowance would need to be accompanied by granting of independent entitlement to unemployment benefits and by training assistance.

A final issue to be considered is the status of women under income tax legislation. In most Member countries, including many with joint taxation, married women are treated in the same way as their husbands under fiscal legislation. However, in some countries with joint taxation systems a woman loses her status as an independent taxpayer on marriage. Status discrimination against married women usually takes the following forms[22]:

- The annual tax deduction may have to be signed by the husband only, so that the wife is obliged to reveal her income to her husband whilst the reverse is not the case;
- All correspondence from the tax authorities may be addressed to the husband, even when it concerns the wife's income;
- The husband may be legally responsible for the payment of the tax due on the wife's income.

These three practices exist to varying extents in France, Ireland, Luxembourg, Switzerland and the United Kingdom. In France, for example, the husband is deemed responsible for payment of tax on his wife's income. Moreover, married couples file only one tax return which may be signed either by the husband alone or by both spouses, but not by the wife alone. Both the United Kingdom and Ireland retain provisions which deem the wife's income to be that of the husband for taxation purposes. In both countries, however, spouses may opt for separate assessment and are then responsible for filing returns on their own income and for payment of tax due.

9. CONCLUSIONS AND POLICY DIRECTIONS

Social security and taxation systems in OECD countries were developed in the context of a very specific set of social and economic circumstances. Insofar as the treatment of women is concerned, these systems were initially designed to respond to a situation in which family and labour market roles had come to be divided rather strictly on the basis of sex. Married women's labour force participation rates were low and the prevailing social norm was for men to be the main breadwinners in the family and for women to bear responsibility for child care and housework. As such, social security and taxation arrangements tended to treat married women as dependants of their husbands and to assume that they should derive economic security primarily from the husband. A variety of circumstances have rendered existing arrangements inappropriate for women: labour force participation rates for women, especially married women, have risen substantially; family structures have altered, and attitudes concerning men's and women's roles have changed. In these circumstances established social security structures fail to provide adequate security for many groups of women. Moreover, both social security and taxation arrangements give rise to a range of inequities for women, and in many countries they still raise barriers in the way of a free choice by both men and women between performance of paid work and fulfilment of family responsibilities.

Three major issues have been raised in this chapter with regard to social security:

- It is increasingly coming to be accepted that marital status is no longer an appropriate basis for determining women's social security entitlements. Inequities arise when married women's entitlements are restricted on the assumption that they are dependent on their husbands and that they themselves are not responsible for dependants. Further inequities arise from the coexistence of derived and direct entitlements, particularly in social insurance systems. The interaction between both sets of entitlements causes inequities between one- and two-earner couples and between working and non-working women;
- Social security rights based on marital status also give rise to serious problems of insecurity. Such rights are frequently inadequate and insecure;
- Women are disadvantaged in employment-based social insurance systems. Since they tend to be segregated in low-paid employment, entitlements based on lifetime earnings are often inadequate. Moreover, women continue to bear disproportionate responsibility for child care and for care of the elderly and disabled. This burden gives rise to career interruptions which also diminish entitlements. The problems posed by low earnings and interrupted careers are particularly evident in the case of pensions. But women also suffer diminished entitlements with regard to unemployment and sickness protection.

The particular combination of problems facing women varies depending on the nature of the social security system. It has been pointed out that income-tested and universal programmes avoid many of the problems associated with female labour force participation patterns by assuring a certain minimum for everyone, regardless of work history. However, married women are more likely than married men to be disadvantaged by programmes that are income-tested, particularly programmes providing unemployment benefit. Due to the high effective marginal tax rates incurred by recipients entering the labour market under existing structures of income-tested benefits in many countries, there is likely to be a substitution effect away from paid employment. Moreover, very few countries rely entirely on income-tested programmes. In the majority of systems where these exist side by side with employment-based programmes, the social security system may simply produce new social stratifications, with women and other disadvantaged groups subsisting on minimum benefits while those who have had high earnings and secure employment receive relatively high benefits.

The policy responses to the problems affecting women in social security have varied considerably from one country to another in terms of direction and pace. Elimination of formal discrimination against women from social security legislation appears to have proceeded quite far. The systems of most Member countries are already, or soon will be, neutral in terms of sex in most respects. Important exceptions to this are pensionable age, which still differs for men and women in many countries, and reversibility of derived pension rights between married couples. With regard to the more difficult problems posed by derived rights and by indirect disadvantages arising from women's labour force participation patterns, persisting inequalities in pay, and secondary position in the labour market, progress has been more uneven.

In most countries the issue of derived rights is controversial. The main arguments against rights based on marital status are that such rights perpetuate the notion of dependency in marriage, that they fail to provide a secure basis of protection, and that they create inequities between men and women, as well as between one-earner couples on the one hand and two-earner couples and single people on the other. However, the removal of derived protection could produce disadvantages for some groups, in particular older widows and wives who have not participated in the labour force since marriage.

Reforms in this area have been ambiguous. A very few countries have concentrated on improving independent social security rights for women with the explicit long-term aim of phasing out rights based on marital status. However, the more general trend has been to improve both independent rights and derived rights despite the policy paradoxes involved. The retention of rights based on marital status is incompatible with the long-term aim of placing social security entitlements on a purely individual basis. The policy dilemma is how to move towards this aim without disadvantaging certain groups in the short term.

The only way out of this dilemma is for long-range policy goals to be based clearly on the notion of sex equality. This would involve making all benefits available on an individual basis. Over time benefits based on marital status would be phased out progressively and this would involve a reassessment of the conditions under which persons who are not attached to the labour force should receive support. Transitional benefits would be required for groups who would otherwise be disadvantaged by alterations in eligibility criteria. The phasing out of benefits linked to marital status would also have to be accompanied by affirmative action policies designed to enhance women's chances of attaining economic independence.

Many of the disadvantages experienced by women in social security systems arise out of problems affecting them in the labour force. At the same time, it has been pointed out that many aspects of social security and personal taxation tend to reinforce labour market disadvantages. Consequently, progress towards equality of treatment in social security and

taxation must go hand in hand with policies aimed at eliminating structural disadvantages affecting women in employment and at achieving more equal sharing between the sexes of economic and domestic roles.

Positive measures are necessary to secure more equal benefits for women who have been disadvantaged by interruptions in employment. As noted above, some countries have adjusted the rules of entitlement for pensions and other benefits so that time spent out of the labour force caring for children has less serious repercussions on benefits. Another solution has been to divide insurance contribution records equally between spouses, thus compensating the partner whose entitlements have been diminished by interruption in employment. So far, however, this latter solution has been applied only in cases of divorce. It must be emphasized that whatever measures are used should be applied equally to both sexes. Otherwise, they may simply act to reinforce existing sex roles.

The aim of reforms should be not only to produce more equal benefits but also to facilitate more equal roles for the sexes. The essential requirement in this context is that child care be recognised as the equal responsibility of both parents. Policies should aim at facilitating equal participation in paid work by both sexes and should enable both parents to combine care of a family with employment. A few countries have taken initiatives in this direction by allowing either parent to preserve social security coverage for a specified period when employment is interrupted to care for young children and by extending parental leave to both parents. As yet, however, developments along such lines have been limited. Provision of adequate and affordable child-care facilities is also of great importance in facilitating women's continued participation in the labour force.

With regard to taxation, it has been noted that existing unit and allowance structures may in some cases adversely affect married women's work decisions, discouraging them from taking employment. In particular, the use of joint taxation and/or marriage allowances tends to set up disincentives for married women to work and may give rise to inequities between one- and two-earner couples. It would be consistent with the goal of equality to place taxation on an individual basis and to eliminate dependants' allowances except in the case of children and incapacitated adults. In this context, the trend in OECD Member countries away from compulsory joint taxation for married couples is to be welcomed. With regard to provision for persons who forego employment in order to care for children or for incapacitated adults, it has been suggested that such provision should be made in ways other than through the tax system.

In conclusion, therefore, equal treatment in social security and taxation does not simply imply sex equality in formal terms, although of course this is very necessary. Nor does it only imply that benefits should become more equal since this could be achieved in ways which would still entail assumptions of dependency and role differentiation. Ultimately, full equality will only be achieved by treating men and women as independent individuals and by encouraging a more equal division of domestic responsibilities and greater participation by women in the labour force.

NOTES AND REFERENCES

1. Family-based systems do not always assume dependency. In some cases the use of the family unit is based on the assumption of economies of scale.

2. However, very little use is made of this option since it requires an additional contribution on the part of the insured women, whereas derived pension rights for wives are granted without any additional contribution.

3. The Australian federal government presently has the question of occupational schemes under review.

4. Outcomes under different systems may, of course, vary considerably depending on the pension formula and the rules relating to cumulation of autonomous and derived benefits.

5. For a discussion of definitions of family policy, see Sheila B. Kamerman and Alfred J. Kahn (eds.), *Family Policy. Government and Families in Fourteen Countries,* New York, Columbia University Press, 1978.

6. For a comprehensive review of maternity provisions in Western Europe, see Chantal Paoli, "Women Workers and Maternity: Some examples from Western Europe", *International Labour Review,* Vol. 121, No. 1, 1982.

7. A recently published study estimates that only 40 per cent of working women in the United States are entitled to paid disability leave of at least six weeks at the time of childbirth. See S. B. Kamerman *et al., Maternity Policies and Working Women,* New York, Columbia University Press, 1983.

8. International Social Security Association, *Developments and Trends in Social Security 1981-1983,* Geneva, 1983.

9. *Directive on the Progressive Implementation of the Principle of Equal Treatment for Men and Women in Matters of Social Security* (79/7/EEC).

10. See *Women's Contribution to Economic Recovery.* Information paper prepared by the Office of the Status of Women for the National Economic Summit Conference, 1983. Canberra, 1983, pp. 9-12.

11. OECD, *The Tax/Benefit Position of Selected Income Groups in OECD Member countries 1974-1978,* Paris, 1980;
OECD, The Treatment of Family Units in OECD Member Countries Under Tax and Transfer Systems, Paris, 1977.

12. Unearned income is usually aggregated to avoid spouses artificially splitting their unearned income and thereby reducing their joint tax burden.

13. For instance, it has been noted that whilst the effect of income taxes on the work decisions of men appear to be insignificant, that on married women may be more important. See OECD, *Theoretical and Empirical Aspects of the Effects of Taxation on the Supply of Labour,* Paris, 1975.

14. OECD, 1980, *op. cit.* in note 11. The analysis on which this finding is based considered spouses' joint earnings at levels of 166, 200 and 400 per cent of the average production worker's wage. The husband's earnings were taken as 100, 100 and 200 per cent of these totals respectively and the wife's as 66, 100 and 200 per cent.

15. *Ibid.,* pp. 53-55.

16. OECD, 1977, *op. cit.* in note 11, pp. 18-19.

17. Ibid., pp. 18-19.

18. "Family quotient system" – an income-splitting system which extends also to children.

19. Here it is worth recalling the previously noted point that empirical investigation suggests that income tax may exercise a stronger influence over work decisions of married women than of men. See OECD, 1975, *op. cit.* in note 13.

160

20. OECD, 1977, *op. cit* in note 11. Among the assumptions underlying joint taxation are that married couples pool income, take expenditure decisions jointly and benefit from economies of scale. However, in some countries certain of these assumptions have been called into question. See, for example, an Australian study: Meredith Edwards, *Financial Arrangements Within Families,* Research Report for the National Women's Advisory Council, 1981.

21. See, for instance, Patricia Apps, *Theory of Taxation and Inequality,* Cambridge University Press, 1982.

22. See OECD, 1980, *op. cit.,* in note 11, pp. 61-62 for a more detailed discussion of these practices. The report also shows that status discrimination is not an inevitable outcome of joint taxation since many of the countries using joint taxation do not have the practices referred to in this paragraph.

Chapter VII

POLICY RESPONSES – IMPLEMENTATION OF THE 1980
DECLARATION ON POLICIES FOR THE EMPLOYMENT OF WOMEN

1. INTRODUCTION

Although the economic role of women has been undergoing a transformation in recent decades, it will be evident from this report that many areas of inequality and disadvantage remain. Chapters I, II and III reveal that whilst female labour force participation rates have increased considerably, high degrees of occupational segregation persist, women's earnings continue to be substantially lower than men's, underlying female unemployment rates are higher than male rates in a number of countries and women to a greater extent than men are subject to involuntary part-time work and hidden unemployment. Chapter V shows that although there has been increasing female participation in education, significant differences remain between the sexes and clear divisions still exist in terms of subjects studied and training taken. Chapter IV draws attention to the disadvantaged position of migrant women. Chapter VI shows that in the area of social security and taxation recent reforms have removed many forms of explicit, legislative discrimination but a variety of disadvantages, particularly of an indirect nature, persist.

Given what the report reveals about the stubborn continuation of inequality, the effective implementation of policies designed to improve the position of women in the labour force is clearly a matter for active public policy. The Declaration on Policies for the Employment of Women by the 1980 High Level Conference set out a number of policy aims which should be given priority by the governments of Member countries. The Declaration covered a broad range of policies related to participation and equality of opportunity in the labour market[1]. This chapter reviews in general terms the extent to which the policy declaration of 1980 has been implemented in Member countries.

In summary, the policy aims set out in the 1980 Declaration were concerned with the following subjects:

- Equal employment opportunity;
- Equal pay for work of equal value;
- Segregation in employment;
- Employment in the public sector;
- Unemployment amongst women;
- Support services for those with family responsibilities;
- Working conditions and working time;
- Education and training;
- Social security and taxation;
- Migrant women and women in minority ethnic groups.

162

As in the case of many other areas of social and labour market policies, the information which is available on the extent to which policies for equality have been implemented in Member countries is uneven and consequently this review is intended only to provide a general indication of the extent and directions of progress. Moreover, since many reforms are of recent origin and because arrangements for monitoring and evaluation of policies are not well developed, there is little systematic information available on the impact of policy initiatives.

2. POLICIES FOR THE EMPLOYMENT OF WOMEN

The 1980 Declaration on Policies for the Employment of Women called on Member States:

–To adopt employment policies which offer men and women equal employment opportunities, independently of the rate of economic growth and conditions in the labour market.

Discussions of policy options often distinguish between female labour force participation and segregation. An examination of the national answers to the Working Party survey suggests that in practice many of the policy mechanisms which Member countries are adopting are equally appropriate to the problems of both participation and segregation. Additional evidence from national experts supports the view that most policies concerned with the employment of women will be important for both sets of problems. Which category is used may simply be an indication of which issue a country is most concerned with at a given time. Member countries appear to have moved through different phases: the initial concern was with facilitating the participation of women in the labour force but, more recently, the emphasis has been on policy initiatives to reduce segregation and to eliminate differences between men and women in the labour market. Although the range of policies adopted in Member countries is quite varied, the measures tend to fall into a few relatively well defined categories which appear to be considered important for the full labour market integration of women.

Anti-discriminatory Labour Market Policies

One set of policy measures relates to labour market practices which discriminate against women, either directly because of unfair treatment based on sex, or indirectly because personnel procedures operate in ways which disadvantage women. The policies applied to deal with discrimination include:

 – Legislation to prohibit sex discrimination in employment practices;
 – Legislation requiring equal pay for equal work or for work of equal value;
 – The encouragement by government of positive action by employers and trade unions;
 – Action to establish equal opportunity in the public sector.

Training and Education

Women in general are at a disadvantage because, due to inappropriate education and training, they lack the necessary skills to compete for better employment or for employment in

certain sectors and occupations. Policies in this field include efforts to expand educational opportunities for girls, pre-employment or re-entry training and on-going training for those in the labour force. Policies appear to be aimed at encouraging young women to train for and enter employment in sectors in which women have been under-represented; enabling older women not currently in the labour force to re-enter employment; and enabling women already in the labour force to upgrade their skills or to move to different areas of work.

Policies for the Unemployed

Programmes which specifically address the needs of unemployed women are relatively rare but general policies for the unemployed are likely to have an influence on women's employment. The measures adopted in this context include training and placement, job creation schemes and schemes for special groups such as young people.

Family and Working Life

Another set of policy measures may be said, broadly speaking, to be directed at enabling people to reconcile their working life with family responsibilities. Important policies in this area relate to the organisation of working conditions and working time, arrangements concerning maternity and parental leave, and facilities for care of children and other dependent family members.

Social Security and Taxation

Social security and taxation systems may influence the employment decisions of women. Policies instituted in this field include removal of measures which discriminate directly or indirectly against women, policies designed to help workers to reconcile employment with family responsibilities and changes in measures which may carry disincentives for women to participate in the labour market.

Migrant Women and Ethnic Minorities

Some Member countries have policies aimed specifically at counteracting the special disadvantages which affect women in minority ethnic groups and migrant women. These include training and employment schemes and more general measures aimed at expanding the options open to these groups.

Three Types of Problem

The present chapter will be considering all of the above policy areas. Whether one is concerned with participation rates or segregation in the labour force, it is useful to recognise that labour market issues relating to women involve three basic types of problem. First is the series of labour market practices which discriminate against women. Second is that many women may find themselves at a disadvantage in the labour market because they bear a disproportionate share of family responsibilities. Third is that inappropriate education, training and socialisation make it difficult for many women to obtain better employment. Policies in these three areas are likely to influence both participation rates and segregation of the labour market and it is important to recognise their interrelated nature.

Participation rates are likely to be affected by policies which facilitate women taking up employment, such as provision of facilities for care of children and other dependent family members, education and training, tax and social security provisions and measures to aid

employment. But participation rates are also likely to be affected by policies directed specifically at improving the position of women in the labour force. Equal pay and equal opportunity policies may encourage labour market participation.

Conversely, labour market segregation is likely to be affected by policies aimed at removing discrimination and by affirmative action in the labour market. But policies aimed at factors on the supply side of the labour market may also be important. Part of the explanation for segregation lies in lack of provision for training women for higher paid jobs or for jobs in certain sectors of the market. Moreover, the uneven distribution of family responsibilities between the sexes and lack of adequate child-care facilities makes it difficult for many women to commit themselves to full-time, continuous employment.

The remainder of this chapter reviews policy implementation within the six policy areas identified above. It also examines the governmental machinery which has been set up to co-ordinate and implement policies for the employment of women. Insofar as the available information permits, the chapter also comments on results achieved and problems encountered in implementing policies.

3. ANTI-DISCRIMINATORY LABOUR MARKET POLICIES

The 1980 Declaration on Policies for the Employment of Women identified the following priorities with regard to elimination of discriminatory labour market practices:

– To implement an integrated set of policies to eliminate segregation in employment and reduce differentials in average earnings between women and men by means of:

a) The prohibition by law of direct discrimination;

b) Positive action to reduce indirect discrimination in recruitment, training and promotion, and in other terms and conditions of employment;

c) The reduction of persistent social biases and negative institutional practices which limit the range and level of occupations open to girls and women; and

d) The implementation of equal pay for work of equal value;

– To use more actively those measures directly available to governments to expand equal opportunities for women, e.g. recruitment, training and promotion in the public sector, employment exchanges, employment creation programmes and, in certain countries, regional development policies and public procurement.

All OECD countries have introduced legislation, or statements of intent endorsing the principle of equal treatment for men and women in employment, that is to say equal pay and equal opportunity regarding the general terms of employment[2].

A. Equal Pay

Equal pay for equal work legislation has been enacted in virtually all Member countries. Reforms in this area were one of the earliest forms of equal opportunity policy. Although such legislation has been a positive influence in reducing male/female earnings differentials, there still remains a substantial gap, as Chapter III illustrates. Whilst equal pay for equal work legislation has been a success in counteracting overt discrimination in rates of pay in the same occupations, it cannot in its present form equalise overall average earnings, given existing segregation of the labour force by industry and occupation. As noted in Chapter III, persistent differentials in earnings can be explained in large measure by differences in education and

qualifications, length of employment, number of hours worked, and – most importantly – by horizontal and vertical labour force segregation according to sex.

Equal pay legislation in its present form in most Member countries suffers from three important limitations. First, legislation in many countries provides only for comparison of similar jobs. Second, the mechanisms for instituting proceedings generally require that a complaint be brought by an employee who considers herself discriminated against. Third, investigations and adjustment of pay differentials are generally limited to a particular establishment.

As noted in Chapter III, an important step towards narrowing wage differentials would be the enactment of legislation and the development of procedures permitting a comparison of dissimilar jobs, using the principle of comparable worth or equal value as defined in ILO Convention No. 100 (1951). To date, the Convention has been ratified by twenty-two Member countries. This approach, which places more emphasis on the broader problem of discriminatory systems of wage determination than on particular instances of explicit discrimination, has been receiving increasing consideration in many countries. Equal pay legislation in several countries now incorporates the comparable worth principle. In the Scandinavian countries, considerable progress has been made in improving wage rates in predominantly female occupations through the collective bargaining process. In all countries, particular attention has been given to raising female earnings in the public service. Job evaluation schemes offer a valuable framework for comparing the worth of different jobs, and such schemes are being developed in a number of countries. However, it appears that the problem of reaching agreement on what constitutes work of equal value remains an obstacle to progress in broadening the application of equal pay provisions.

Few countries have provision for independent examination of wage practices in individual firms. In the majority of cases enforcement of the equal pay principle is by response to specific complaints by employees. The effectiveness of this mechanism has been questioned in some countries and it has been pointed out that its success depends on employees being sufficiently aware of the law to take action. Moreover, in the use of equal pay for work of equal value provisions, the effectiveness of the legislation depends on employees being able to recognise a pay differential between dissimilar jobs of equal value as being in contravention of the equal pay standard.

Since investigations and enforcement of equal pay are generally limited to a particular firm, differentials between firms or industries tend to persist. Finally, although equal pay legislation promotes earnings equality within occupations or even for work of equal value, it cannot on its own address the problem of the concentration of women in a narrow range of occupations and industries. As long as women's jobs are concentrated at the low end of the pay scale, a policy of minimum wages has been shown in some countries to be effective in reducing earnings differentials. Equal pay legislation must also work in conjunction with other policies aimed at promoting equal opportunity in the labour market.

B. Equal Opportunity

Almost all OECD countries have introduced legislation prohibiting discrimination against women with respect to terms of employment, including recruitment, promotion, dismissal, training opportunities and conditions of employment. In several countries such legislation has been introduced only relatively recently.

Several countries have gone further than simply forbidding discrimination by introducing affirmative action measures to counteract employment and personnel procedures which have a disproportionately negative impact on women. Such measures require employers

to promote a representation of the sexes in different types of jobs and at different levels of responsibility proportionate with their availability in the occupation and in the feeder population. This approach puts particular emphasis on recruitment and promotion procedures and on in-service training. A few countries have tried to encourage affirmative action on a voluntary basis.

A major target of affirmative action programmes have been companies receiving government contracts or state subsidies. For instance, in some countries such companies are required, or at least strongly encouraged, to take active measures to ensure that women are afforded equal opportunity for employment and advancement within the firm. While the emphasis is generally on voluntary action by employers, a few countries have machinery for obliging employers in the private sector to implement equal opportunity policies. Collective agreements between employers and unions have also been used as a vehicle for the introduction of equal opportunity policies in some countries. In general, affirmative action programmes are not as yet well developed in Member countries. Only in three countries do such programmes constitute a major plank of equal opportunity policy although a few other countries have experimented with encouraging affirmative action on a limited and voluntary scale.

The public service has a significant leadership role to play in promoting equal opportunity and affirmative action policies. Since the late 1970s an increasing number of countries have implemented equal opportunity policies in the public service, although there are still countries which have yet to take action in this area. Insofar as it is possible to measure the effect of affirmative action policies in the public sector, results appear encouraging. Some countries which have had equal opportunity and/or affirmative action programmes for long enough to make an assessment, report an increase in the proportion of women employed in the public sector generally and in senior positions within it.

While policies aimed at improving opportunities for women in recruitment and promotion appear to have had some success, labour market segregation is still a problem. Women continue to be concentrated in certain types of employment and in the lower échelons of enterprises. Equal opportunity and affirmative action programmes must be more widely applied and must be combined with measures which operate on the supply side of the labour market, particularly pre-employment and re-entry training programmes, support services for parents of young children and social security and taxation structures which do not discourage female employment.

4. EDUCATION AND TRAINING

With regard to policies on education and training the 1980 Declaration emphasized the following priorities:

- To stimulate and further the development of, and increased access to, employment, training and "recurrent" education programmes, particularly for women whose skills need upgrading and for women re-entering the labour force, taking into account new technologies and industrial developments;
- To develop education so as to progressively eliminate traditional sex role stereotyping in curricula and to provide a full range of educational choices for young women and young men, both for further education and skill qualifications for employment.

Concern about the situation of women in education and training has grown over the 1970s and 1980s. Although the information available covers only some of the Member countries, the

evidence suggests that an increasing number of governments are seeking policies to break down sex-based segregation in this field.

A. Education

Information on implementation of reforms in the education system is available for fewer than a third of the Member countries. Amongst those which have provided information, there appear to be a few clear paths of reform. One of the most common policies mentioned by countries is the elimination of sex stereotypes from teaching materials. In several countries there have been efforts to direct girls towards courses leading to training in subjects and areas in which women are under-represented. Policies in this context include career counselling, curriculum changes and initiatives to eliminate overt and covert sex bias in school programmes and teaching practices. Although most of the policies cited by countries relate to primary and secondary education, a small number of countries mentioned that efforts are being made to make tertiary education more accessible to mature-age students through easing entry requirements.

A number of countries have cited attitudes towards women's roles as a barrier to increasing the proportion of girls studying technical and scientific subjects. As such, changes in the content and organisation of the curriculum as well as career guidance at secondary level are extremely important in broadening educational horizons for girls so that they are not already restricted in choice of career by the time they reach the job market or the stage of post-secondary training.

B. Training

Over half of Member countries have indicated that they have implemented some policies aimed at breaking down existing sex imbalances in training. However, the level of activity and commitment varies considerably between countries. Only a few countries appear to have well developed measures for expanding training opportunities for women and encouraging them to enter a broader range of occupations. The strategies and policies aimed at bringing about such changes appear to be in their infancy in most countries, with some experimental or pilot programmes being initiated. Moreover, even in the countries which have advanced furthest in this field, not enough has been done in the way of assessment or evaluation of the impact and effectiveness of policies.

The range of policy measures adopted in Member countries is very varied. One of the most common approaches has been to try to encourage women to train or retrain in occupations where they are under-represented. A few countries have taken further steps by creating additional training places for women in such occupations or by giving priority to applications from suitably qualified women. Quotas for women in training and apprenticeship courses have been established in a small number of countries but this is not a widespread policy. A few countries have also made efforts to improve access to training for women by making entry requirements more flexible or by providing pre-training courses to enable women to make up deficiencies in their education. Some countries have established information programmes directed to encouraging women to train for non-traditional occupations.

Policies have also been initiated to encourage employers to train women in a broader range of occupations. Several countries provide grants or other cash incentives for firms which train women in the relevant skills. Efforts are made in some countries to persuade employers voluntarily to train and employ women in these occupations.

Several countries have established schemes to reintegrate women who have dropped out of the labour force, with an emphasis on training in marketable skills or upgrading of existing skills. Some efforts have been made to train women in occupations related to new technology but such programmes appear to be limited to a small number of countries. Very few countries mentioned any effort to provide ongoing support for women who actually enter predominantly male occupations although it is recognised that support may be vital in such cases.

Efforts to overcome vertical segregation do not appear to be widespread. Only a few countries specifically mentioned initiatives to encourage private employers to train women for more advanced duties so that they could progress within the hierarchy of the firm. Initiatives in the public sector have been more numerous. About a third of Member countries have indicated that policies have been introduced to equalise training and promotion opportunities for women within the public service. However, the degree of commitment varies from training courses and career advancement programmes aimed specifically at helping women to advance in the career structure to simply instructing those responsible for personnel policy to bear in mind the goal of equality. Many of the programmes are still in an experimental stage but some countries have been able to report an increase in the promotion of women into higher-level posts.

Member countries have cited a number of difficulties encountered in trying to develop effective policies in the field of training for women. One problem is that of setting targets for changing the occupational balance. The criteria for defining occupations as disproportionately "male" or "female" vary widely between countries. Some countries favour getting women into occupations which are currently almost wholly carried out by men. Others prefer to devote their effort mainly to increasing female representation in occupations where there is already a reasonably large minority of women. Policy-makers are faced with a strategic question of whether to concentrate limited resources on the most segregated occupations with the possibility of achieving only small quantitative results, whether to adopt a medium-term strategy of tackling less highly segregated fields first, or whether to opt for some combination of both.

A second problem is that, at a time of limited supply of jobs and rapid structural change in the economy, training programmes must take account not only of the need to train women in a wider range of occupations but also of the employment prospects in various fields of activity. Although there is a shortage of jobs in many occupations in which women are concentrated, the same problem applies to many of those in which most workers are men. Conseqently, there is a need to concentrate resources on training women in emerging and growing occupations.

5. UNEMPLOYMENT

The 1980 Declaration calls on Member countries:
- To adopt policies to deal with unemployment which do not discriminate either directly or indirectly against women.

Few countries have adopted special programmes designed specifically to address the unemployment problems of women. In fact, several countries have explicitly rejected this idea favouring instead the approach of catering for women within mainstream employment measures. However, some countries which do not have special schemes for women have indicated that particular attention is given to women's needs when administering schemes and when considering access to programmes.

In the minority of countries which have employment measures aimed at women in particular, the emphasis appears to be on counselling and retraining: a few countries have special information services for women which provide advice on employment problems and prospects; some countries have programmes for retraining women who left the labour force while their children were young, but in general insufficient attention has been given to the difficulties facing women who wish to resume employment after such a period of absence. One country indicated that subsidies for creating new jobs in depressed areas of the country are only given to firms which reserve at least 40 per cent of the jobs for either sex. Another country has set a target of 50 per cent female employment under its job-creation schemes.

Most countries which have provided information on the topic indicate that although women are benefiting to an increasing extent from training, placement and job-creation schemes, they are still under-represented in many programmes. Several countries have also commented that most women continue to retrain in occupations in which women are over-represented. For instance, one country which provides subventions to employers for taking on difficult-to-employ people reported that women benefit in substantial numbers from the scheme but that most are placed in "female" occupations. The general indication is, therefore, that although women take increasing advantage of employment measures, policies in their present form have not contributed to any great extent in de-segregating the employment market.

6. FAMILY RESPONSIBILITIES AND EMPLOYMENT

One of the main difficulties facing workers with children is combining employment with family responsibilities. Women are still expected to bear the main burden of child care and household chores and this limits their ability to undertake employment, to take up certain types of work and to advance in the career structure. The 1980 Declaration calls on Member countries to take the following action to enable employees to reconcile more easily work and family responsibilities and to ensure that the provisions of protective labour legislation are consistent with the goal of equal opportunities:

- To encourage the development, in co-operation with employers and unions, of more flexible working-time arrangements (e.g. part-time, flexi-time) on an optional basis, in order to achieve the more efficient functioning of labour markets and provide a wider range of employment choices to women and men; special consideration should be given to workers, both men and women, with responsibilities for children;
- To provide for part-time workers levels of pay and social security benefits which are proportional to those of full-time workers, and the same levels of working conditions and standards of protection;
- To review the provisions of labour legislation, for example protective legislation for women, to ensure its consistency with the goal of equal opportunity in employment, and to improve working conditions and the environment for all workers;
- To guarantee pregnant women and women returning from maternity leave protection from dismissal and the right to return to work without loss of earned benefits.

A. Working Time and Working Conditions

Approximately half of the Member countries have furnished information on changes in working-time arrangements and working conditions. With regard to working-time arrangements, flexible hours have been introduced to varying degrees in a number of European

countries, in North America and in Australia. However, the extent of application and the degree to which governments have encouraged this development is very uneven. Systems of flexible working hours are relatively widespread in the public service, although they are by no means generalised as yet. In the private sector progress appears to be slow. About one quarter of Member countries indicated that flexi-time systems had been introduced by private employers on a limited scale and mainly in the services sector. There appear to have been few specific measures aimed at encouraging private employers to establish flexible working-time systems. In general, this is left to negotiations between employers and trade unions.

Part-time work constitutes a very important part of the female labour market, as described in Chapter I. Little information has been provided on conditions affecting part-time workers. A few countries have stated that part-time workers have equal status with full-time workers with regard to rates of pay and social security coverage. However, it has been pointed out that part-time workers do not in general have access to fringe benefits and that their employment may not be as secure as that of full-time workers. It appears that an increasing number of countries are making efforts to improve conditions for part-time workers by extending to them the same legal rights as full-time workers. Some countries are also seeking ways of eliminating barriers which prevent part-time workers from coverage in collective bargaining agreements.

There is little information on job-sharing, which is a variation on part-time work whereby two people voluntarily share one full-time position. This practice seems to be limited as yet and there have been few explicit attempts to promote it.

Member countries have provided only very limited information on labour legislation related to such topics as night work and health and safety regulations. From such information as is available, it appears that most countries are now taking the position that different treatment of men and women is necessary only with regard to pregnancy. Beyond this, it is becoming accepted that any provision in protective legislation which discriminates between men and women should be removed or applied to both sexes. As yet, however, provisions which require the sexes to be treated differently remain in force in many countries.

B. Maternity and Parental Leave

The statutory right to a period of paid maternity leave with protection of employment exists in most Member countries. However, a minority of non-European Member countries do not have generalised systems of paid leave. As noted in Chapter VI, many Member countries have extended the period of statutory maternity leave beyond the International Labour Organisation standard of twelve weeks and there has also been a tendency to extend leave to the self-employed and to workers in family firms. However, there are still wide variations between countries, with the period of leave ranging from twelve weeks to 360 days.

Leave of absence for care of children for both men and women (parental leave), as described in Chapter VI, represents an important means of encouraging a more even division of child-care responsibilities between parents. It also enables parents of young children to maintain continuity of employment by simply suspending their work contract temporarily without having to relinquish their jobs. So far, paid parental leave has been introduced only in three Scandinavian countries. Some other European countries allow either parent to take unpaid leave with security of employment after the normal period of paid maternity leave has expired. Several European countries which do not as yet have provision for parental leave are examining the possibility of its introduction. Non-European Member countries appear to have made little progress in this area.

C. Child-care Facilities

Over half of the Member countries have provided information on the development of child-care services. It appears to be generally recognised that such services are essential if women are to have more equal access to employment. All the countries that provided information on this topic concluded that current facilities for care of pre-school children are inadequate to meet demand. The degree to which day-care facilities have been developed varies considerably between countries. In most cases, expansion of facilities has taken place only since the mid-1970s and a sizeable number of countries do not as yet have very active policies in this field. Many countries report regional disparities in availability of child-care places.

The approaches favoured for expanding day-care facilities are varied. The Scandinavian countries in particular have tended to emphasize the co-ordinated development of public facilities. In many other countries, expansion of day care is not centrally co-ordinated and is left in the hands of local or regional authorities. Private facilities have expanded considerably in some countries. In a number of Member countries, public authorities appear to be slow to respond to the need to increase day-care places. Two reasons for this are limitations on funds and reluctance to accept that the State should play a more active role in care of pre-school children. A few countries have attempted to stimulate employers to provide crèche facilities, but this approach does not appear to be widespread. Lack of care facilities after school hours for school age children has been mentioned as a problem in some countries but experiments with solutions have been very limited.

7. SOCIAL SECURITY AND TAXATION

The 1980 Declaration calls on Member countries:

- To endeavour to ensure that the provisions of taxation, social security and child-support systems do not bias the decisions made by both women and men as to how they allocate their time between paid employment and other activities.

As noted in Chapter VI, explicit sex discrimination has been eliminated progressively from the social security and taxation systems of Member countries. However, unequal pension ages still apply in a number of countries and dependants' and survivors' benefits are not yet accorded on the basis of similar criteria to men and women in many systems. Although there appears to be a trend towards placing social security entitlements on an individual basis, many systems still retain rights which are based on family or marital status. Most countries continue to provide derived social insurance rights for spouses of insured persons and only in a very few countries is there an explicit commitment to phasing out derived rights. It was also pointed out that in many income-tested and universal programmes, marital status continues to be used as a basis for determining entitlements, with possible adverse consequences for married women's employment decisions.

Women continue to experience disadvantages in employment-based social insurance systems because of their labour-market disadvantages. While problems in this area should abate with an improvement in women's position in the labour force, adjustments to the rules of employment-based systems so that coverage can be continued during periods of time devoted to caring for children are of considerable importance to parents of young children. Few countries have so far made provision for parents to preserve their social security entitlements in this context.

172

There has been a trend away from joint taxation to individual taxation for married couples in Member countries. However, just under half of OECD Member countries continue to use joint taxation systems, although such systems may have disincentives for married women to take up paid employment. It was also pointed out in Chapter VI that the structure of tax reliefs may adversely affect married women's work decisions, especially in those countries which give additional tax relief to married men whose wives do not work. Depending on the rate of withdrawal of such relief when the wife begins to earn, and on whether two-earner couples can claim tax relief for child-care expenses, or on the availability of subsidised care, this type of system may discourage married women from taking employment.

8. MIGRANT WOMEN AND MINORITY WOMEN

The 1980 Declaration calls on Member countries:
– To ensure that the special problems of migrant women are given consideration in all policies aimed at equal opportunity.

Information on measures aimed at improving the employment situation of migrant women and women belonging to minority ethnic groups is rather sketchy for most Member countries. While there has been increased concern about the problems experienced by these groups in recent years, reforms to date appear to have been relatively limited. Moreover, little has been done in the way of assessing the effectiveness of such policies as have been implemented.

Several countries have indicated that measures undertaken to promote equal employment opportunity for ethnic minorities and immigrants apply to both men and women, with little intended specifically for women. With regard to minority groups, the most common measures are special public training programmes and efforts to stimulate employers to provide employment and training opportunities. In the case of migrant workers, the emphasis appears to be on education and training, including courses aimed at facilitating the full participation of migrants into the community.

9. MECHANISMS FOR THE CO-ORDINATION AND IMPLEMENTATION OF EQUAL OPPORTUNITY POLICIES

The 1980 Declaration calls on Member countries:
– To ensure that there are effective organisational arrangements for the co-ordination and implementation of policy over the whole range of relevant public policies which affect the equal employment opportunities for women.

The majority, though not all, of Member countries have established mechanisms and structures for the promotion, co-ordination and implementation of policies. These mechanisms vary considerably from country to country to take account of differing political, economic and social structures. However, the following remarks attempt to provide a more general overview of the most important common characteristics and variations in organisational arrangements[3].

For the most part, mechanisms for the co-ordination and implementation of equal opportunity policies have only been established since the mid-1970s. The common pattern is

for countries to have several bodies, differentiated according to area of competence (e.g. general equality policy, labour market policy, equal pay policy, education) and/or function (e.g. co-ordination, advice, consultation, surveillance of application of legislation). Some of these mechanisms have been established by law, with permanent status and clearly defined functions, others are of an *ad hoc* nature.

The position of these bodies vis-à-vis the governmental/administrative structure also varies. Most countries have some mechanisms which are fully integrated in the governmental structure (e.g. ministries or sections of ministries dealing with women's affairs). The level of government at which such mechanisms operate is likely to be of considerable importance for their effectiveness. A few Member countries have mechanisms which come directly under the control of the Prime Minister, but they are more commonly attached to Ministries of Labour/Employment and Ministries for Social Affairs. A few countries, particularly those with federal systems of government have established mechanisms at regional and local level.

Most countries also have semi-autonomous consultative bodies which liaise with government, while a few countries have independent bodies which exercise a watching brief over the implementation of equality legislation. The composition of consultative bodies varies considerably between countries. However, a common pattern is for such bodies to be composed of representatives of employers, trade unions, women's organisations, government and political parties.

With regard to the functions of mechanisms currently in place, these vary according to the situation of the mechanism vis-à-vis the governmental/administrative structure. Mechanisms which are situated within the governmental/administrative structure are more likely to have decision-making functions and to play an influential role in the elaboration of legislation and policy. Such mechanisms also usually perform an advisory and informational function in relation to government, non-governmental bodies and the general public. Consultative bodies do not have decision-making powers although, depending on the nature of their links with the governmental/administrative structure, they may play an active role in the elaboration of policy. Such bodies also tend to play an important informational role. Most countries have a central mechanism for co-ordinating equal opportunity policies, usually within the Ministry for Labour/Employment or attached to the Prime Minister's office.

Some countries have bodies charged with monitoring the application of equal opportunity legislation and dealing with infringements. In some cases these bodies have the power to institute legal proceedings in cases where the law is being flaunted or inadequately applied. In at least one Member country the monitoring body has the power directly to impose penalties for infringement of equal opportunity legislation.

Insofar as it is possible to judge, the effectiveness of co-ordination and implementation mechanisms varies a good deal from country to country. The most effective bodies are likely to be those which have access to decision-makers at a high level and which operate directly within the decision-making structure. Such bodies would appear to have a relatively high capacity to influence policy. However, consultative bodies also have an important role to play in bringing into the decision-making arena a wide range of groups whose activities impinge on the situation of women in the economy. It would appear highly desirable to have mechanisms for monitoring the implementation of equal opportunity legislation. Once in place, such legislation can only be effective if actively applied. Finally, attention has been drawn in the course of this chapter to the urgent need for ongoing evaluation of the effectiveness of policies. Such evaluation would make a valuable contribution to further policy development and adaptation in the context of structural changes presently affecting the economies of OECD countries.

The evidence presented in this chapter suggests that, while considerable progress has been made in some countries in implementing policies for the employment of women, much still remains to be done. In the context of the current economic crisis it is imperative that Member countries should continue to develop such policies. It is also of the utmost importance that policies for economic recovery incorporate the principle of equitable treatment for women. With regard to policy priorities for the future, these will vary from country to country. In general terms, it would appear that anti-discrimination legislation is well developed in many Member countries and the main requirement in this area is that existing laws should be vigorously applied. Affirmative action, designed to ensure that women do not suffer indirect discrimination in the labour market, is an important policy instrument which is, as yet, insufficiently utilised in many countries. It is also clear that the application of policies related to the labour market must proceed in tandem with policies aimed at enhancing women's employment skills. In this context it has been noted that education and particularly vocational training and retraining are areas of crucial concern which have not always received sufficient attention. Finally, further reforms are required to improve the compatibility of employment and family responsibilities for all workers and to ensure that taxation and social security provisions do not exercise an adverse influence on women's work decisions.

NOTES AND REFERENCES

1. See "Declaration on Policies for the Employment of Women", in *Women and Employment,* Paris, OECD, 1980, pp. 153-155.
2. For a summary of the measures in force in Member countries see, *Women and Employment, ibid.*
3. The following paragraphs draw on information supplied by OECD Member governments and by the Council of Europe.

Chapter VIII

CONCLUSIONS AND POLICY DIRECTIONS

1. SUMMARY

This report has examined the position of women in the context of a range of economic, social and institutional factors. The first three chapters are directly concerned with problems arising in the labour market. Other chapters have examined factors which affect female labour supply patterns, including education and training and the responsiveness of public institutions to the changing situation of women. The report has attempted to identify barriers in the way of full integration of women into the economy and policy implications arising from its findings.

The participation of women in the formal labour market has increased in all OECD countries in the post-war period, as shown in Chapter I, Table I.1. Women's employment makes a crucial contribution to the economy, and women's earnings, particularly in low-income families, are essential to the economic well-being of their families and to strengthening consumer demand.

But the persistence of inequality in the labour market, in education and training and in social security and taxation systems, along with the uneven division of domestic work, has helped to maintain women in a position of economic disadvantage, rendering them vulnerable to poverty and dependence. Segregated labour markets largely confine women to low-paid, low-skill, low-productivity occupations, often in declining sectors of the economy.

The report has focused particularly on the period since 1979. Trends in this period give cause for concern. While female labour force participation rates have continued to increase, growth has levelled off considerably, possibly indicating the presence of a substantial group of discouraged women workers who do not appear in official unemployment statistics. As shown in Chapter I, Table I.1, between 1975 and 1979 the average female labour force participation rate in the OECD area grew by 3.5 percentage points (from 49.2 per cent to 52.7 per cent) as compared with a growth rate of 1.6 percentage points between 1979 and 1982.

Although female unemployment rates have risen more slowly than male rates during the current recession, data from some countries indicate a substantial incidence of hidden unemployment among women, as well as a high rate of involuntary part-time employment. Moreover, disaggregation by age shows that unemployment is higher for young women than for young men in most countries as demonstrated in Chapter I. Earnings differentials between men and women have narrowed only slightly in the period since 1979 and in a few countries differentials have actually increased, as is shown in Chapter III. Since measured female unemployment exhibits a lower cyclical elasticity than male unemployment, it is likely to fall less rapidly in post-recessionary periods. The crowding of women into a narrow range of occupations and into jobs requiring little skill or training reduces their employment opportunities and places them at a disadvantage at a time of rapid structural change in the economy.

176

Indications from many Member countries are that the current recession is not only increasing the barriers to equality in the labour market, but that existing achievements are being undermined in some cases. As noted in Chapter I, some countries have responded to the problem of high unemployment by attempting to discourage women's employment. Moreover, pressures on public expenditure have tended to delay policy changes necessary to support women's equal participation in the labour market.

It will be evident from the various chapters of this report that the disadvantaged position of women in the labour market is the result of a complex of interrelated and mutually reinforcing factors. Inequality is reinforced because of the ways in which labour market factors, institutional factors and supply factors interact. Discrimination and labour market segregation make it difficult for women to improve their position in the labour market. At the same time, the unequal division of domestic labour also contributes to the problem: because women continue to bear the main share of family-care responsibilities, their employment options tend to be more constrained than those of men and established employment practices tend to penalise them indirectly. But the sex role stereotypes which give rise to discrimination and role differentiation are in turn reinforced by existing patterns of female employment, as well as by tax and social security arrangements which treat men and women differently. Differences in the education and training given to men and women also contribute to perpetuating inequality and segregation in the labour market. However, because of real or perceived barriers to employment opportunities, women themselves may be discouraged from investing in marketable skills.

Because of this circularity of cause and effect, the pattern of discrimination and disadvantage is difficult to break. Despite considerable changes in some areas the central problem of the concentration of women in a narrow range of jobs and occupations persists along with its attendant ills of low pay and high unemployment. The policy interventions required to reduce labour market inequality are as diverse as its causes. This report has identified the following main fields of policy action:

i) Prohibition of discrimination in employment and wage practices;
ii) Affirmative action policy to change recruitment, promotion, pay and firing practices which discriminate indirectly against women;
iii) Education and training programmes to prepare women for a wider range of labour market opportunities;
iv) Provision of child-care facilities and other service infrastructures;
v) Promotion of equality in the public sector;
vi) Rearrangement of working time and working conditions to accommodate family responsibilities of employees;
vii) Greater equity in taxation and social security institutions;
viii) Increasing the influence of women in structures affecting their opportunities.

In the same way that factors giving rise to labour market segregation reinforce one another, so also should the policy options listed above operate in combination. What is needed is co-ordinated action on a variety of fronts so that the different policy instruments strengthen and support one another.

2. ANTI-DISCRIMINATION LEGISLATION

Laws requiring equal pay for equal work and prohibiting direct discrimination against women in the labour market have formed the basis of equal opportunity policy in most

Member countries. Equal-pay legislation has made a valuable contribution to narrowing male-female wage differentials while anti-discrimination laws have expanded employment opportunities for women. The removal of overt discrimination in employment and wage priorities is clearly an essential first step on the path towards equal opportunities in the labour market. Given that equal-pay and anti-discrimination legislation has now been enacted in virtually all Member countries, the main future policy requirement in this area is that the law should be vigorously enforced. One important barrier to progress in this context is lack of effective enforcement machinery in a number of countries. Another is that some of the existing laws are framed in ways which limit their effectiveness. These require strengthening.

While equal-pay and anti-discrimination legislation is a necessary precondition for achievement of equality in the labour market, such measures are not in themselves sufficient to overcome all of the obstacles to reaching this goal. Despite the success of these laws, a substantial gap persists between male and female earnings, and labour market segregation remains high. The general conclusion to be drawn from this report is that policy must go on a considerable way beyond prohibiting direct discrimination and requiring equal pay for equal work in order to impinge upon the wide range of factors which contribute to women's disadvantaged economic position.

With regard to women's earnings, a serious limitation of legislation requiring equal pay for equal work is that in a segregated labour market it affects a relatively narrow range of occupations. In recognition of this, the notion of equal pay for work of equal value has been receiving increasing attention in Member countries and is widely advocated as a means of narrowing male-female earnings differentials and reducing labour market segregation. Over time there has been a policy evolution from equal pay for equal work to equal pay for work of equal value. As mentioned in Chapter VII, the International Labour Organisation has had a convention on the equal value principle since 1951, and this has been ratified by most Member countries. Equal-value legislation has been enacted by several Member countries and it is to be hoped that more countries will move in this direction.

As noted in Chapter III, job-evaluation schemes represent a useful framework for reassessing wage differentials and are an important concomitant of equal-value legislation. The development of such schemes at firm and collective level is desirable and in this context government has an important role to play in providing technical support. Several Member countries have, however, pointed out that job-evaluation schemes are not a guarantee of equal remuneration. In this context it should be noted that collective-bargaining mechanisms and minimum-pay legislation have proved efficacious in narrowing earnings differentials in a number of countries.

3. AFFIRMATIVE ACTION

The trend in Member countries has been to progress from equal-pay and anti-discrimination legislation to the broader notion of equal opportunity. An important element in this evolution has been the development of affirmative-action programmes, aimed at removing labour-market practices which discriminate indirectly against women. Such programmes are widely recognised as an essential policy instrument in breaking down occupational segregation, both horizontal and vertical, and, by association, in raising female earnings and reducing female unemployment. Affirmative action policies are concerned with ensuring that employment practices (e.g. recruitment, training, promotion and firing) do not

discriminate indirectly against women and that women are represented in the occupational structure in number proportionate to their qualifications and availability in the feeder population.

As noted in Chapter VII, affirmative-action policies have to date been widely applied in a relatively small number of Member countries. Given the recent development of these policies it is difficult to evaluate the effectiveness of alternative types of affirmative-action measures. While it is to be hoped that more Member countries will adopt affirmative-action programmes, the most effective policy mix will vary from country to country. Finally, information from countries where such policies are already in place suggests that a critical factor in their success is the existence of effective mechanisms for their enforcement and evaluation.

While the potential achievements of affirmative-action policies are great, they can only be fully effective where accompanied by specific measures to improve employment-related skills of women, to enable parents to reconcile more easily work and family life and to encourage the sharing of family responsibilities between the sexes. It has been stressed in this report that since the factors contributing to economic disadvantages affecting women arise from a combination of factors internal and external to the labour market, equal opportunity policy must be defined in a sufficiently broad sense to encompass measures in a wide variety of arenas. In this context it is worth noting that in some Member countries the concept of affirmative action encompasses not only measures directly related to employment practices but also policies to facilitate the access of women to the labour market.

4. EDUCATION AND TRAINING

The importance of education and training in breaking down occupational segregation has been stressed in this report. Chapter V shows that despite changes in this field there are important differences in the type of education and training received by boys and girls. Girls and young women are seriously under-represented in those courses of study at secondary and post-secondary level most likely to lead to highly-skilled, well-paid occupations with opportunity for advancement. There is similar under-representation of women in vocational education, while in occupational training programmes there is marked segregation by sex. At present women in many countries are not well represented in apprenticeships and pre-employment training programmes, and few women are given on-the-job training. Moreover, the type of training given frequently reinforces existing occupational and job segregation.

Chapters III and V have drawn attention to the need for suitably designed educational and training programmes to enable women to achieve their full potential in the labour market. In schools, sex stereotyping and segregation can be counteracted by various means, including careful structuring of courses, particularly at stages during which specialisation occurs, use of non-biased teaching methods and curriculum materials, and counselling.

Occupational training programmes, including both pre-employment and on-the-job programmes, have been identified as a key policy instrument in combating the horizontal and vertical segregation of the labour market. With regard to pre-employment training, several Member countries have developed policy instruments which appear to be proving successful and which might usefully provide a guide for other countries to follow. As noted in Chapter II, such instruments include removal of unnecessary entry barriers to training programmes (such as age limits or unnecessary educational requirements), giving women priority access to

179

certain programmes, and active recruitment and counselling to encourage women to take up a wider range of occupations. A crucial element of the programmes would appear to be placement and follow-up support services to ensure that female trainees for occupations in which few women were previously employed find jobs and, once employed, receive any support that they might need in pursuing their occupations.

On-the-job training is essential if women are to advance within the occupational hierarchy and constitutes one key element of affirmative-action programmes. Policy options include requiring or encouraging firms to provide training opportunities for women through such mechanisms as training quotas, subsidies and technical support from government agencies. As with pre-employment training, it is crucial that women should be trained for a wider range of occupations and for higher levels of responsibility. All training should, of course, be planned in the context of prevailing labour market conditions. In particular, resources should not be wasted in training women for occupations in declining sectors of the economy but should be concentrated on emerging areas of employment.

In an era of high unemployment, public job creation schemes and retraining programmes have become a major policy instrument. In order to avoid reinforcing labour market inequalities, such programmes should take particular account of the need to counter occupational segregation. Retraining also has valuable potential in raising the skill level of both young women who have yet to find employment and older women who may need to update their skills, or who seek to re-enter the labour market after a period of absence.

A specially important area is training for newly emerging occupations, particularly in high technology fields. As noted in Chapter II, such occupations have the advantages of relatively high status and remuneration and relative freedom from sex stereotyping. Thus, while it is desirable that women should be well represented throughout the labour market, special attention should be given to training them for jobs created by new technology. Moreover, evidence from several countries indicates that women are facing a high risk of redundancy due to technological change in the employment market. Consequently, training programmes are essential for upgrading existing skills and imparting new ones so that women are in a position to enter emerging areas of employment.

5. FAMILY RESPONSIBILITIES AND EMPLOYMENT

The difficulty of combining work with family responsibilities is one of the major obstacles in the way of achievement of equality by women in the labour market. Because women are still expected to bear most of the responsibility for child care, housework and care of the elderly, they frequently find themselves unable to take full advantage of employment opportunities. Policies are needed to promote a more even division of family responsibilities between the sexes and to enable workers to cope with the pressures of child-rearing. In this context the following are very important:

 i) Day-care facilities of a high standard and at an affordable price;
 ii) Paid maternity leave;
 iii) Parental leave for both parents in connection with child-rearing.

The provision of an adequate number of low-cost, day-care places is a pressing problem in most Member countries. Moreover, the problem is exacerbated by the current recession: public finance for day-care facilities has been severely limited in many countries, and women have been obliged to withdraw from the labour market due to the high cost or inadequate

provision of facilities. Despite official commitment to the principle of expanding day-care provision, the number of places provided still falls short of needs and the financial accessibility of care varies considerably between countries. The strategy followed in a number of Member countries emphasizes incentives for women to withdraw from the labour force or to work part-time in order to care for children and therefore reinforces rather than reduces sex-role stereotyping. Policy options for expanding care facilities include public provision of low-cost day care, subsidisation of privately-organised facilities and encouragement of employer-sponsored care as a fringe benefit for employees, or some combination of all three. Particular attention should be given to the requirements of low-income women and single parents.

Paid maternity leave with full protection of employment is an essential element of protection for working women. As noted in Chapter VI, some Member countries do not yet have generalised systems of paid maternity leave. Parental leave available to either parent of young or sick children is a very important policy instrument in sharing the responsibilities of child care and in enabling mothers of young children to maintain continuity in the labour market. As noted in Chapter VI, if such leave is to represent a viable option for parents it must be accompanied by replacement of a proportion of earnings and by protection of employment.

6. EQUALITY IN THE PUBLIC SECTOR

As a major employer, amenable to direct government control, the public sector is in an excellent position to promote sex equality in employment. The public sector should be in the vanguard of the movement towards improving the position of women and should serve as an example for the private sector. Despite some progress in recent years, there is still much scope for improvement in the public sector of many countries. Female employees tend to be segregated in certain branches of public sector employment and in the lower échelons of the hierarchy, and disparities persist between average male and female earnings.

As in other sectors of employment, equal opportunity policy in the public sector should not be limited to simply eliminating discriminatory practices. Measures are required which will actively promote the recruitment and advancement of women throughout the public sector. Important policies in this context include:

i) Review of recruitment procedures with a view to improving access by women to areas where they are under-represented;

ii) Positive efforts to improve women's prospects for professional advancement and access to positions of responsibility;

iii) Development of job evaluation procedures which will enable a review of male-female earnings differentials on the basis of the comparable worth principle;

iv) Professional formation and preparation for internal competitions;

v) Protection of job and seniority during periods of maternity leave;

vi) Measures to enable employees of either sex more easily to combine work and family responsibilities.

In order to ensure the success of equal opportunity policies and to overcome possible resistance to change, ongoing review of progress is essential. An important element of the review procedure is regular monitoring of statistical indicators regarding the position of women in the public service. Finally, in the context of the current emphasis on limiting or even reducing public sector employment, particular care must be taken to ensure that progress towards improving the position of women is not halted.

7. WORKING TIME AND WORKING CONDITIONS

Changes in working time and working conditions can be an important indirect aid for women to participate in employment, or to enter certain sectors of employment. Policy in this area should aim at encouraging, in co-operation with employers and trade unions and in consultation with bodies concerned with the employment of women, more flexible working-time arrangements (e.g. flexible hours and fully protected part-time employment). Particular consideration should be given to the requirements of workers, both men and women, with family responsibilities. Where necessary, facilities should be provided which would enable women to be employed in a wide range of jobs, and every effort should be made to ensure that protective legislation does not restrict women's employment opportunities. In this context, regulations concerning night work are of particular significance.

In the context of high unemployment and in view of structural change affecting labour markets, the issue of redistributing available work among a larger number of employees through changes in working-time arrangements has received some consideration. While such a redistribution might in principle expand employment opportunities for both men and women, careful consideration would need to be given to the full range of possible implications for the functioning of the labour market and the economy in general. While some Member countries are interested in pursuing this line of policy, others regard it with little enthusiasm.

While part-time employment is one possible option for facilitating more satisfactory integration of work and family responsibilities and for offering workers in general more flexibility with regard to working time, it is an option which must be treated with caution. At the present time, the conditions surrounding part-time work in many Member countries are such that it represents another form of labour market segregation and disadvantage. A high proportion of part-time jobs are in predominantly female sectors of the labour market; they are generally badly paid, low in skill content and carry little legislative protection or entitlement to coverage under public and employer social security programmes. Thus, in its present form, part-time work is often regarded by employers as a source of cheap labour. Moreover, available evidence suggests that there is a relatively high rate of involuntary part-time employment among women, particularly married women, because full-time work is unavailable.

If it is to represent a viable option, part-time work should in all cases be voluntary and should be available throughout the labour market. Such work should not in any sense be regarded as a means of enabling women to continue bearing a disproportionate share of the responsibility for child care, care of adult dependants and housework. Nor should it be seen as an alternative to measures aimed at enabling women to achieve full equality in the labour market. Part-time work should be properly remunerated and should carry the same rights, protection and opportunities as full-time employment.

8. TAXATION AND SOCIAL SECURITY

The State also has an important role to play with regard to adaptation of the taxation and social security systems to the changing role of women. Chapter VI has argued that the systems in many Member countries have failed to adapt sufficiently quickly to the requirements of women. Important elements of social security systems continue to assume a secondary role for married women and to favour a situation whereby only one spouse participates in paid

employment. Similarly, personal income-tax systems in many countries are structured in ways which may adversely affect married women's work decisions, encouraging them to refrain from employment. Moreover, the effects of budgetary restrictions on social security expenditures have been felt severely by women in some countries. Necessary reforms have been delayed and benefits and services of special importance to women (e.g. family benefits, child-care services) have in many instances suffered from expenditure restraint.

9. CO-ORDINATION AND IMPLEMENTATION OF EQUAL OPPORTUNITY POLICIES

The problems facing women in the economy have been clearly identified in this and other studies. Yet, to date, progress in the design and implementation of policies to remedy the situation has been uneven, and adequate policies are urgently required in many areas. Given the broad range of reforms required, there is a need for mechanisms to co-ordinate the implementation of policy and to monitor and assess progress over a variety of policy areas. This includes monitoring the implementation of existing policy instruments and advising upon the introduction of new ones; identifying barriers in the way of policy implementation; assessing the effectiveness of policy; and gauging the impact on women of general policy in all fields which may affect their lives. Information campaigns by government have an important support role to play in informing employers, employees and the general public about equal opportunity policy.

As noted in Chapter VII, it is desirable that some co-ordination and implementation mechanisms should be situated at a high level of government and that they should have the power to participate actively in decision-making. The value of advisory bodies, which bring together various social and economic interests in the policy formulation arena has also been noted. It would appear highly desirable also to have an independent body charged with watching over the implementation of and compliance with equal-opportunity laws. Co-ordination and implementation mechanisms at lower levels of government, in enterprises and in trade unions, may also serve a valuable purpose in hastening necessary policy changes and innovations.

It is crucial that women should be well represented in all areas of decision-making, particularly those which affect their role in the economy. Among the most important ones are the full range of governmental administrative and judicial institutions at local, national and international level, bodies representing the interests of industry and labour, decision-making mechanisms in individual enterprises, political parties and the media.

Women play a vital role in the economy in all OECD countries and have a valuable contribution to make to economic recovery through participation in new high-skill, high-productivity enterprises and by enhancing the economic security of their families. If women are to realise their full economic potential and to participate equally in economic growth, then the recovery must go hand in hand with the pursuit of equity. Measures to promote sustained growth must be based on maximisation of the productive capacities and skills of both men and women.

OECD SALES AGENTS
DÉPOSITAIRES DES PUBLICATIONS DE L'OCDE

Les commandes provenant de pays où l'OCDE n'a pas encore désigné de dépositaire peuvent être adressées à :
OCDE, Bureau des Publications, 2, rue André-Pascal, 75775 PARIS CEDEX 16.

Orders and inquiries from countries where sales agents have not yet been appointed may be sent to:
OECD, Publications Office, 2, rue André-Pascal, 75775 PARIS CEDEX 16.

68656-05-1985

OECD PUBLICATIONS, 2, rue André-Pascal, 75775 PARIS CEDEX 16 - No. 43293 1985
PRINTED IN FRANCE
(81 85 05 1) ISBN 92-64-12735-6